ART GUIDE FOR
Bruges

W9-CGZ-199

ISBN 90 5240 033 4
D/1989/4237/24
Copyright © 1989 by Uitgeverij Hadewijch nv, Antwerpen/Baarn
Translation: A. M. Lannoo

No part of this book may be reproduced in any form, by print, photoprint, microfilm or any other means without written permission from the publisher.

Fernand Bonneure

ART GUIDE FOR
BRUGES

HADEWIJCH

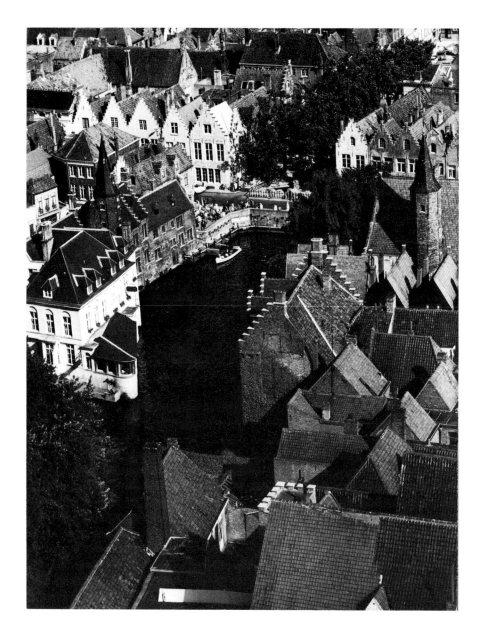

Contents

Introduction

What should be examined by people who love Bruges or come to visit the city and want to become acquainted with its artistic expressions?

That was the... challenge, to which this art guide wants to try and give an answer. Though many texts have already been written and published about art in Bruges, this guide wants to present an easy-reference and practical summary of the city's – and not the suburb's – artistic patrimony. It contains a lot of information about old and modern art of all disciplines which can be looked at or experienced by the general public in Bruges.

The book has been subdivided into four chapters: art on the squares of Bruges, art in the Brugean museums, art in the Brugean churches and art in the street scene of Bruges. Each of these chapters contains a situation and discussion of the main works of art and refers to the bibliography.

The guide can be used to prepare a visit to Bruges, but can also be taken along as a souvenir.

In an appendix a kind of Brugean 'Pantheon' is given, a list of about one hundred people from both the past and the present living in Bruges or closely connected with it. They played an important role in the field of art or general culture and evidence of them can still be found in works of art, houses, portraits, statues, books or commemorative plaques. This appendix gives the reader a fuller picture of some periods and characters.

Though not complete, this book does discuss the most essential artistic moments and expressions illustrating and explaining the unique and world-famous value and appeal of Bruges as a city of art.

If, after reading this book, more art-loving visitors come to Bruges and select the city's rich treasures they want to get acquainted with, the composer will feel richly awarded for the lenghthy work of investigation and arrangement.

Fernand Bonneure

Eiermarkt (Egg market)

Art on the squares of Bruges

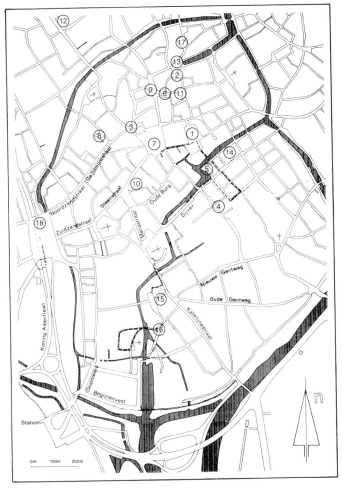

1 Burg
2 Biskajersplein
3 Eiermarkt
4 Garenmarkt
5 Huidenvettersplein
6 Kraanplein
7 Markt
8 Muntplein
9 Schouwburgplein
10 Simon Stevinplein
11 Sint-Jansplein
12 Achiel Van Ackerplein
13 Jan van Eyckplein
14 Vismarkt
15 Walplein
16 Wijngaardplein
17 Woensdagmarkt
18 't Zand

Most squares in Bruges are of the medieval type, with a street running into each of the (four) corners. From the very start, these open, unbuilt sites in the city landscape have had very specific functions. In many cities they constitute the spacious entry to a monumental palace, a city hall, theatre or cathedral. Markets were also held in these squares. They opened on to a port or railway station or were simply status symbols around monuments or statues. The Bruges squares also satisfy some of these functions, though they have sometimes changed roles in the course of history.

Squares have always been and the Bruges squares still are meeting-places. They have deliberately been surrounded with large, beautiful buildings which were regularly adapted to meet the taste of the time. Artists were commissioned to decorate the interior and exterior of these buildings. In Bruges many artistic expressions of all ages are to be found on and around squares.

Burg (Borough)

The Market square being the place where the heart of the people has been beating and where the City Council first assembled, the Burg, on the other hand, could be called the cradle and soul of Bruges. From the very beginning the city, count's, church and judicial authorities have had their seats on this 'burgus Brugensis'. Moreover, the square has, through the ages, been a separate entity, which was walled in and, up to the 18 th century, locked with four gates, traces of which can still be seen in the Blinde Ezelstraat. The buildings which were put up in this square contain many art treasures and constitute a fascinating survey of ten ages of architecture, which is one explanation already for the square's unique value.

Unfortunately, a number of remarkable buildings have disappeared. The north side of the square, now planted with trees, was once covered by the impressive complex of *Saint Donatian's Church*, founded in 961 by Arnulf I the Great, count of Flanders, and built after the Aachen palatine chapel. Nothing is left of this originally Carolingian building that was later adapted to the prevailing styles. It was sold by auction in 1799 and completely demolished in the next few years. In 1955 the foundations were exposed and an outline of the church plan was inserted in the cobbles of the square. In 1957 a scale-model of the church was put on a foot made of stones of the church discovered here. The commemorative plaques read as follows 'Hier stond de burchtkerk der graven van Vlaanderen omstreeks 900' (Here stood the castle church of the counts of Flanders about 900) and 'Hier viel voor recht en volk graaf Karel de Goede 1127' (Here was slain for justice and

people count Charles the Good 1127). In 1987 a little four language tablet was added commemorating the murder on the count in this church. During the same year excavations for the construction of the Burg Hotel, on the corner of Burg and Burgstraat, exposed remnants of part of the choir and three radiating chapels of the Romanesque church. These remnants have been preserved and integrated in the construction of the hotel.

During the many ages of its existence in the very centre of town, Saint Donatian's Church was the outstanding centre of religious and cultural life: it had a chapter and chapter-school, a dean who was also hereditary chancellor of Flanders with both religious and administrative functions, a choir-school with famous musicians and an outbuilding with little shops where the first printed books were once sold. Important works of art were given to this church and many prominent people such as Jan van Eyck, Joris van der Paele, Hubertus Goltzius, Juan Luis Vivès were buried here. Since the Burg square has been closed to traffic this area under the trees offers a favourite and unique view on all the riches which have been preserved here.

Under the trees stands a little marble statue of Jan van Eyck made by the Brugean sculptor Jan Robert Calloigne in 1820.

The monumental outline of the *Steen*, which took up the whole west side of the square, can now be seen on old prints and maps only. The former porch building – now a little souvenir-shop – next to the entrance stairs to the Basilica of the Holy Blood, is the only remnant of the 'domus comitis lapidea' (the count's stone house), later used as the criminal court's office. Over the door in the middle of the façade, count Charles the Good has been represented. The medallions show from left to right: emperor Ferdinand of Germany, Charles the Fifth and his wife Isabel of Portugal and to the right, half, Mary of Hungary. All these pictures in the façade of the Steeghere Gallery and of the criminal court's office, so in the façade of the Chapel of the Holy Blood as well, were designed by Lanceloot Blondeel from the region of Poperinge in 1542. Most of them were copied by the Bruges sculptor Michiel Dhondt in the 19th century.

'On the Burg square where the Holy Blood reminds of Golgotha,' said the poet Guido Gezelle. The chapel got its name because part of Jesus' blood is kept here. It was brought to Bruges in 1150 by the count of Flanders Thierry of Alsace (†1169) after one of his four crusades to the Holy Land where he would have received this relic from the Patriarch of Jerusalem as a reward for his exceptional courage. In 1256 the relic was mentioned for the first time, when an oath had to be sworn on the Holy Blood. The present relic is stored in two round, crystal vials flanked by two gold angels holding a little chain. In times of war and occupation the relic was hidden by citizens. The relic is celebrated in the annual

Procession of the Holy Blood on Ascension Day ('Bruges' finest day'). The procession is one of the oldest in the world, dating back to 3rd May 1303, but has regularly been adapted to fashion and taste. It has always been attended by both church and secular authorities. The chapel, relic and procession have been consigned to the 'Noble Brotherhood of the Holy Blood', mentioned as early as 1405, consisting of at most 31 men chosen among the nobility and prominent people of the city.

The Basilica of the Holy Blood in the southwest corner of the Burg consists of two parts: the lower or Saint Basil's Chapel and the upper or Basilica of the Holy Blood. The porch façade facing the Burg square, called 'De Steeghere', presents, in a mixture of styles, a somewhat incoherent comic strip of counts and countesses, rulers and dukes of Flanders. Above the crypt and the stairs to the upper chapel we see, quite at the top, six coats of arms of popes who stimulated the cult of the Holy Blood by granting indulgences: Innocent IV, Clement V, Paul V, Pius VI, Pius IX and Leo XIII. Between the windows below four bronze angels present the coats of arms of the diocese of Tournai, the Provost, the diocese of Bruges and the Abbey of the Dunes. The floor below shows from left to right: archduchess Isabel and archduke Albert (in half medallion), Maximilian of Austria (half), Mary of Burgundy (a falcon on her hand), Margaret of York (half), Sibylle of Anjou (half) and Thierry of Alsace and, at the other side of the gate, Philip of Alsace.

The lower chapel, also called crypt because it is always cloaked in darkness, is a Romanesque three-aisled building of 14 by 10 metres with four short, thick sandstone columns, nine cross vaults and small windows. Over the passage of the little side chapel in this oldest extant church of Bruges, a building which is only architecture, the oldest sculpture of the city can be discovered: a *Romanesque low relief tympanum* (about 1100) in Tournai stone with a rudimentary representation of a baptism (of Basil or of Jesus in the river Jordan).

The chapel was rebuilt on the site of an older building about 1150 by count Thierry of Alsace and his wife Sibylle of Anjou. They dedicated the count's chapel to Mary and to bishop Saint Basil, Doctor of the Church and patron saint of the bricklayers. In 1923 the chapel was proclaimed a basilica by Pope Pius IX. In 1875 graves were discovered in the floor of the chapel, among which probably Jan van Oudenaarde's tomb, a master bricklayer who took part in the construction of the Belfry and of several city gates. The bricklayers used to celebrate their annual patron saint's day in this chapel.

The most remarkable work of art is the *Virgin with Child* in the right-hand aisle, the former chapel of the chandlers. This wooden polychrome and gilt statue of the enthroned Madonna with the Christ-child standing on her right knee is one of the oldest (about 1300) and most beautiful Gothic sculptures to be found in Bruges. The 19th century Ecce Homo in the little side chapel has less artistic value

but is much worshipped by the general public.

The more spacious Chapel of The Holy Blood or upper church has not kept many original characteristics. Though it can be traced back to Romanesque times, it was heavily restored in a somewhat old-fashioned neo-Gothic style. The monumental stairs lead us to this one-nave chapel lit by nine stained-glass windows left and three right, representing Flemish rulers under Burgundy, Austria, Spain and the Habsburg dynasty. In 1830 the city sold the original 15th century stained-glass windows at a very small price to an antique dealer; they can now be seen in the Victoria and Albert museum in London. Today's windows were made from the original cartoons by J.Pluys from Mechelen in the 19th century.

The objects worth seeing in this chapel are the communion rails from the end of the 17th century originating from the Dominican Engelendaele convent which was suppressed after the French Revolution. The panels contain fluent, graceful and elegant pictures of the typical Dominican saints Rosa of Lima, Hyacintus, Dominicus and Catherine of Siena. The 19th century symbolist wall paintings in the choir were made from sketches by Thomas Harper King and William Brangwyn. The globe-shaped 1728 pulpit was made by Hendrik Pulinx, probably from a single block of wood. He also sculpted the marble rococo altar in the cross chapel with two worshipping angels by Pieter Pepers to the left and to the right. The centre of this altar is a wonderful silver tabernacle (1767) by the Bruges silversmiths François Rielandt and Charles Buntinck. It shows the tools of the passion and the symbols of the four evangelists and is crowned by a tall silver altar cross.

Every Friday the Holy Blood is exhibited for adoration on the blessing altar to the right, a two-step platform designed by William Brangwyn in 1865.

The Holy-Blood Chapel complex also includes a small but important museum. The most precious work of art is certainly the *Reliquary of the Holy Blood*, a shrine 129 cm by 61 cm consisting of five hundred parts and completed by goldsmith Jan III Crabbe in 1617. It substituted a former shrine stolen and melted by the Protestants in 1578. Crabbe's work of art is an outstanding example of vigorous and elegant Renaissance forging. The little statues on the crowning (Christ, the Virgin Mary, Basil and Donatian) are of solid gold. The rest of the shrine has been made of gilt silver and richly decorated with precious stones, enamel, cameoes and pearls. The foot is surrounded by the skilfully enamelled coats of arms of the 31 members of the Brotherhood and of goldsmith Jan Crabbe himself. This reliquary is each year carried about in the Procession of the Holy Blood.

The members of the 1555-1556 Brotherhood have been portrayed on *two panels of a polyptych* by Pieter Pourbus; the middle panel is missing. It brings a realistic picture of the 31 of them, all wearing their black brown gowns. The 32nd character in the top left corner is the Master of Ceremonies of the Brotherhood. The frame with the coats of arms has enabled historians to identify all the charac-

ters. Though incomplete, this painting is an early example of a group portrait.

This museum holds two more important anonymous paintings: *The legend of Saint Barbara* from about 1480, attributed to the Master of the Barbara Legend. It is in fact the side panel of the triptych on which the saint's complete life was represented. Barbara was the daughter of the rich gentile Dioscorus who, very much against the will of the father, was converted to christianity and baptized. The father publicly disowned his daughter and later locked her up in a tower. She was beheaded and died a martyr's death. The splendid painting excellently represents the different substances such as stone, plants and clothing, using soft and poised colours. The *Entombment* from about 1520 is younger but equally important. This triptych attributed to the Master of the Holy Blood shows Mary Magdalen with a jar of balm on the left panel and Joseph of Arimathaea with the crown of thorns on the right panel. The landscape with Mount Calvary has been painted in smooth colours. This master reminds the spectator a little of the work of Quinten Metsys from Antwerp.

In this little attractive museum still more treasures can be seen: a collection of chasubles and paraments, a smaller but delicately worked silver reliquary, Canon boards, a Bruges woollen tapestry (1637) of 260 by 530 cm with the transfer of Saint Augustine's relics from Africa to Sardinia, lace, six medallions by Hendrik Pulinx, drawings, coins and medals, a 1586 holy-water font and the cartoons of the original stained-glass windows of the upper church. And in one of the display cases a little portrait (1908) by Eduard van Speybrouck of the Bruges priest and writer Ludovicus van Haecke, curate of this church from 1864 to 1908 and the author of, among others, 'Le Précieux Sang à Bruges' (1869). Van Haecke was an intelligent, somewhat eccentric priest who was famous for his funny stories and practical jokes. He was said to have been the model for the satanic canon Docre in the naturalist novel 'Là-bas' by the French author Joris-Karl Huysmans. He neither comfirmed nor denied this imputation, which has been studied by many and was refuted and disproved by the Brugean author Herman Bossier in his essay 'Geschiedenis van een romanfiguur' (1942) (History of a Novel Character). Still, the Basilica of the Holy Blood under its minaret in the corner of the Burg, remains a place full of history, devotion and mystery.

The *City Hall*, the oldest of Belgium and built on the site of the former 'Ghiselhuus' or prison, is a jewel of civil Gothic architecture. Illuminated at night, it dominates the whole square. The foundation stone was laid in 1376 by Louis of Male, the last count of Flanders. The main rectangular building of about 25.5 by 12 metres was finished in 1421. The Burg square façade displays an exceptionally elegant and slimline verticalism with six tall Gothic window niches. Between the windows of the first and second floor 24 polychrome coats of arms (1984) represent the puisne or subordinate cities of the 'Brugsche Vrije'

(The Franc of Bruges) who came to Bruges to settle their legal disputes: Wervicke, Loo, Oostburgh, Lombaertsyde, Oostende, Munnikerede, Mude, Houcke, Ghistele, Blanckenberghe, Poperynghe, Brouckburch, Mardyck, Nieupoort, Dunckercken, Bergen Sint-Winoc, Gravelinghe, Veurne, Oudenburch, Torhout, Sluys, Dixmude, Ardenburch, Damme and moreover the coats of arms of Vlaanderen (Flanders) and Brugghe (Bruges).

The town-hall façade again holds its 48 statues. The original statues – twenty made by Jan of Valenciennes (1376-80), four by Collard de Cats (1423-26) and eight the painter Jan van Eyck is said to have designed and painted, of course had to be replaced in the course of history. In 1852 the sculptors Charles Geerts and Jozef Geefts received an order of 48 new statues which were again eaten away by corrosion by 1960. After many conflicts, contests and scale-models the sculptors Livia Canestraro, Stefaan Depuydt, Pierre Goetinck and Jan Franck were asked to furnish new statues for the niches: Flemish and European history personalized. In the left tower (looking at the façade from the square) the statues of Robert the Frisian, Robert II of Jerusalem and Baldwin VII Hapkin, all of them on nice consoles. In the middle tower Charles the Good and William of Normandy and in the right tower Thierry of Alsace, Philip of Alsace and Margaret of Alsace. The upper row of niches holds a series of fifteen statues, representing from left to right: Baldwin VII of Contantinople, Joan of Constantinople, Ferrand of Portugal, Margaret of Constantinople or of Dampierre, Guy of Dampierre, Robert of Bethune, Louis of Nevers or of Crécy, Louis of Male, Philip the Bold, Margaret of Male, John the Fearless, Philip the Good, Charles the bold, Maximilian of Austria and Mary of Burgundy. The middle row also has fifteen statues, in the same order: Philip the Fair, Margaret of Austria, Charles V, Philip II, Philip III, Albert of Austria, Archduchess Isabelle, Philip IV, Charles II, Philip V of Anjou, Charles VI, Maria Theresia, Joseph II, Leopold II of Austria, Francis II of Austria. Downstairs finally, from left to right: Our Lady with the Inkpot (1926) by Prosper Hinderyckx and from 1969 by sculptor Maurits Witdoeck the statues of Our Lady of the Annunciation, archangel Gabriel, Baldwin Iron Arm, King David, King Solomon, Jeremiah, Zacharias, Daniel and Job.

From the balcony right the decisions of the city administrators used to be proclaimed and the counts of Flanders appeared before the public and promised to respect the privileges of city and county. On Good Friday the balcony was used to preach the Passion of Christ.

The roof of the town hall is finished with six turrets, two artfully spiralling brick chimneys and six dormer windows with six angels in gilt copper. Hardly visible under the roof's parapet 34 trefoils have been decorated with fanciful figures, heads and animals.

The Town Hall is still used for different ceremonies and contains part of the city administration. The mayor and aldermen have their office bureaus there.

The entrance hall, the large passage and the Gothic and Historical Halls on the first floor are open to the public.

In the entrance hall works of art of several disciplines can be seen. Sculpture is represented by ten 14th century stone consoles by Jan of Valenciennes which supported the former façade statues. The scenes are vigorous, popular and expressive: a blind man, cuddling young people, a foot-bath, two centaurs, a drummer, a bagpipe player, a nursing mother. The ceiling has a series of beautiful bosses with biblical scenes. The 1985 standards of a number of corporations were designed by Arno Brys. Paintings in this hall are the 'Seven Physical Works of Charity' (1860) by Henri Dobbelaere. Anonymous portraits on either side of the hallway remind of the long Spanish occupation of the city; they show two governors of the Spanish Netherlands, to the right Infant-cardinal Ferdinand of Spain (1609-1641) and to the right archduke Leopold William of Austria (1614-1661).

In the central passage to the offices and former council chamber which are inaccessible, more portraits of rulers illustrate the successive periods of Bruges history. To the left, from the French period, mayor Charles Enée de Croeser, a typical portrait by Franciscus van der Donckt, and prefect de Chauvelin of the Lys department by Jozef Odevaere, who made another (double) portrait of the mayor on the occasion of the visit of First Consul Napoleon in 1803. On the back wall of this passage, next to the city arms of Bruges, two more mayors: Cornelis van Baersdorp, doctor and mayor in 1562-63, and Niklaas Despars, chronicler and mayor in 1578-84, two paintings by Edward August Wallays of Bruges. To the right, next to the marble bust (1949) of Achiel van Acker by Idel Ianchelivici, portraits again: King William I of the Netherlands, painted by Jozef Frans Ducq in 1820, and Emperor Joseph II of Germany probably by Gertrude de Pélichy and Count de Viry, prefect of the Lys department by Frans Jozef Kinsoen, a Bruges painter who was in good repute in Paris and became the court painter of both Jérôme Bonaparte and the princes of Orange.

Another large painting by Camille van Camp (1878) decorates the entrance hall at the foot of the grand stairway: the accident of Mary of Burgundy while she was hawking, probably in the woods of Wijnendale near Torhout.

The richest room inside the City Hall is the *Gothic Hall* (1380-1401) on the first floor, to be reached by a broad, stately flight of stairs (1894-95) designed by Louis Dela Censerie, with a rail in wrought iron by the ornamental ironworker Pieter Mestdagh. In this most beautiful drawing-room of Bruges the city-council sits, marriages are concluded and several ceremonies and receptions are organised. The most striking element of this Gothic Hall is the vault, the richly decorated and gilt ceiling. Especially the stone consoles receiving the ribs of the vault along the walls (they represent the twelve months and the four elements) and the twelve wooden bosses which constitute the crossing of the ribs are real jewels of realistic Gothic sculpture. They have moreover very well withstood the vicissitudes of

history. The bosses (50 centimetres across), hanging twelve metres high and therefore somewhat difficult to make out, represent biblical scenes such as the Annunciation, the Visitation, the Adoration of the Shepherds, the Circumcision, the Presentation in the Temple, the Flight into Egypt, the Baptism of Christ, Jesus Receiving the Thorn-Crown, Christ Bearing the Cross, the Entombment, the Resurrection and the Coronation of the Virgin Mary in heaven. They date back to the end of the 14th century and were made by three artists-woodcarvers Jan of Valenciennes, Gillis van der Houtmeersch and Cornelis van Aelter.

In 1895 the walls of the Gothic Hall were decorated with large neo-Gothic wall-paintings by Juliaan and Albrecht de Vriendt, evoking milestones in the history of Bruges: the triumphant return of the Flemings from the Battle of the Golden Spurs in 1302; Philip the Good founding the Order of the Golden Fleece (1430); the arrival of the Holy Blood in Bruges, 12th century; interior of the ward of Saint John's Hospital, 13th century; the renewal of the privileges of the German Hanse (1360); Philip of Alsace giving a charter to Bruges (1190); magistrates visiting Jan van Eyck's workshop, 15th century; Jan Brito exhibiting books in the outbuilding of Saint Donatian's Church, 15th century; laying of the foundation stone of the new City Hall by Louis of Male (1376); Jacob van Maerlant, the father of Dutch literature, 13th century; Free Market in Bruges, 12th century and Inauguration of the new canal 'Het Zwin' (1401).

Next to these wall-paintings neo-Gothic wainscoting and stained-glass windows designed by Louis Dela Censerie have been added to the Gothic Hall in the 19th century. The mantelpiece by Pieter de Wispelaere goes back to 1899. It was a present of the Province of West Flanders to the City of Bruges because the provincial council had had its seat in this City Hall as long as the Government Palace (1887) in the Market Square was not ready. A little phrase from the 1305 privilege by Count Robert of Bethune has been sculpted on the mantelpiece: 'Alle Poorters int scependom van Bruge ambactman iof andre sin vri so even deen en dandre' (All citizens in the City of Bruges are free whether workers or others).

The *Historical Hall* is situated next to the Gothic Hall. In this little but interesting museum objects and documents about economy and commerce, coins and city regulations are exhibited. It contains four beautiful 14th century consoles of the Town Hall façade probably by Jan of Valenciennes: two consoles with Tristan and Isolde, an Adam and Eve and an Annunciation to Zacharias. And then there are a little stained-glass window from about 1400, magnificent copper inkstands (1632), paintings with townscapes (The Commercial Inner Harbour, the Burg Square, Homage to Bruges Seaport) and privilege boxes. The famous city map by Marcus Gerards (1562) and four out of the ten original copper plates are on view here and the equally important 1865 land registry map by Philippe-Christian Popp. Finally, many reminders of the corporations and of former legislation can be seen in the display cases.

Separated from the Town Hall by the partly overarched Blinde-Ezelstraat (Blind Donkey Street, after a former pub situated here), the *Old or Civil Recorders' House* has a façade in pure Flemish Renaissance style and was built in 1535-1537 by Christiaan Sixdeniers and Willem Aerts and designed by the stonemason Jan Wallot. Up to 1983 the Justice of the Peace Court was situated here. The original statues decorating the building were lost during the French Revolution. In the 19th century the Bruges sculptor Hendrik Pickery was entrusted with the design of new statues; he drew his inspiration from jurisdiction. Ten bronze statues were cast by the Brussels Compagnie des Bronzes and covered with a thin layer of gold leaf in March 1884. They were repaired in 1987. Dame Justice in the middle is surrounded by Moses with the tables of the law and by Aaron and the symbols of the four cardinal virtues: prudence, justice, temperance and fortitude. At the back of the building in the Blinde-Ezelstraat the statues of Solomon, prosperity and peace can be seen. The façade of the house is decorated with the scene of the unjust judges to the left of the central window and the judgment of Solomon to the right. Between the first and second floor the heads of Maximilian of Austria, Mary of Burgundy, Philip the Fair, Joanna of Castile, Charles V and Isabelle of Portugal have been applied, and, at the back again, Ferdinand of Aragon and Isabelle of Castile.

The *Palace of the 'Brugse Vrije'* next to the Recorders' House on the east side of the Burg Square refers to the Franc of Bruges, the rural region just behind the present coastal strip which constituted a kind of administrative unit in Frankish times already. At the end of the 12th century it was subordinate to the magistracy sitting on the Burg square and to a board of independent sheriffs. Between the 15th century and 1794, when this feudal institution was abolished by the French, the government of the Franc was, along with the cities Bruges, Ypres and Ghent, one of the 'four members of Flanders' in the Flanders estates. The Franc extended from Ypres to the west to Beveren near Roeselare to the south, and included sixteen cities and villages: Ijzendijke, Aardenburg, Oostburg, Sint-Anna-Ter-Muiden, Sluis (now in Zealand Flanders), Damme, Hoeke, Monnikenrede (disappeared), Blankenberge, Oostende, Lombardzijde, Oudenburg, Diksmuide, Gistel, Torhout and Eeklo. The administrative centre and court of the 'Brugse Vrije' were situated in this hall.

The present building on the site of the former 'Loove', the residence of the counts of Flanders, was built in 1722-77 according to the plans of architect Jan van der Cruyce. It was the Brugean Palace of Justice up to the early eighties, when the court moved to a new building near the Cross Gate. Under the arms of the 'Brugse Vrije' over the central entrance we see the statues of Themis, the goddess of justice, and Veritas, the truth, with torch and mirror, both sculpted by Karel Lateur in 1911. In the same year the inner court was embellished with four statues by sculptor Fonteyne. Since 1988 the *Administrative Centre 't Brugse Vrije* has been

established here, with several services such as the Tourist Office, the Culture Department and the City Archives.

The main work of art in the Provincial Museum of the 'Brugse Vrije' is the monumental *Mantelpiece of Charles V* in the sheriff's courtroom. This pure Renaissance work of art in marble, wood and alabaster from 1528-31 was realized and directed by the painter, sculptor, architect and poet Lanceloot Blondeel, who also created stainded-glass windows, tapestries and decoration for official entries and ceremonies. It celebrates the victory of Charles V, count of Flanders over the French king François I in Pavia in 1525. Hence the central figure is the emperor with the imperial sword and globe. To his left we see his paternal grandparents Maximilian of Austria and Mary of Burgundy and to his right his maternal grandparents Ferdinand of Aragon and Isabelle of Castile. In the black marble of the mantelpiece a splendid alabaster frieze has been incorporated, representing four children and the biblical story about Susanna. Three copper handles (1530) cast by Jacob de Keysere would have enabled the sheriffs to stay upright when they were warming their wet feet. The statues and the frieze from 1530 were made by Guyot de Beaugrand, the Flemish sculptor who died in Spain. This sheriff's courtroom also contains paintings such as 'A Session in the Sheriff's Courtroom' (1659) by the Brussels painter Gillis van Tilborgh and portraits, copper inkstands (1566) by Jan Crabbe and a little portable fire. In the orphan's room and the deliberation room of this museum several more paintings, chests, clocks and benches have been preserved and a beautiful filing cabinet from 1646.

The last historical building on this square is the *Provost's House*, the hall of the provost of Saint Donatian's Church, on the corner of the Burg square and the Breydelstraat. It was the seat of the property of Saint Donatian's in town and in the 'Brugse Vrije'. Part of this property, the canon's, was administered by the dean and canons of the church and another part, the provost's, by the provost who up to 1560 was at the same time the chancellor of Flanders and held the judiciary. The Provost's House, which was once connected with Saint Donatian's Church, was built in Flemish baroque style by Cornelis Verhouve according to the plans of one of the church's canons, Frederik van Hillewerve in 1665-66. High above the richly decorated entrance and the caryatids three allegorical figures have been put. In the middle Themis, the Greek goddess of justice with the balance, sword and blindfold. Left Leto, the mother-figure symbolizing love, with the twins Artemis and Apollo and right Gorgo with snakes in her hair, representing envy. The original building consisted of nine bays but six bays were added to it towards the Market square in 1907. The building and its façade have thoroughly been restored in 1973-74. The Provost's House served as the residence of the bishops from the moment the Brugean diocese was established (the present bishop's residence is the Hall of Pittem in the Heilige Geeststraat) and was used by the prefects of the Lys department in the French period (1794-1814).

Though used for occasional exhibitions, the house does not have a specific function now. The public is not admitted.

On the other corner of the Burg square and the Breydelstraat, on the west side of the Burg, a pseudo neo-Gothic house from 1931 and next to it the very youngest building, Ten Steeghere, a 1980 short-cut to the Wollestraat, designed by the architect Luc Vermeersch.

Thus the rich history of architecture illustrated in this square is extended to this very day. The architect-historian Geert Bekaert put it as follows: 'All these divergent and conflicting elements on the same city square, which we justly consider as a unity, testify to Bruges' lively history, long after Bruges had, according to the legend, become a dead city'.

Note

* Basilica and Museum of the Holy Blood are accessible from 1.4 to 30.9 between 9.30 a.m. and 12 and 14 and 18 p.m.; from 1.10 to 31.3 between 10 a.m. and 12 and 14 and 16 p.m. Closed on Wednesday afternoons. Museum shop and souvenirs. Admission (Museum) 20 BF. Bibliography: J. van den Heuvel, De H. Bloedkapel te Brugge, 1963 (The Chapel of the Holy Blood in Bruges); C.H. Vlaemynck, Hoe in troebele tijden de relikwie van het heilig Bloed te Brugge verborgen werd, 1984 (How in troubled times the relic of the Holy Blood was preserved in Bruges).

* Town Hall, Gothic and Historical Hall are accessible from 1.4 to 30.9 from 9.30 a.m. to 12 and from 14 to 18 p.m.; from 1.10 to 31.3 from 9.30 a.m. to 12 and from 14 to 17 p.m. Handout. Admission for Gothic and Historical Hall 20 BF. Bibliography: L. Beuckels, De gotische Zaal, pronkstuk van het veertiende eeuwse Stadhuis te Brugge, 1982 (in five languages); J. Ballegeer, Brugge Stadhuis 1987 (Bruges Town Hall).

* Provincial Museum of the 'Brugse Vrije' is accessible from 1.4 to 30.9 from 10 a.m. to 12 and from 14 to 17 p.m.; from 1.10 to 31.3 from 14 to 16 p.m. on Saturdays and Sundays. Handout in 5 languages. Admission 20 BF. Bibliography: L. Devliegher, De Keizer Karelschouw van het Brugse Vrije, 1987 (The Mantelpiece of Charles V of the Franc of Bruges).

Biskajersplein (Biscayans' Square)

Just like many other countries, the Spanish principalities had become regular guests in Bruges as early as the 13th century. Wool and skins were imported from Castilia and iron-ore mainly from Biscay. The 'Spaanse Loskaai' and the 'Spanjaardstraat' remind of this Castilian presence. In the Spanjaardstraat were situated the Spanish hanse-house and warehouse, next to the house of the Della Torre

family; only a little entrance has survived.

Up to 1585 stood, on the present numbers 2 and 3 of the square, the Biscayans' consulate. As can be seen on the Marcus Gerards city map (on view in, among others, the Historical Room of the City Hall), it must have been a very roomy and imposing house with four round corner turrets. In the middle of the 19th century it was already falling into disrepair and so by now it has disappeared completely.

The square was the scene of part of 16th century humanistic life in Bruges. The painter, drawer and numismatist Hubertus Goltzius from Venlo (the Netherlands) had become acquainted with the Bruges humanist Marcus Laurinus through Abraham Ortelius. In 1558 Goltzius settled in Bruges, Laurinus founding a printing office for him in the 'Groene Wynckle' on the Biscayans' Square. Eighteen books were printed in this 'Officina Goltziana' between 1563 and 1576, illustrated works by Goltzius himself, but also by Erasmus and several Brugean humanist writers.

Eiermarkt (Egg Market)

First this square was a swampy cloaca accordingly called 'Bergpoel' (Mountain Pool); later it was used as a butter and egg market and nowadays it is a centre of pub-life for young and old. In the middle of it a pump decorated with lion, bear and coat of arms of Bruges, made by the Brugean sculptor Pieter Pepers in 1761.

Garenmarkt (Yarn Market)

The Yarn Market, forming one unit with the Eekhoutstraat, was formerly called Flax Market. Up till Word War I it was indeed the meeting-place of people growing and selling flax. The Eekhoutstraat was named after the Augustinian Eekhoute Abbey, the oldest of Bruges, mentioned as early as the 13th century. Nothing of the cloister, of the large church or the beautiful gardens has survived. In this street are situated the offices and printing machines of the 'Brugsch Handelsblad', an important weekly of the north of West-Flanders. It was first published in 1906.

In the Sint-Andreasinstituut in the street children have been educated ever since 1868. Its buildings and grounds cover part of the former Abbey site and the entrance (Garenmarkt 8) was part of the Hall of Cuba, called like this because in the 16th century the Dominican Jan de Witte became the first bischop of Cuba, which was hardly more than an honorary title, however. Finally, the hotel of the College of Europe and the Royal Technical Academy are situated in the Garenmarkt.

Huidenvettersplein (Tanners' Square)

This square, also called Little Fish Market, is almost completely surrounded by buildings with entrances on the Rozenhoedkaai and on the Fish Market. On the famous city map of Marcus Gerards (1562) real gates can be seen. It was the market square of the tanners; their craft-house was very well restored in 1983-85 (as mentioned on a memorial stone, earlier restorations happened in 1630 and 1912). This very large craft-house was successively used as a pub ('Het Dreveken'), a fish shop and (between 1960 and 1983) as the permanent exhibition centre of the West Flanders Provincial Committee for Applied Arts and Industrial Design which organised about ten exhibitions of contemporary art each year.

In the 18th century the main building with turret and seven dormer windows was completed with a corner house on the Rozenhoedkaai, finished with an attractive and well preserved baroque façade in 1718.

In the middle of the square stands a little column on which two lions hold the tanners' coat of arms. It was erected in 1925 on the occasion of the 25th Archeological Congress, held in Bruges.

Kraanplein (Crane Square)

Only the place names Crane Square and nearby Crane Canal remind of the large loading and unloading crane which functioned here as early as the 13th century till the end of the 18th century, when the Canal was overarched. The 'Mystical Marriage of Saint Catherine' by Hans Memling in the Memling Museum and the Portrait of Jan van Eyewerve by Pieter Pourbus in the Groeninge Museum contain beautiful pictures of this crane.

The Korrekelder on this square, founded in 1961, was Bruges' first pocket-size theatre and a real pioneer for Brugean culture and theatre life. It still produces about six plays a year and regularly organised exhibitions of contemporary visual arts.

Other small and/or experimental theatres have followed the example: a cultural centre in the Langestraat founded by the Bruges playwright Rudy Geldhof in 1973 was turned into theatre 'De Kelk' in 1977, 'De Werf' in the Werfstraat, the puppet theatre in the cultural centre Boterhuis in the Sint-Jakobsstraat. Next to all this private enterprise the municipality has started cycles such as Nieuw Theater (New Theatre) and Fris Kabaret (Fresh Cabaret) in the cultural centre 'De Dijk' (Blankenbergse steenweg). Every year they also organise the 'Hansatornooi' in support of local amateur theatre.

Markt (Market Square)

The Market square, one hectare in size, has always been the heart of the city. Markets were of course held here, from 1200 onwards, but in the course of history it has also been the forum where political issues were followed, discussed and settled by the assembled crowd: from the 'Brugse Metten' on good Friday 18th May 1302 to the anxious September days 1944. Occupying forces of all colours put up their flags here and left again without drum or trumpet. Princes were led to this square for their inaugurations, on which occasion jousts and tournaments and artistic pageants were held. On the Market Square the gallows and guillotine functioned, trees of liberty were planted, open-air theatre was performed and people have danced and played music.

The wide significance and one thousand year of history of this square can be read in the buildings, façades and monuments which stood or still stand around it.

The *Belfry*, the tower crowning of the Halles, is the city's central monument and the only tall tower above a civil building. The etymology (berg and frithu) of the word also occuring in the forms belfroiz, belfragio, belefroit, belfroot, belfry (E), Belfried (G) and beffroi (F) refers to mountain and peace. The tower was originally used as the seat of the municipality and for the city treasury. The money, valuable records, documents and charters and the city seal were kept in a chest, the so-called 'comptoir secreet', with ten locks, the keys of which were in the hands of the heads of the nine corporations and of the city mayor. Later the Belfry became a prestigious symbol of power and freedom, but also an observation post and watchtower with a bell calling and warning the citizens on all sorts of occasions. From the balcony on the first floor over the central entrance, the official messages called 'the Halles commands' were read to the public by the bailliff after the bell had been sounded; two aldermen escorted him as witnesses. Over the balcony a beautiful Madonna by sculptor Michiel Dhondt has been placed in a niche designed by Lanceloot Blondeel about 1525 already. On the pavement in front of the Belfry the bronze silhouette of Halles and Belfry by Jef Claerhout has been put up, especially designed and realized on behalf of the visually handicapped. The spacious halls on the first floor are used for exhibitions, congresses and festivities.

There were Halles on the Market square in the beginning of the 13th century already, but in 1280 the tower was destroyed by fire. The history of the Halles and Belfry buildings is indeed one long series of repairing (after fires or storms) and completing. The present outline dates back to the 19th century and the latest thorough restauration was done in 1969-74. The height of the tower is 83 m and it leans over in south eastern direction (Wollestraat) about 90 cm. So Bruges had also got its leaning tower! The tower's foundations are ten metres underground

and at the foot the walls are almost three metres thick.

The tower holds a victory bell and a remarkable *carillon*. We know that bells were already hanging in the tower after the 1280 fire and reconstruction. In the beginning of the 14th century there were the bride's bell, the alderman's bell, the victory bell and the work bell, together constituting a quadrillon, an ancestor of today's carillon. The four octave carillon of 47 bells (weighing 27 tons together) was cast by Joris Dumery in 1748. The heaviest bell weighs 5,881 kg and the smallest and lightest hardly 15 kg. These bells are used in the automatic carillon or alarm marking the time every quarter of an hour. The first clock was installed on the Market-side of the tower in 1448-50. Yet, concerts are of course also given on this carillon, which is considered as one of the country's most beautiful instruments, because of the clarity and timbre of its bells. The city has its permanent carillon player (now Aimé Lombaerts, °1945) who plays concerts twice a week and on special occasions. About thirty colleagues preceded him, among whom Adriaan van der Sluus, the oldest (1532-37) who is known. From 1922 tot 1939 the 'Brugsche Klokkenspelvereniging' stimulated the carillon concerts and its audience. This association has been re-founded in 1987.

Some 200,000 visitors climb the 366 steps of the Belfry every year. The first 55 steps lead to the treasury where the chest with charters, official documents and the city seal were kept behind a marvellous 13th century medieval wrought – iron gate by Erembald the Smith. They were lost in the 1280 fire after a social rising called 'de Grote Moerlemaye'. Next a safer and locked 'comptoir secreet' was installed on the second floor, which was overarched with a stone vault. The gate is the oldest example of wrought-iron work in Bruges. In the treasury five 18th century bronze bells by Joris Dumery can be seen, scale-models of the Belfry and the carillon, a number of chests and an iron fire nozzle.

The victory bell, weighing almost 6 tons, can be seen after the 222nd step. It was made by bell-founder Melchior de Haze and originally hung in Our Lady's Church. It is only sounded on special occasions. At the 333rd step we see the clock mechanism from 1748 (by A. de Hondt) and the copper barrel, weighing 9 tons, of the alarm, chimes or mechanical carillon. At step 352 we arrive at the carillon room with the manual and pedal keyboard and from the top of the tower a unique panoramic view over the coast and the entire north of the province West Flanders may be enjoyed. In his 'Impressions of Bruges' (1953) Henry Miller describes his experience as follows: 'Let us look down again from the height of the bells – on the flaming roofs, the burnished domes, the modulated tones of the brick walls, the ghostlu greys of churches and convents, the soft verdure of the surrounding fields, the still mirror of the canals, the everwinding streets whose angles never meet. All still flouts, wavers, staggers – as in the dreams of the masters. With even less effort than the Crusaders made to reproduce the Holy Sepulchre of Jerusalem we can people the sky with the apocalyptic birds and

beasts and things unnameable which inhabit the paintings of Bosch, Breugel, Memling'.

The halles, tower, bells and carillon have always been the favourite themes of literary art about Bruges. The Swiss doctor and professor Felix Platter was probably one of the first to view and describe Bruges from above. He was in Bruges in September 1599 and described how he climbed 'ein sehr hoher turm, der midt bley überdekt ist' and he was able to admire the whole city and saw six Spanish ships enter the port of Sluis. At the top of the tower they showed him the place in the rafters where, twenty years before, the ... devil had passed and had started fire.

After the Battle of Waterloo (1815) mainly the English authors' attention was drawn to Bruges, their pilgrimage to the Battlefield inevitably leading them across the city. They also caught sight of the halles and the tower immediately. The famous Pre-Raphaelite painter and poet Charles Dante Gabriel Rossetti was here in 1849, with his fellow artist William Holman Hunt. He climbed the tower and wrote:

> 'I climbed at Bruges up the flight
> The Belfry has an ancient stone.
> For leagues I saw the east wind blow
> The earth was gray, the sky was white.
> I stood so near upon the height
> That my flesh felt the carillon'.

The Poet Laureate and recognized leader of the Lake Poets Robert Southey had been in Bruges for two days and two nights already. He looked at the city 'from the Belfroy's height' and, said he, 'no happier landscape may on earth be seen' in an enthusiastic poem of many stanzas, published in 'The Poet's Pelgrimage to Waterloo', the project for the much solicited laureateship.

The most famous and beautiful poems about the carillon and tower were written by the American Henry Wadsworth Longfellow, however. He was in Europe between 1826 and 1829 and visited Bruges on that occasion; in May and September 1835 he was back again and in 1842 he visited Bruges. His 1846 collection of poems called 'The Belfry of Bruges and other Poems' was reprinted over and over again and spread Bruges' reputation all over the Anglo-Saxon world.

> 'In the ancient market-place of Bruges
> Stands the Belfry old and brown;
> Thrice consumed and thrice rebuilded,
> Still it watches o'er the town...'

And in his poem 'Carillon' in the same collection he wrote:

'In the ancient town of Bruges,
In the quaint old Flemish city,
As the evening shades descended,
Low and loud and sweetly blended,
Low at times and loud at times,
And changing like a poet's rhymes,
Rang the beautiful wild chimes
From the belfry in the markt
of the ancient tower of Bruges,'

In the middle of the 19th century Longfellow's poems about Bruges were successful touristic publicity pamphlets avant la lettre. Neither he nor Georges Rodenbach have been given a street name in Bruges, let alone a statue. The American Longfellow would indeed have deserved one, for, long before the French Romantic author, he spread Bruges' reputation all over the world.

Later as well the Britons have always come to Bruges. Almost a century after Longfellow's writings, the novel 'Carillon in Bruges' (1952) by Suzan Gillespie was published. 'She stopped in the Grand'Place to ask the way and as she did so the bells rang out from the Belfry. It was all as she remembered, as she had known it would be. Another day shining in soft colours on rose brick, on Gothic magnificence, on pointed-gabled roofs, on gray cobblestones. A town of spires and towers, of churches and convents, ringed by its waterways, shadowed by its trees. But how alive!' And, for this author too, the picture of Bruges is complete only when the sounds are falling from the tower.

Not all authors were equally enthusiastic, however, critical notes were struck. Gilbert Keith Chesterton was standing in front of the Belfry in 1906 and knew little good about it. The tower, said he, 'is built in defiance of all decencies of architecture'. 'It is a church on stilts', a 'sort of sublime deformity' which is, according to Chesterton, 'characteristic of the whole fancy and energy of these Flemish cities'. He calls the Belfry 'a gargoyle', 'an unnaturaly long-necked animal, like a giraffe' and talks about 'buildings that are shapeless in their strength, seeming to lift themselves slowly like monsters from the primal mire' and 'spires that seem to fly up suddenly like a startling effect of height'.

The French authors' approach of Bruges' central monument was totally different. Unlike the British authors, who did not turn the quiet 19th century city into a myth, the French introduced regret, pity and even remorse in their contemplation. The centre of this deep and widely spreading sorrow was to be Georges Rodenbach with his famous novel 'Bruges la Morte' (1892) and especially with his last work 'Le Carillonneur' (1895) which is completely situated on and around the tower and the carillon. The main character Joris Borluut is indeed both the city architect and city carillon player. He is a very conservative man who opposes any form of architectural innovation or technical progress, and will ruin

himself. When he has to sound the victory bell when Parliament has ratified the construction of the Bruges seaport, he climbs the tower and hangs himself on one of the bells. But the next day, Rodenbach writes, the bells kept sounding 'sans que personne ait senti, parmi la ville ingrate, qu'il y avait une âme dans les cloches'...

Many more authors have followed Rodenbach in describing the Belfry and the carillon, as symbols of the whole city, in this oppressive and often decadent way. Ernest Raynaud wrote a beautiful poem about Bruges, the last stanza of which runs as follows:

> 'A l'ombre du beffroi qui te marque les heures,
> Tu languis oubliée ainsi qu'une relique,
> Dans ta châsse d'eau morte et de saules en fleurs'.

Others found that 'son bourdon réveille un trop vivant écho pour éternellement pleurer sur son tombeau' (Emile Verhaeren) or spoke about 'la molle candeur des cloches coutumières' (Louis Beyaert). And the Austrian poet Stefan Zweig for his part climbed the tower in 1904 and wrote about the 'kühle und dunkle Treppengewinde des Beffrois, der breitschultrig and nackensteif am Hallenplatze steht'.

The importance of tower, halles and belfry for the life of the people can, among others, be read in the number of magazines and periodicals named after them: 'De Halletoren' (1874-81) and 'De Brugsche Beiaard' (1881-1913) both founded by the poet Julius Sabbe, 'De Beiaard (1918), 'Het Belfort' a weekly from the twenties and even the English 'The Belfry' (1931).

A work of art of stone and sound has thus really inspired written art of varied forms and quality and added to these writings' world-wide reputation.

In the middle of the square stands the 1887 bronze statue of two 'stout warriors', the two medieval Brugean popular leaders *Jan Breydel and Pieter de Coninc.* Jan was a butcher and trader and belonged to a well-to-do family. Pieter's family was less rich, he was a weaver and became the dean of the corporation. They were the leaders of the 'Brugse Metten' (18th May 1302), a massacre in which hundreds of French occupying soldiers were killed by Flemish workers and citizens, called the 'Klauwaerts'. Pieter also took part in the Battle of the Golden Spurs (11th July 1302) resulting from the 'Brugse Metten'. He was even knighted. The two characters – Jan representing power and Pieter wisdom – have especially become popular by 19th century' Romantic literature. In 1838 Hendrik Conscience – who followed the fashion set by Sir Walter Scott – published his novel 'De Leeuw van Vlaanderen' which was also filmed, partly in Bruges (1983). In 1880 the Bruges author Adolphe Duclos, who wrote the standard book 'Bruges. Histoire et Souvenirs' (1910), followed suit with his story about 'Onze Helden van 1302'

(Our Heroes of 1302).

The history of the statue itself is quite interesting. It was the result of a contest, in which sixteen sculptors participated. The Ghent sculptor Paul Devigne became the laureate; the plinth was designed by the Bruges neo-Gothic architect Louis Dela Censerie. The first step towards this monument was taken by the Breydel Movement and the Breydel Committee, and its realization should be situated in the romantic cultural atmosphere of the Flemish Movement and in the local politics and school funding controversy of the time. This explains also why the statue was three times unveiled: on 11th July 1887 by the Breydel Committee, whose periocal 'De Halletoren' had a marked political character, namely liberal, free-thinking and pro-Flemish. Hendrik Conscience was the honorary president and the Bruges poet Julius Sabbe the motor and soul of the whole enterprise. On 15th August 1887 followed the inauguration by the City Breydel Committee, organized by the then homogeneously catholic city council. This second inauguration lasted a full week. Guest of honour was King Leopold II, who held a French speech, whereupon pamphlets with 'Leopold, King of the Walloons' circulated in Bruges. On 15th July 1888, finally, the plinth was inaugurated. The four little corner statues represent the cities of Ghent, Ypres, Courtrai and Bruges and the low-reliefs the 'Brugse Metten' 18th May 1302, the Battle of the Golden Spurs 11th July 1302 and the Battle of the Pevelenberg in 1304. In 1987, one hundred years after these celebrations, the re-founded Breydel and De Coninc Committee called new attention to this monument with a one-year programme. It is indeed the Brugean monument with the richest history, which provoked lots of local passions at the time of its inauguration.

The complete east side of the Market square is now taken up by the *Provincial Government Palace* and the Central Post Office. These buildings were realized as late as 1887-1921 according to plans by the Bruges architects Louis Dela Censerie and René Buyck. The building stands on the site of the former Water Halles, an enormous covered dock where ships moored and freights were loaded and unloaded. From 1786 onwards the Water Halles were demolished and replaced by a French classic building, which was completely lost in a fire in 1878. Only five days later a group of Brugean architects and archeologists addressed a letter to the Provincial authorities in which they asked the reconstruction of the Provincial Palace in 15th century Gothic style. Even the King received letters from, among others, the 'Société Archéologique' and the 'Davidsfonds'. The result was a neo-Gothic building.

The Provincial Palace, which is not open to the public, consists of a middle part with two floors and three bays and two lower wings with three and four bays. The flight of steps leading to the entrance is finished with a stone balustrade ending downstairs in two seated lions holding coats of arms, sculptures (1893) by

the Brugean artist Hendrik Pickery. The copper statue of Saint Michael high above the central façade was made by Edmond De Vooght in 1904, according to a design by sculptor Gustaaf Pickery. In this building are situated the council chamber of the Provincial Council, meeting rooms for the Permanent Deputation and several rooms, such as the balcony hall, for celebrations, meetings and exhibitions.

The building to the left of the Provincial Palace, which continues around the corner in the Philipstockstraat, was put up in 1910-14 as the official residence of the provincial governor, but has never been used as such. Instead, it houses the offices of roads and bridges maintenance.

The Market of Bruges offers an interesting survey of *façade architecture*. The oldest, more or less original house, called 'Bouchoute' stands on the west side of the square, on the corner of the Sint-Amandstraat. Its brick screen façade has been decorated with an octogonal wind dial and vane. The house across the Sint-Amandstraat, called 'Craenenburgh' now has a neo-Gothic façade. Its name refers to the family of grocers and chemists who owned the house for many centuries. In February 1488 this house was chosen by the Brugean population to lock up Maximilian of Austria. From his prison he could witness the decapitation of his bailiff Pieter Lanchals. Next to this house stands a series of restored neo-Gothic façades, among which the house called 'De Maene' (the moon) and the building of the Bank van Brussel, in which lectures and artistic and historical exhibitions are often organized. The north side of the square is now entirely taken up by hotels, restaurants and pubs. It used to be the site of the tilers' corporation houses and especially of the fishmongers, who sold fish on this square as late as 1745.

Moreover, the Market square has for many years been the favourite place to view the grand events such as the yearly Procession of the Holy Blood, the Pageant of the Golden Tree every five years (next in 1990) and many other high points of the city's touristic programmes.

Note

★ Admission to the Belfry from 1.4 to 30.9 daily between 9.30 a.m. and 12.30 and from 13.30 to 18 p.m.; from 1.10 to 31.3 between 9.30 a.m. and 12.30 and from 13.30 to 17 p.m. Museum shop. Entrance fee for tower and treasury 50 BF. Parties of min. 20 people 40 BF. Schools of min. 20 people 30 BF. Family ticket 100 BF. Bibliography: H. Dacquin & M. Formeseyn e.a., Brugge. Belfort en Beiaard, 1984 (Bruges. Belfry and Carillon); A. Vanhoutryve, Jan Breydel en Pieter de Coninc, 1987.

Muntplein (Mint square)

This square reminds of the mint workshops already mentioned in the beginning of the 14th century. As early as the Carolingian age, coins were struck in Bruges. In 1858 more than a hundred silver deniers from Carolingian times were found in Assebroek. Yet, the mint was especially active in the Burgundian period. It belonged to the very large complex of buildings including both the Princes' Hall and the Charolais Hall, many houses for the ducal families and their civil servants but also a bathhouse, stables and even a zoo. There were three entrances, in the Geldmuntstraat (the present vaulted Mint gate), the Ontvangersstraat and the Gheerwynstraat.

In 1987 a little equestrian statue was put up in the middle of the Mint square: 'Flandria Nostra' by sculptor Jules Lagae.

Also on this square the beautiful little entrance door to the organ hall of the *City Conservatory* can be seen, surmounted by the bust of the 16th century Brugean polyphonist Marcus Houterman, a contemporary of Palestrina and an organist in Rome, where he died.

His statue might inspire the numerous students of the Conservatory, if only they saw it more often. Yet, the official entrance of the school of music and drama is situated in the Sint-Jakobsstraat.

During the middle ages Bruges must have been quite an important centre of music. A school of music probably existed in the 14th century, judging from the city brassband with minstrels, pipers and trumpeters which was called upon to grace private and public ceremonies. The Speelmanskapel (Musicians'Chapel) on the corner of the Speelmansrei and the Beenhouwersstraat reminds of this. Built in 1421 by the musicians' corporation (mentioned as early as 1292) and restored in 1968-69, it is the last corporation chapel which has survived in Bruges. Of the musical life in the churches, especially in Saint Donatian's Church which had an important choir school, little tangible traces have been left. Which does not mean, however, that the musical life in Bruges cannot have flourished and flourish.

Bruges has many choirs and bands which are often called upon to accompany processions and pageants. The centre of its musical life, however, is situated in the Conservatory, which is almost 150 years old. In November 1847 a private school of music and drama was founded for some fifty pupils who met in the pub 'Au Jambon' in the Spanjaardsstraat. From 1861 subsidies were obtained from the city and the province and the school moved to the former convent of Sarepta on the Lange Rei, directed by the dynamic composer Hendrik Waelput. He was soon succeeded by the equally active Leo van Gheluwe, who saw to it that the school received the title of conservatory.

In 1886 the school moved to the present spacious building in the Sint-Jakobs-

straat, the Hall of Borsele from about 1730. In its many halls and rooms numerous generations of young people have practised music and drama under the direction of a series of famous composers such as Karel Mestdagh, Jozef Ryelandt, Renaat Veremans, Maurits Deroo, Jules Bouquet and today's director Willy Carron. What strikes one most at the entrance in the Sint-Jakobsstraat is the beautiful forged gate under a wall crowned with a parapet. The most beautiful part of the building cannot be seen from the street side, however: the very large façade now facing the garden and the Gheerwynstraat and the Mint Square. It is an example of French rococo architecture with two jutting corner parts and in between the large seven bay façade with stately high windows on the ground and first floor.

The 1639 private house with the marvellous Renaissance façade next to the entrance in the Sint-Jakobsstraat has also belonged to the Conservatory since a couple of years. And in the former Anglican Church on the Achiel van Acker Square in the Ezelstraat the new organ hall of the conservatory has been installed; it has been called Ryelandt Hall.

Schouwburgplein (Theatre Square)

This square used to be called Exchange Square and the Brugeans liked to call it Comedy Square or Theatre Square. It is not even a proper square, but the Vlamingstraat which broadens at the Municipal Theatre. A number of very important buildings reminding of trade in Bruges in the previous centuries are situated here: the House of the Genoese, the Ter Buerze House, the Old Stock Exchange of the Gentlemen from Venice and the House of the Florentine merchants.

One of the most beautiful buildings is the *House of the Genoese* or *White Wool Hall*, Vlamingstraat 33, of course reminding of the trade relations between Bruges and Genoa. Genoese traders settled in the city as early as 1375; they controlled a lively trade of cloth, yarn and grain which went to Genoa and spices, silver, gold and precious stones which were imported on a fleet connecting the two cities twice and sometimes three times a year. In 1395 the cities entered into a commercial treaty, negociated by Philip the Good, by which the Genoese commercial centre was transferred from London to Bruges. In 1399 it was housed in this building on the corner of the present Vlamingstraat and Grauwwerkers-straat. Not only were goods stored and marketed here, from 1411 onwards the Genoese consul or representative lived in the house around the corner in the Grauwwerkersstraat. This situation lasted till 1516, when the Genoese hanse, together with those of Florence and Lucca, left Bruges and settled in Antwerp. Malcolm Letts in his book 'Bruges and its Past' (1924) is not unhappy about this: 'Deserted by its traders, its quays empty and its streets forsaken, Bruges was still

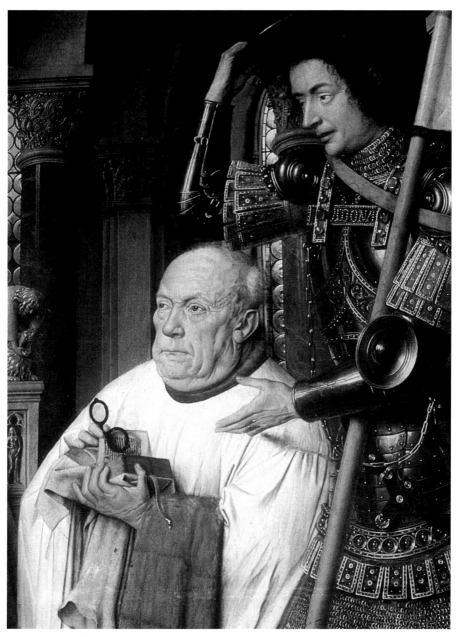

Jan van Eyck, The Madonna with Canon Joris van der Paele, *painting, 1436, detail, Groeninge Museum.*

Michelangelo Buonarotti, Madonna, *marble, 1503-04, detail, Church of Our Lady.*

Anonymous, The Old Age of Gombaut *or* The Wolf, *tapestry, early 17th century, detail, Gruuthuse Museum.*

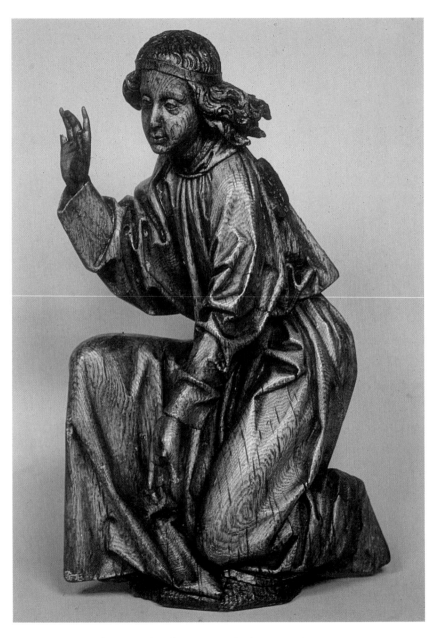

Anonymous, Kneeling Angel, *oak, c. 1500, Flanders, Gruuthuse Museum.*

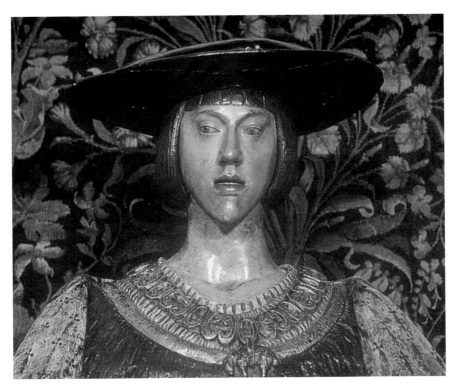

Attributed to Konrad Meit, Bust of Charles V, *terracotta and wood, c. 1520, Gruuthuse Museum.*

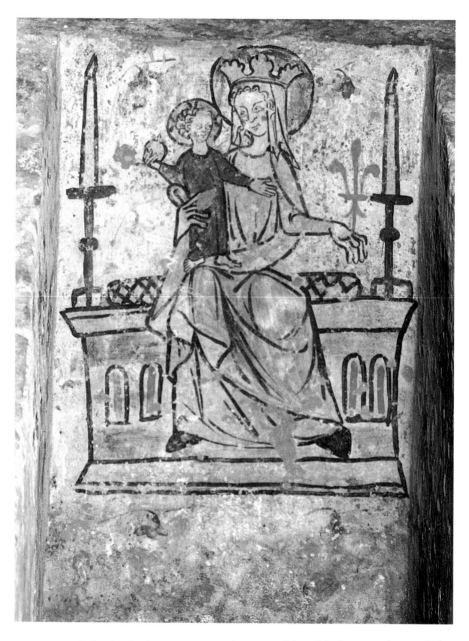

Anonymous, Sedes Sapientiae, *painting in the grave of dean Nicolaas van Steene, 15th century, choir, Church of Our Lady.*

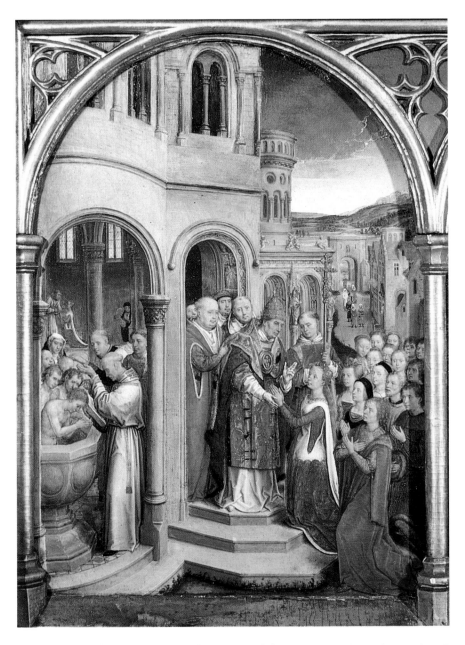

Hans Memling, Shrine of Saint Ursula, *painting, before 1489, detail long side: Ursula and company received by pope Cyriacus in Rome, Memling Museum.*

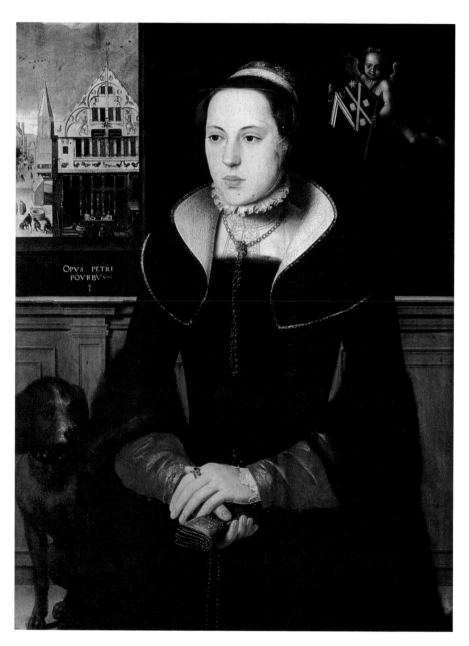

Pieter Pourbus, Portrait of Jacquemyne Buuck, *painting, 1551, Groeninge Museum.*

a city of enchantment, but it was only a beautiful shell. It was a great tragedy, yet, selfish as it may seem, we need not regret it. If Bruges had prospered and developed through the sixteenth and seventeenth centuries and later, it could scarcely have retained its charm. Steam cranes would have disfigured its water-ways and huge warehouses would have defaced its streets. There is no necessity to elaborate the picture, but we should never forget, as some visitors are apt to do, that this old town with its cobble ways and sleepy canals was once the great market of Western Europe, the assembly of good merchants, the staple of all Christendom'.

From 1558 the House of the Genoese was used as a trading centre for white wool, an industry which had been brought to Bruges by weavers who had fled from the French Flemish city of Hondschoote because of religious troubles – in this French Flemish city the 'Breaking of the Images' did indeed start. The second name of the building 'Saaihalle' (Wool Hall) reminds of this. After this activity had also stopped towards the middle of the 18th century, the house had several functions. It became a shop, a pub, a dance hall, Garnisonsbücherei and Seemannshaus during World War I and after the war a cinema called 'Coliseum'. The latter was the scene of 'L'incident de Bruges' on 6th June 1919, the result of the school funding controversy of the time. Exceptionally, students from both the catholic Saint Louis' college and the Royal State Secundary School were watching the patriotic 'L'Armée Belge en Campagne 1914-1918', a film with French subtitles in which cardinal Mercier appeared a couple of times. This resulted in cheers and jeers on both sides and finally in a full-blown fight. For weeks the local press was filled with reactions by both supporters of the Flemish Movement and pro-French Flemings...

After the 1978-84 restoration directed by architect Luc Vermeersch, the present owner, the Generale Bankmaatschappij, has turned the house into a prestigious meeting-place for seminars, but also for lectures, receptions and exhibitions. The interior of the building, not accessible, is hidden from the street with an exceptionally beautiful façade. The low relief in the tympanum over the entrance, representing Saint George, the patron saint of Genoa, fighting the dragon, was re-sculpted by the Bruges sculptor Jan Franck in 1970. The five coats of arms around it have not been identified yet. The original screen façade to be seen in Sanderus' 'Verheerlijkt Vlaandere' from 1735, was then substituted by a bell form in the Louis XIV fashion, which has survived till today.

The *House Ter Buerze* is situated on the other corner of the Grauwwerkers-straat. The Van der Buerze family ran a pub here from about 1280 onwards, which quickly became a meeting-point for traders and businessmen. Since the 15th century, when Bruges was the most important commercial centre of Europe, the whole world has become familiar with the 'beurs, bourse, Börse'or stock exchange. Called after this family of Brugean brokers, it is the 'collegia

mercatorum' of the Romans, the place where traders meet to sell their goods and merchandise. When, in the second half of the 15th century, Antwerp took over the commercial role of Bruges, the first real stock exchange was built there. In the beautifully restored façade, behind which the Bank van Roeselare is situated today, can be seen a tablet from 1453, when Jacob Van der Buerze, brother and chairman of the old corporation of the Saint George's arbalest bowmen, had this house built. The four letters 'S Y H V' are still some kind of a rebus. Some pretend they stand for 'Smeden Yser Houdt Vast' (Smith's Iron Holds Firm) and others keep to 'Salva Yhesu' (Jesus protects). The 1981 signboard by the ornamental metalworker Yves Parmentier from Damme contains the coats of arms of West Flanders, of Roeselare and of the Van der Buerze family.

Bruges is quite proud of being called 'Venice of the North'. Venice, the city of the doges situated in a lagoon with more than a hundred little isles, had its colonies in Southampton, London and Bruges in the beginning of the 14th century already. They were connected by their own shipping service. Square next to Ter Buerze, in *Ter Oude Buerze* (now Generale Bankmaatschappij) the gentlemen of Venice resided. The Spanish traveller and chronicler Pero Tafur was probably the first person to compare Bruges to Venice after having visited both cities in 1438. In his story 'Andancas e Viajes por diversas partes del mundo avidos', one of the oldest descriptions of Bruges discovered and published in Madrid in 1874, he makes the following probably somewhat exaggerated but certainly flattering comparison: 'It appears to me, and many will agree with me, that there is more business activity in Bruges than in Venice. This can be explained. In the whole western world there is no such large trading centre like Bruges, though England is doing some business too. It is said that at some moments as much as seven hundred ships a day leave the port of Bruges. In Venice, however, also a rich city of course, only the inhabitants of the city itself are involved in the trade (...) For many regions Bruges seems to be the appopriate port and the best market where all these goods can be traded'.

The *Florentines* too had their hanse– house here, on the corner of the Vlamingstraat and Academiestraat. On Marcus Gerards' plan from 1562 a splendid building with four turrets can be seen. Built in 1430, it stood there till the Florentine traders also left the city, after which it was sold in 1637. The present corner house has lost all prestige. Yet, it preserves one souvenir of Florence, the memorial stone in the Vlamingstraat façade in which three verse lines by Dante Alighieri, the most important author of the rich city of Florence and one of the greatest writers of all ages, have been chiseled. In the 15th song of the Descent into Hell of his 'Divina Commedia', he says:

'Quale i Fiamminghi tra Guzzante e Bruggia
Temendo 'l fiotto che in vêr lor s'avventa

Fanno lo schermo, perchè 'l mar si fuggia'.

(Just like the Flemings between White Sand and Bruges who, fearing the flood which is making for them, build a dam, a protection for which the sea flees). In the 20th song of the Purgatory Bruges is quoted again, together with Dowaai (Douai), Ghent and Rijsel (Lille). If these cities had the power to, says Dante, 'vengeance would soon be taken'. Though Bruges does not play an explicit role in this masterpeace of literature, it is quoted and used by Dante as a symbol of greatness, power and authority, which proves that in the beginning of the 14th century Bruges was famous all over Europe. The same lines are also quoted in the fountain monument on the Zand. The memorial stone is a present from the 'Società Dante Alighieri. Comitatu di Roma' and was originally (1976) masoned in the floor of the Market Square, at the foot of the Belfry. Fortunately it was removed and inserted in the cornerhouse façade in 1984, for the stone was already cracked and the letters were already wearing away. The former Florentine hanse-house is a more appropriate place now anyhow. In the mean time in 1985 a 'Società Dante Alighieri Comitatu di Bruggia' was founded, with their own periodical 'Pagine delle Dante', lectures, concerts, slide-shows about Italian art and culture and an Italian course.

In the Vlamingstraat is also situated the *Municipal Theatre* (1868). It was played in on 30th September 1860 with the comic opera 'Les Mousquetaires de la Reine' by the Paris composer Ludovic Halévy who was to become a member of the Académie Française in 1884. We should not be surprised that a French play performed by French actors was chosen. Only very seldom Dutch plays were on the programme at that time, performed by a number of companies from Ghent. Bruges has never had a professional theatre company, but plenty of amateur companies, who, up to this day, sometimes perform in this theatre. A few small but active theatres have started lately: the Korrekelder on the Kraanplein, the Kelk in the Langestraat, the Dijk on the Blankenbergse steenweg and the Werf in the Werfstraat.

The Municipal Theatre was built on the site of a historically important and quite valuable quarter between the Vlamingstraat and the Kuiperstraat. Its architecture has never been highly appreciated. This building by the Brussels architect Gustave Saintenoy is typical, though, of the eclectic architecture of the second half of the 19th century which has left marks in so many cities. The neo-Renaissance building can certainly be called a massive, somewhat pompous con-struction with a strongly jutting front. The theatre and foyer inside have been decorated excessively and in different styles; especially the large chandelier and the busy wall and ceiling painting catch the eye.

In front of the theatre a young Pagageno sculpture by Jef Claerhout can be admired, with the following inscription: 'Der Vogelhändler bin ich ja. Aria uit

De Toverfluit. Opera van W. A. Mozart 1756-1791. Wer ich bin? Dumme Frage! Ein Mensch wie du. Ingehuldigd door Frank van Acker, burgemeester van de stad Brugge. 1 juli 1980' (unveiled by Frank van Acker, mayor of the city of Bruges. 1st July 1980). Across the street a bronze score from the same opera by the same sculptor decorates the pavement. The corner house next to the score used to be the baker's and confectioner's shop of Honoré and Ernest van Mullem, up to the 1950's. From the beginning of 1880 to Easter 1891 the baker and confectioner Frank Lateur, who was to become the famous Flemish author Stijn Streuvels, served his apprenticeship here.

Simon Stevinplein (Simon Stevin's Square)

As appears from an inscription on the rim of a well, discovered in 1980 when the square was relaid, up to 1819 the West Meat House of the butchers' corporation was situated here.

On 26th June 1846 the statue of *Simon Stevin* was inaugurated. The first statue to be erected in Bruges, this work by Louis Eugène Simonis from Liège arrived at its destination more than a month later. Still, the solemn inauguration could take place thanks to a couple of young Brugean artists who had hurriedly made a bronze coloured plaster statue.

Simon Stevin, born in Bruges in 1548, was one of the most important scholars of his time. Though like the great Erasmus of Rotterdam he was a bastard son, he was able to study Latin and Greek and had a marked aptitude for mathematics. He became a bookkeeper in Antwerp and in 1577 a tax officer of the Franc of Bruges. In the mean time he had become a member of the Bruges Chamber of Rhetoric of the Holy Ghost in 1571. About 1580 he left his native city because of the religious conflicts and he settled in Leiden, where he studied mathematics and became friends with prince Maurits of Orange, who was to determine the rest of his life. Simon Stevin became his teacher and adviser and later the quartermaster general of the States army. He made his reputation by a series of important publications which were very progressive and even experimental for those days, in the spirit of his motto 'Wonder is no wonder'. Though Latin was the fashionable language for publication, he used Dutch and even introduced a number of words still particular for Dutch, such as wiskunde (mathematics), stelkunde (algebra), meetkunde (geometry), breuk (fraction), evenwicht (balance). When in 1600 the university of Leiden started the first engineers' academy, he saw to it that Dutch became the language of instruction. He wrote about tables of interest, the decimal fractions, arithmetic and algebra, statics, the construction of fortifications, the situation of ports, geography, astronomy, perspective and other subjects. His complete works were translated into Latin and some of them into French. In 1955-63 a six volume Dutch-English version of his most important

writings was published. Stevin also became famous by a sand yacht he designed, with which he managed to touch 35 kilometers an hour in 1600. So it is with good reason that this famous Brugean got his statue on this pleasant square fringed with linden trees, though it is not known where exactly he resided in Bruges.

Sint-Jansplein (Saint John's square)

The name of this square should be traced back to the John the Baptist church which would have stood here towards 1200. It can be seen in the vista on the 16th century portrait of Jacquemine Buuck (Groeninge Museum), but was pulled down in 1787.

The entrance gate of the girls' school Hemelsdaele catches the eye. This former house De Lecke passed into the hands of the English hanse from whom the jesuits bought it in 1574. In the 19th century it was for some years the Saint Louis' College, till finally the Hemelsdaele institute took possession of it in 1878.

Several streets in the neighbourhood remind of the commercial ties between England and Bruges. The oldest trade agreement (which was lost, however) dates back to 1216. In the 14th and the 15th century the English and Scottish traders lived in the quarter of the city between the Theatre Square and Saint Anne's church, in the Crommewal (now Koningstraat), the English Street (still called like that since 1333), the Scots' Square (1532) now Sint-Maartensplein, along the English quay (the part of the Spinolarei between Engelse straat and Koningstraat) where the 'English landing stage', a stone flight of steps for loading and unloading ships, is still used by skaters in cold winters today, and along the Scots' dike, now Sint-Annarei. The English weighhouse was situated in the Engelse straat and from 1574 to 1585 the consulate, residence and entrepôt of the English wool traders (the 'Staplers') was situated in the 'Domus Anglorum Brugae' built about 1340 along the Spiegelrei. The house is now a Royal Grammar School.

On the corner of Saint John's Square and the Wijnzakstraat (Wineskin street) – this used to be the wine-trading district of the city – stands one of the most beautiful houses of Bruges, the former wine tavern 'De Croone', a Gothic building from the end of the 15th century. After having been used as a police school and a youth hostel for a few decades, in 1967-68 the house was finely restored by its present owner, the Gemeentekrediet van België. This typical high brick gabled house with numerous windows in flawless bays illustrates the splendour with which the houses in Bruges used to be built and looked after.

Achiel Van Ackerplein (Achiel Van Acker's Square)

This is one of Bruges' youngest squares. It was given its name in 1984, when on the little square in front of the Anglican Church in the Ezelstraat, a portrait-bust

of the Bruges politician was put up, a work of art by the Rumanian Idel Ian-chelivici. *Achiel Van Acker* was born in the neighbouring Klaverstraat in 1898. The fourth of twelve children of a basket maker, he received little education. From the days of his youth he sympathized with the situation of the working class, a life he had been familiar with himself. In 1926 he became a socialist member of the city council (till 1958) and in 1927 a Member of Parliament. Later he became a Minister and twice Prime Minister of Belgium and he ended his political career as chairman of the House of Representatives in 1961. In 1964 he moved into a spacious house along the Sint-Annarei, the present art gallery Marnix Neerman. A memorial tablet in the façade reminds of him. He died here in 1975.

Van Acker's life was not just politics, however. He often attested himself that he had perhaps rather become an author. And he did write quite a lot: poems, memoirs, collections of proverbs and sayings and lots of political aphorisms in the 'Vlaams Weekblad', a socialist weekly which he founded in 1932 and which is still being published. Van Acker was a bookseller, a book dealer and publisher too.

Van Acker's statue on the square turns its back to the church of the Theresianen Convent (1648) which was suppressed by emperor Joseph II and turned into barracks and later into a secondary school, which it still is. In the Dutch period the church itself was used by the Protestants, mainly military men and civil servants, and from 1830 onwards by the Anglicans, who called it Saint Mary's Church. The mainly catholic Bruges population, however, called it the Beggars' Temple. Now the chapel has been equipped as a hall for organ and chamber concerts and got the name of the composer Joseph Ryelandt, the former director of the Municipal Music Conservatory. In 1987 a number of exuberant bronze sculpture creations by Livia Canestraro and Stefaan Depuydt were integrated in the Baroque façade of this former church to signal to the public that this is a concert hall. Inside a white stone polychromed Stations of the Cross from the demolished Capuchin church in the Sinte-Clarastraat has been installed. It is a work by sculptor Hendrik Pickery. The new concert organ (1988) was realized by Loncke organ builders from Kortemark.

Jan van Eyckplein (Jan van Eyck Square)

Up to 1787 the Saint John's bridge over the 'Reie' was situated on this square. Next, the square was called Academy square and afterwards, up to World War I, the Potato Market. The British poet Robert Laurence Binyon (1869-1943) might be referring to this in his poem

'The unharnessed carts are left, the labourers all

Gone home, their last load emptied; dusking air
Sends stones of many bells about the square;
More intimate the deepened shadows fall:
And, secret under a dim height of wall,
Two lovers meet, kiss long, and shyly share
Their mystery of fierce heart-throbs – ignorant where
Stands Van Eyck darkening on his pedestal.'

Yet, since 1844 this square between the Spiegelrei and the Spinolarei has officially been named after the painter Jan van Eyck. His tall (3,90 m) metal statue, made by the Brugean sculptor Hendrik Pickery, was unveiled in the presence of King Leopold II in 1878. Two important paintings by Jan van Eyck, masterpieces of the first Flemish Primitive which add to the worldwide fame of the art collection of Bruges, can be seen in the Groeninge Museum.

The most important building on the square is the *Poorters' Lodge*, which used to be a meeting place for Brugean burghers and from about 1394 tot 1487 the premises of an exlusive sports and leisure club called 'The White Bear', which organised tournaments and jousts. Quite a series of influential Brugean citizens have been 'statued' in the façades of the building: Claeys Grootwerc, a silver-smith and alderman of the city: Jan Inghelbrecht, stamp maker; Jan van Oudenaarde, a famous mason who worked on the Belfry and several bridges and city gates and the painter Jan Coene, all from the 15th century. Other 14th century prominent figures appear on the side of the actual square: Maarten van der Rughe, a contractor and one of the leaders of the Brugeans taking part in the Battle of the Golden Spurs in Courtrai; Pauwel van Langemarc, a treasury offi-cial; Willem De Deken, the famous mayor who was emprisoned, tortured and killed in Paris for having sought contact with England when the textile industry was declining and finally Saint John the Baptist after whom the former bridge over the Reie was called and the former Saint John's Church on the Sint-Jans-plein. The Academiestraat façade holds nine statues: Reinier, the first provost of Saint Donatian's; Gervaas van Praet, Charles the Good's advisor; Walbrecht van Brugge, priest, notary and chronicler of the murder of Charles the Good; Walter van Zande, a Brugean Frior Minor who became the bishop of Poitiers; Christiaan de Langhe, representative of the London Hanse in Bruges; Matthias van der Buerse, the contact person with the German Hanse; Jan Metten Eye, chairman of the Society of the White Bear; Jan van Hulst, one of the founders (1428) of the Chamber of Rhetoric of the Holy Ghost and perhaps one of the authors, with Jan Moritoen and others of the famous Gruuthuse manuscript and finally the Bear of the Lodge, the legendary first citizen of Bruges who was first put in this niche as early as 1417. All these statues were made by the sculptors Michiel Dhondt, Jules Anthone and Franz Vermeylen in the 19th century.

After having been used by the Company of the White Bear, the Poorters' lodge

became a fencing hall and the meeting-place of the rhetoricians of the Holy Ghost. From 1719 tot 1890 the academy of painting and drawing was housed here, which explains the name Academiestraat and constituted the start of the city's collection of paintings. Finally, it was for some time the house of the Chamber of Commerce. The original building was destroyed by fire on 30th January 1755, but is was soon reconstructed, as appears from the chronogram over the elegant entrance door 'Ut PhoenIX eX CInero sUo brUgensiUm Donare VIVIsCo'. The building was restored in 1899-1903 and has been used by the States Archives since 1910. An exhibition room with documents from the 11th century onwards can be visited on request (Monday to Friday from 9 a.m. to 12 and from 13 to 17 p.m.).

In the corner house 'De Roode Steen' between the Genthof and the Spiegelrei, a memorial plaque for *Georges Rodenbach* catches the eye. Though the building itself is not very important and though Rodenbach had no link whatever with the house, the man deserves being mentioned. He was born in Tournai in 1855, graduated as a lawyer at the university of Ghent but settled in Paris as a full-time writer in 1888, where he died in 1898. In 1892 he published the novel 'Bruges la Morte', the book by which at the end of the 19th century, the French artictic and intellectual circles became again acquainted with Bruges. Much to the dissatisfaction of the inhabitants of Bruges, the title of this not quite successful novel is still sometimes used to describe the dead character and provincialism of the former metropolis in a somewhat scornful and slighting way.Is this the reason why Georges Rodenbach did not get a street name or a statue in Bruges, though his relative Albrecht Rodenbach did? This very modest bronze plaque is indeed the only souvernir. Put up in 1950 by the author's family and an 'Association des Ecrivains Belges des deux Flandres', the plaque contains one of the poet's verse lines 'O, ville, toi ma soeur, à qui je suis pareil' – a dedication to the 'soror dolorosa' and the essence indeed of Rodenbach's relationship with Bruges. The melancholy romantic took himself out on Bruges, though he never actually lived in the city. He did spend quite some time here and had many friends in the city. His morbid melancholy must have got some response in the misty, lifeless atmosphere of 19th century Bruges. In his prose everything is dark and it is raining all the time. Every relationship is broken and at the end of each novel there is violent death: murder in 'Bruges la Morte' and suicide in 'Le Carillon-neur', the author's last and best novel. His characters are individualists living outside society. The reader does not read anything about the miserable way of life in 19th century Bruges, for only the atmospheric appearances seemed to be important for Rodenbach. His best-known novel about Bruges was translated into seven languages (only in 1978 in Dutch) and filmed twice. It was also used in a screenplay for Erich Wolfgang Korngold's opera 'Die tote Stadt'.

The three most beautiful façades, together called the *Old Customs House*, on the

Jan van Eyck square are situated between the Spanjaardstraat and the Genthof. Long ago these premises were used as a fire station and afterwards by the City Library, which moved to a new complex in the Kuipersstraat. The Old Customs House (1478) is the highest of the three façades. Ships which wanted to enter the city by the Reie had to pay customs duties here, but the building was also used as the city weigh-house and as a store of all kinds of merchandise. Towards the end of the previous century the very balanced façade and the beautiful porch-loggia to the left were restored. This porch is decorated with the coat of arms of Peter of Luxemburg, a knight of the Golden Fleece who had the Customs House built and levied the taxes. To the left of this little porch a very beautiful blue stone Gothic façade from about 1470 can be seen. It is part of the former 'pijnders' house, corporation of unloaders of ships at Saint John's bridge. Over the round-arched gate the four patron saints of the pijnders: Saint Lambert and Saint George in the middle and John the Baptist and Saint John to each side.

So the Jan van Eyck square offers another series of souvenirs of the rich history of Bruges, both in the field of trade and economic activities and in the field of literature and visual arts. For the latter, Jan van Eyck must be considered as its most important citizen.

Vismarkt (Fish Market)

In this region so close to the sea fishing and fish trade have always intensively been practised. In the 15th century Damme was the most important herring staple town of Western Europe. In the 14th century already a fish market was held in Bruges on the present Market square. The corporation owned five houses on the north side and had its own altar in the Saint Christopher Chapel on the present Eiermarkt. In 1745 the French king Louis XV ordered that the fishmongers should be removed from the Market square, whereupon the city authorities referred them to the Corn Market on the Braamberg, the present Fish Market.

Only in 1820 did the Fish Market get its present cold and classicist appearance: a rectangular building with 126 Tuscan columns in two rows and the actual display tables in between. Only a few of these are still used today. This is the only public building which was erected in the Dutch period. It was designed by Jan Robert Calloigne who got his training in Paris and Rome and who is best known as a sculptor. The statue of Jan van Eyck on the Burg was also made by him. The British poet Robert Laurence Binyon (1869-1943) bears witness of his visit to the Fish market:

> 'Under the market's low stone roof the new
> Beams of cold morning slantingly invade
> A pillared shadow where heaped fish are lead

On broad slaps. O the wet gleams, bright as dew!
…
With cries the sunned, sea-smelling market drones, –
Debate and gesture of that world-old play'.

From the Fish Market the visitor has a marvellous view on the Reie, the pictures-
que Steenhouwersdijk and the back of the City Hall and of the Palace of the Franc
of Bruges.

Walplein (Rampart Square)

Tourists like to dwell on this quiet little square on their way to the Beguinage and
the Minnewater. The recent (1982) bronze sculpture under the linden trees called
'Zeus, Leda, Prometheus and Pegasus visit Bruges' was made by Jef Claerhout.
The winged horse is a tribute to the coachmen who have been driving tourists
about town for years now. The Stoofstraat in the corner of the square is Bruges'
smallest alley and a curiosity.

Wijngaardplein (Vineyard Square)

From this square, the name of which refers to a low-lying meadow, one has a
very broad view on the Beguinage, the Lockhouse and the Lake of Love, the
outstanding centres of tourism in Bruges. The largest building on the square is
the former orphanage of the Sisters of Saint Vincent de Paul. The neo-Gothic red
brick building dates back to 1883.

The Lockhouse cuts off the Reie from the Lake of Love. This lock already
existed in the 16th century, but the present house was designed by the architect
Louis Dela Censerie in 1895.

Close to the Lockhouse stands the bust of the author *Maurits Sabbe* by Octave
Rotsaert (1950). He was the son of Julius Sabbe, who played an important role as
a liberal pro-Flemish leader in 19th century Bruges; Julius' house, (birthplace of
Maurits) along the Potterierei has been marked with a bronze memorial plaque,
also reminding of Sabbe's efforts for Bruges-Seaport.

The philologist Maurits Sabbe became the custodian of the Plantin-Moretus
Museum in Antwerp and a professor of Dutch literature in Brussels in 1923. His
literary oeuvre is quite voluminous: poems, songs, cantatas (he was himself a
much appreciated baritone singer), literary and musical studies and works about
the history of civilization and above all a series of novels and stories all situated in
his native city. Especially 'The Philosopher of the Lockhouse' (1907), which was
also filmed, made Sabbe a famous author in Flanders and in the Netherlands. The
main character is the 40-year-old lockkeeper who is a bachelor and a great lover
of nature. Unexpectedly, he marries the charming 19-year-old daughter of his

friend Casteels. This story, in which the fortunes of 19th century Bruges play an important part, has been written in a late romantic style: an outstanding example of an art of moods and feelings, with occasional humorous passages, some dialect, a typical, descriptive and even onomatopeic impressionism.

The *Minnewater* (Lake of Love) is the well-known meeting-place, picturesque in all seasons. The name of the lake has never adequately been explained. The translation Lake of Love is certainly not correct. One theory holds that 'minnewater' was derived from 'menewater' or 'gemenewater', meaning common water; others say it refers to 'binnenwater', meaning an inner harbour or reservoir. For a long time all the city's important visitors and guests were welcomed here; they arrived (later at Saint Catherine's Gate) with the barge from the canal connecting Bruges and Ghent. In his poem about Bruges the British Poet Laureate Robert Southey uses a Dutch word for the ship:

'Beside the busy warf the *Trekschuit* rides,
With painted plumes and tent – like awning gay;
Carts, barrows, coaches hurry from all sides,
And passengers and porters throng the way,
Contending all at once in clamorous speech,
French, Flemish, English, each confusing each'.

Next to the six-arched bridge stands a Powder Tower (a second one used to stand at the other side of the bridge) which was used for the production and storage of gunpowder from the 15th century onwards. Powder was stored here till the 1920s. From this bridge the visitor has a marvellous view of the Lake of Love, the Lockhouse and the tower of Our Lady's Church. Up to the beginning of the 20th century, both in Winter and in Summer, magnificent festivities and nocturnal water feasts were regularly organised on the lake, appropriate to the Venice of the North.

Small wonder that many painters, draughtsmen and photographers have put down this scene, that films have been shot here and that writers have tried to express this special atmosphere in words. Emile Verhaeren, Stefan Zweig, Marino Moretti, Maurice Carême, Paul Claudel are just a few names of authors who stood here at this lake and spoke about it in their works. Luis Marden describes his experience in a 1955 issue of the National Geographic Magazine: 'Along the canal glided sight-seeing boats with noiseless underwater exhausts. The boatmen's voices, explaining the sights, echoed from the stone arch of a bridge, one of 82 that span the city's canals. Across one end of the lagoon called the Lake of Love, a multiarched bridge, lighted in amber, hung like a golden caterpillar over the still water and touched legs with its inverted counterpart below... Once I waited a long time, my camera on a tripod, until the reflections stopped trembling, then opened the shutter. When the exposure was nearly

complete, a swan glided out of the shadows of the bridge, pushing a bow wave that formed a glassy rope of orange light around its breast'.

And of course the Lake of Love occurs in many legends and lovers of all time have thrown coins into the water.

In 1978 to this neighbourhood of Wijngaardplein, Beguinage and Lake of Love was added the *Minnewater Park*, a very beautiful and restful green spot in the city. It used to be a bleaching meadow where linen was spread and regularly sprinkled with water. In the 18th century the china and faience factory of Hendrik Pulinx stood on this site, but nothing of it survives. The park now contains hornbeams, plane-trees, horse chestnuts, maple trees and white willows. Each year the Cactus Festival of contemporary music and the Third World Festival are organised here.

Close to the Wijngaardplein is situated the *City Academy of Fine Arts*. The entrance is in the Katelijnestraat, but this large complex which also includes the restored Bogarden Chapel, can also be reached via the Noordstraat and the Arsenaalstraat. The Brugean Academy is one of the oldest of the country: it started in 1717, after the Antwerp academy and almost simultaneously with the Brussels academy. In that year Brugean painters, backed by a number of canons and unfluential citizens, addressed an appeal to the city council in which they asked to be relieved of the age-old obligation for painters to join the corporation of 'saddlers, harness makers, mirror makers and statue makers'. Their appeal in fact stated the decline of painting in Bruges and asked for greater freedom. Their prayer was answered and the Free and Excellent Brotherhood of Drawing and Painting was founded. They acquired the Poorters' Lodge between the present Jan van Eyk square and the Academiestraat, then still called Zouterstraat. In 1755, however, the Poorters' Lodge burnt down. The building, the materials and above all a great number of works of art were destroyed. Only one year later everything was re-built, as can be read in the chronogram over the entrance of the present State Archives in the Academiestraat. In 1775 the school received the litle of 'Royal' by prince Charles of Lorraine, governor of the Austrian Netherlands. In 1891 the academy, which had in the mean time received the title of 'City' as well, moved to the former Bogarden School in the Katelijnestraat, under the same administration as the City Technical School already situated there. From 1910 onwards the schools got independent administrations.

The academy has had a series of important directors. The first, founding director was Jozef Vanden Kerckhove, a disciple of Erasmus Quellin in Antwerp. The example of the Antwerp Academy must have inspired him to found an art school in his native town as well. He was succeeded by his disciple the painter Matthias de Visch and next by painter Jan Garemijn, architect and painter Paulus de Cock, painter J. A. van der Donckt, painter Jozef Frans Ducq, sculptor Jan Calloigne, architect Jozef van Gierdegom, portrait painter Albert Gregorius,

painter Romain van Maldeghem and historical painter Eduard Wallays. From the 19th century onwards, when the academy had become a municipal institution, it was directed by the architect Louis Dela Censerie, by painter Florimond van Acker, who also designed costumes and floats for pageants, by painter Jules Fonteyne, who was at the same time an etcher, sculptor, designer of flags and church furniture and an illustrator of literary work, by the art historian Alex Roose and by Luc de Jaegher, etcher, graphic artist and illustrator. The academy is now directed by the architect Jean Hocepied and has become a flourishing institute with hundreds of day and evening students. Next to the directors many of the academy's students have moreover made a name in one or another art discipline. To mention just a few: the sculptor Pieter Pepers, painter Jan Beerblock, Pieter Ledoulx, chronicler and painter of insects and flowers, Karel van Poucke, who was to become the director of the Ghent academy, Bernard Verschoot who controlled the Brussels academy, painter Jozef Benedictus Suvée, portrait painter Frans Jozef Kinsoen, court painter Jozef Odevaere, marine painter Paul Claeys, the well-known Flemish expressionist painter Constant Permeke and of course numerous contemporary Brugean artists. The work of many of these painters can be seen in the churches and museums of Bruges.

The academy buildings are situated on the site of the former Bogarden School. Bogarden were friars of Francis of Assisi, a kind of male counterparts of the beguines. As early as the 13th century they organized a school for orphans and children of poor families whom they taught languages, mainly Latin, and manual work, mainly weaving. In the beginning of the 16th century their school became the official municipal orphans' school where the children received an excellent education. On important occasions such as great funerals the pupils had to act as mourners. They were nicknamed 'the city bowls', because of the municipal institution but mainly because of the typical bowler hat belonging to their uniform. Important parts of this school have survived and have been very well restored: a monumental fireplace from the beginning of the 16th century in the Arsenaalstraat and the Bogarden Chapel from 1672. At the end of the 19th century this chapel was temporarily used as the municipal museum of fine arts and recently as an exibition centre, in which both the academy and modern tendencies in the visual arts have made themselves kwown to the general public.

Woensdagmarkt (Wednesday Market)

This square in the Genthof was laid out in 1545 and had many different names: it was called Square of the Orientals for the presence of the German hanse, Coal Square because charcoal and peat were once sold here, Memling Square because his statue stands here and Wednesday Market because this was the square and the day on which markets were held until the 1920s.

The marble statue of Hans Memling in the middle of the square was made by the Brugean sculptor Hendrik Pickery. The solemn inauguration took place on 3rd September 1871. Masterpieces by this painter can be seen in the Memling Museum of Saint John's Hospital and in the Municipal Groeninge Museum.

Behind Hans's back we see the convent of the Black Sisters behind a series of brick gabled houses. It has a conspicuous low relief of Augustine (1953) designed by the Bruges artist Jules Fonteyne over the entrance gate on the left.

't Zand

Situated at the end of Noordzand- and Zuidzandstraat, this is Bruges' largest square. Galbertus of Bruges, a 12th century chronicler, already speaks about 'apud harenas', the arena. Two railway stations were successively built on this square; the remnants of the last one disappeared in 1948, when the new lay-out of this large square was started by the Planning Group, a partnership of architects, engineers, town and traffic planners under the direction of architect Jan Tanghe. In 1978-83 a tunnel was built for the through traffic and the largest of Bruges' four underground car parks, the entrances of which emerge on the square in pagoda-like little houses. To give it back its old aspect more than a hundred trees have in the mean time been planted on this square, for in the 18th century already, it was fringed with a double row of linden trees. The weekly Saturday market is held on this square (up to 1983 the Market square was used for this purpose) and jumble sales and other festivities are organised here.

The impressive *fountain sculpture* in the middle is the eyecatcher of the square. This open work of art, finished and inaugurated in 1986, consists of a number of rust-coloured columns in Corten steel rooted as it were in four large, bronze groups of sculptures. 'The Bathing Women', four proud and stout women, symbolize four historical Flemish cities: Antwerp, Ghent, Courtrai and Bruges. They are showing Flemisch cloth. The fussy crows on their heads represent the circular movement of life and death. 'Flemish landscape' is an almost abstract sculpture referring to the flats, the water and a lock, the harvest and a plough-share. 'The Fishermen' with a sawfish, boathook and loop stress the verticalism of the sculpture. The group of young 'Cyclers', finally, includes Nele, who is waving to Owlglass, sitting on top of one the columns. The sculpture complex is illuminated at night and equipped with an ingenious fountain system spouting water from various figurative and abstract holes. Little plates with poetic texts by Dante Alighieri, Guido Gezelle, René de Clercq, Anton van Wilderode, Bert Decorte and others have been affixed here and there. This work of art is the result of a contest organised by the City Council in 1981 which stipulated that the theme should refer to Bruges, that the design should be typical for the art of the 1980s and that its volume should be in keeping with the surroundings. The

winning artists Livia Canestraro and Stefaan Depuydt have combined severe columns with a figuration of warm bronze sculpture, its rich symbolism inspired by Flanders, the sea, Bruges, the past and the future. Both as a whole and in its details this is a remarkable monument. The structure of a hand, an arm's movement, the direction of a look, a proud appearance in hollow and round parts, in smooth and worked surface, not only illustrate the creators' vision but also their intense artistic passion.

On the Zand (Vrijdagmarkt) is situated the Orgelmuseum (Organ Museum), a private museum based on the organ collection of D. Dagraed-Pareyn exhibited in Koksijde on the coast until 1984. The collection was bought by the International Bookshop which has been promoting the dissemination of culture via the press and books ever since 1912. The museum contains more than a hundred mechanical instruments and is the most important museum of this kind in Belgium. The visitor can follow the evolution from the 18th century so-called canary-organ or serinette up to the large Verbeeck organ with 600 pipes. In the 19th century and the beginning of the 20th century Flanders used to be an important centre of the book organ industry with mainly barrel organs, fairground organs and dancing organs. After World War I Flemish organs were exported all over Europe, important names being Bursens, Decap, Duwijn, Fasano, Hooghuys, Mortier, Van der Beken and Verbeeck.

This museum shows the complete evolution of this outstandingly popular form of entertainment. In the first department we see the cylinder type with musical boxes, barrel organs, reed organs, pipe organs, organ clocks, cylinder pianos and harmoniums. The disk type in this mainly 19th century mechanical music is illustrated with disk organs and disk musical boxes. And the survey continues with instruments with perforated cardboard rolls such as orchestrions and player-pianos and instruments with perforated cardboard books, such as fair-ground organs and barrel organs. There is also an interesting collection of phonographs and grammophones on view, appliances which have in fact speeded up the decline of mechanical music. High points of the collection are the Swiss cylinder musical box, which was used in railway station waiting rooms, a rare komet music cabinet from Germany on which two disks can be played at the same time and a Frati barrel organ with pipes produced in Berlin. And then there is a pneumatic grand piano with paper rolls and foot-controls, a portable reed organ popular with itinerant preachers and a few large and very large concert organs. Some organs have been preserved better than others; most of them are still playable and produce a sound noise during the tour.

The design of the sound boxes or cabinets also gives us a good idea about the evolution. The oldest musical instruments which can be seen here are often hidden in artfully tooled wooden boxes or cabinets with fanciful marquetry, while the younger ones were finished according to the fashion of the time. Large

concert organs were painted in pastel or in clashing colours.

Note

★ The Organ Museum, Vrijdagmarkt 11, entrance via Zwijnstraat 3 is open from Easter to 15th November, every day from 10 a.m. to 19 p.m. Entrance fee: 120 BF. Parties 100 BF. Children 50 BF. Guided tours. Museumshop. Catalogue. Cafeteria.

Art in the museums of Bruges

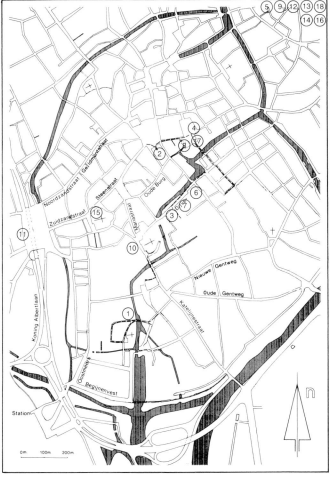

1 Begijnenhuisje
2 Belfort
3 Brangwynmuseum
4 Provinciaal Museum van
 het Brugse Vrije
5 Guido Gezellemuseum
6 Groeningemuseum
7 Gruuthusemuseum
8 Heilig-Bloedmuseum
9 Kantcentrum
10 Memlingmuseum
11 Orgelmuseum
12 Potteriemuseum
13 Sint-Janshuismolen
14 Sint-Jorisgilde
15 Sint-Salvatorsmuseum
16 Sint-Sebastiaansgilde
17 Stadhuis
18 Stedelijk Museum voor
 Volkskunde

The Torch Dance, *tapistry, 1650, detail, Gruuthusemuseum*

A museum is a temple of the muses. As early as the 17th and 19th century collections of curiosities and Wunderkammer were furnished with works of art; the initiative was mainly taken by private collectors.

Museums as we know them today are a 19th century invention, which served a scientific purpose: collections of works of art had to be preserved, arranged, completed, studied, described and exhibited. Visitors were discouraged rather than attracted while museums today try to interest the general public with important exhibitions, publications, lectures and educational activities. They even play a social role in today's cultural policy, and in the past fifty years barriers for visiting museums have been considerably lowered.

Bruges has about twenty museums or museum collections which are open to the public. Their origins differ. Though most of them have a scientific vocation, they all appreciate the fact that the number of visitors each year increases.

Begijnenhuisje (Beguine's House)

Begijnhof, 1
(see Beguinage, p. 89)

Belfort (Belfry)

Markt
Tower and treasury
(see Market square, p. 24)

Brangwyn Museum

Dijver, 16
The entrance of the municipal Brangwyn Museum is situated in the Arents Park, to be reached via the Dijver, the Groeningestraat or the little Bonifacius bridge. The Arents House is a classicist mansion with a porch. The last owner, who lived in the house for more than thirty years, was Aquilin Arents de Beerteghem, after whom the house and the park were named. In 1908 the premises were expropriated by the council in order to open and add to the Gruuthuse garden. The Brangwyn Museum was re-opened in December 1987, on the occasion of a large retrospective exhibition of the work of Frank Brangwyn, the British Brugean whose name was again given to the museum. Between 1908 en 1987 the building was used for several kinds of museums and functions. Parts of the Steinmetz

collection were exhibited here and, just before World War II, part of the Brangwyn collection. During the war the people of Bruges had to queue here for their Provision Service. In the 1950s the building was used by the Municipal Office for Theatre, Art and Culture, which was the basis of the present Municipal Museums Department.

The present renovated Brangwyn Museum could be called the museum of maecenatism, for it mainly consists of parts of rich and attractive donations of the last few decades to the Bruges museums.

Downstairs there are four rooms. In the first one the visitor is confronted with a very rich tinware collection, the so-called *Dubois donation,* consisting of 160 tin objects given to the city of Bruges by François Dubois from Trazegnies in 1978. They were made in the 18th, 19th and 20th century mostly in Walloon and Brabantine tin-casting workshops, though some objects come from the Netherlands, Germany and England. Some of the plates and dishes are Brugean work.

The second room brings a selection of more thans 800 mainly 18th and 19th century works of art (tin, silver, china and ceramics) donated by Mr. and Mrs. *Herssens-Vanden Broeck* from Hamme in 1976. High points of the collection are German and Brussels china and a very beautiful series of blue and brown Chinese work or work with an Imari pattern and a series of blue and polychrome Delft pottery.

In the third and fourth room part of the donation of Mrs. *M. Olbrechts-Maurissen* is exhibited. This is a specialized collection of mother-of-pearl and its applications: pen holders, paperknives, signets, spoons, forks, party games, fans, perfume bottles, little purses, sewing-things and clogs. The fourth room also contains a number of shell-shaped objects, some of them from Israel, in which religious motives were carved, and a couple of altar crosses.

The ground floor of the Brangwyn Museum is also important for its exhibition of quite a large number of townscapes with squares and monuments in their former appearances and hence with much iconographic and historical value. The first room shows the Burg with Saint Donatian's Church (1751), the Spiegelrei (1747), preciously and delicately painted by Pierre Le Doulx, the gardens of the Eekhoute Abbey or the pleasure garden of Groeninge by Jan Garemijn from 1759, Saint Giles' Church in 1825 by Lambert Noos and the Jan van Eyck square in 1865 by Antoon L. Joostens. In the second room we see paintings by Jan Baptist van Meuninckxhove (the Market square), by Eugène Legendre (the southern façades of the Franc of Bruges) and, an exception among these townscapes, a portrait of the empress Maria Theresia of Austria (after 1743) by Matthias de Visch. In the third room a beautiful anonymous 17th century painting of the Huidenvetters square, still shut off by gates, the Markt in 1826 by August Vanden Steene and the Steenhouwersdijk in 1844-46 by Edward Wallaeys. In the fourth room an 18th century interior of Saint Saviour's Cathedral by Jozef War-

lincourt, an interior of the former Saint Donatian's church by van Meuninckx-hove from about 1704 and a plan of the Abbey of the Dunes (1580) by Pieter Pourbus. Part of a map of the Franc of Bruges (1571) by the latter has been put up in the passage along the rooms, together with a hand-coloured etching of Marcus Gerards' 1562 map. In the reception room, next to the stairs, a large tapestry can be seen, a self-portrait (1776) by Antonius Suweyns and a beautiful portrait study of Louis Rameau (about 1793) by the Brugean Jozef Suvée.

The six rooms on the first floor of the Brangwyn Museum now show the work of *Frank Brangwyn*. He was an important name among the many Britons who came and settled in Bruges in the 19th century. His father William Curtis Brangwyn worked in Bruges as an architect, muralist, church decorator (the blessing throne in the Chapel of the Holy Blood) and textile designer. He also played an important role in the promotion of British neo-Gothic art in Bruges, was a friend of Guido Gezelle's and one of the founders of the 'Société Archéologique', which lay at the basis of the present Gruuthuse Museum.

Frank Brangwyn was born in Bruges (Oude Burg 30) on 12th May 1867. He was baptized in Our Lady's Church by Lodewijk Van Haecke. When he was only eight years old, he and his parents returned to England, where he went to school for about four more years and then started a career as an artist, supported by his father and especially by the famous William Morris, the so-called 'prophet of social emancipation', to whom he apprenticed himself for some time. Frank learned how to make stained-glass windows, how to draw, paint and design tapestries. At the age of 17 he exhibited his first painting. He then made long trips to Turkey, Spain and especially North Africa, countries which fully inspired his paintings and drawings. He worked as a designer for Siegfried Bing in Paris, where the gallery 'Art Nouveau' was an international meeting-place for avant garde artists. Its name was to become the name of the style. Brangwyn made large wall paintings there and he earned himself an international reputation as a progressive artist. Afterwards he was more or less forgotten.

Bruges possesses the largest Brangwyn collection in the world. From 1927 onwards, in 1936 and later as well did Brangwyn give works of art to his native city. In a letter from June 1936 in which he donated his works of art to the city, he argues as follows: 'Many of the sketches have been inspired by the lovely city which has inspired so many whose names are immortal – and I am most happy that the people of Bruges are willing to accept this offering of one of her sons, who, though staying far from her unforgettable charms, has always remained grateful for what she is, and has done for him'. They were exhibited in the Arents House at that time. In 1936 the freedom of the city was bestowed on him in appreciation of his work and the Arents House became the first Brangwyn Museum. When the artist died in Ditchling, Sussex, in 1956, his museum was being used for other purposes, as described above. Since 1987 the British-Brug-

ean artist has been restored to full honour and the visitor can get acquainted with his varied works in the museum called after him. The Brangwyn collection has been arranged thematically. In rooms 1 and 2 work about *industry* can be seen (paintings and etchings). In room 2 we see a carpet and six little armchairs designed by Brangwyn in 1930. Room 3 illustrates the exotism in his work and the reminiscences to his numerous travels. The eye-catchers here are a colourful carpet *The Vine* from 1896-97, a table and an armchair from 1923. In the middle of one of the walls the very colourful and moving *Slave Market* (1920-21) has been put up. In room 4 our attention is caught by the wall decoration with a *British Empire Pannel* (1925-30) and a study drawing of it and a carpet from 1930. The rooms 5 and 6 are devoted to *bible and religion,* themes which frequently occur in his work. We see a Deposition from the Cross (before 1926), several Stations of the Cross, and others. Scattered on the walls and in display cases in these rooms, many examples of Brangwyn's graphic work and drawings can be seen. In most of them the line is strikingly emotional, with sharp strokes and a deep empathy in the different themes.

Together with the neighbouring great museums (Memling, Gruuthuse, Groeninge) this recently re-arranged Bruges museum of maecenatism constitutes an outstanding meeting-place for every art-lover.

Note

★ The Brangwyn Museum is accessible from 1.4 to 30.9 from 9.30 a.m. to 12 and from 14 to 18 p.m.; from 1.10 to 31.3 from 9.30 a.m. to 12 and from 14 to 17 p.m. Closed on Tuesdays. Museum shop. Entrance fee: 50 BF. Parties 25 BF. Schools 25 BF. Family ticket 125 BF. Bibliography: A. Janssens de Bisthoven, Catalogue of the Bruges townscapes, with an introduction about the Arents House, 1977; V. Vermeersch, Catalogue of the Herssens Donation, containing a list of the most important identifying marks on silver, tin and pottery, 1977; S. Vandenberghe, Catalogue of the Dubois Donation, with a survey of tin marks, 1982; D. Marechal, Catalogue of the Brangwyn Collection, 1987.

Provincial Museum of the 'Brugse Vrije'

Burg
(see Burg, p. 11).

Guido Gezelle Museum

Rolweg 64
The memorial stone (1906) in the façade of the city's only literary museum

reads: 'Reverend Master Guido Gezelle, priest and poet, was born in this house 1st May 1830. He died in the English Convent of which he was the Director 27th November 1899'. Guido was the oldest of the nine children of Pieter-Jan Gezelle and Monica De Vriese. Four of them would grow up after Guido: Romaan who was to become a pyrotechnist and the father of the poet Cesar Gezelle, Louise, who was to marry Kamiel Lateur and to be the mother of Stijn Streuvels, Jozef, who became a priest and died as the parish priest of Stene and Florence, who became a nun in Heule. The parents got married in 1829 and up to 1849 lived in this countryhouse, an old farm of the Theodoor Van de Walle-van Zuylen van Nyevelt family. They could use the kitchen, the upstairs room, the cellar and the barn and Pieter-Jan could work a large part of the garden for personal use. He was a gardener and tree-nursery man and also the 'overseer of the plantation of forest trees along the coast on the territory of Klemskerke in the dunes'.

The idea of arranging Gezelle's birthplace as a museum arose in the Bruges department of the Davidsfonds, lead by the priest Leo Vanhalst, on the occasion of the 25th anniversary of Gezelle's death. On 31st October 1924 the house and garden were acquired by the city and in the same year the 'Friends of the Gezelle Museum' were founded, who wanted to collect and preserve as many documents and souvenirs of Gezelle as possible. On 14th September 1926 the museum was inaugurated in part of the house. Gezelle's cousins Karel and Isa Lateur, brother and sister of the author Stijn Streuvels, became the first caretakers. The curator Paul Allossery (1875-1943) greatly added to the collection which now comprised about 14,000 objects and documents. He was succeeded by the historian and man of letters Antoon Viaene (1900-1979). Only in 1969 after the death of Stijn Streuvels, was the museum collection sold to the city of Bruges by the heirs Gezelle-Lateur. In 1976 the complete collection and activity of the museum were taken over by the city and on 12th July 1976 the restored and re-arranged Gezelle Museum was inaugurated. The actual museum is documentary and didactic, with mainly photographs and reproductions of books, manuscripts and documents. The Gezelle archives and library, city property, have been transferred to the City Library. The famous 'word bag' with about 15,000 leaflets with data about language, history and folkore collected by Gezelle, has been given on loan to the Institute of Dutch Lexicology in Leiden.

This new approach to the museum, with almost no original items on the spot, has been quite heavily criticized. 'Interior design has arranged the past didactically and made it transparent', appeared in the De Standaard daily (8.9.1976). They spoke about 'the purity of a refrigerator'. In the local weekly Brugsch Handelsblad (21.8.1976) a real epigram called 'Neorealistic Hommage to Guido Gezelle' was published and the poet Christine D'haen, who has for years been studying and classifying the Gezelle archives, wrote in the local weekly Burgerwelzijn (2.9.1976) about 'a barren, boring, worthless Gezelle graveyard'... The

museum's present curator is Willy Dezutter. The scientific responsibility for the Gezelle archives, now belonging to the Historical Collection of the Municipal Public Library, is held by Willy Le Loup, while the librarian Willy Muylaert attends to the specific Gezelle correspondence.

Not much has been altered to the museum's arrangement. About eighty objects connected with Gezelle have been exhibited on the walls and in display cases: his baptismal certificate and christening dress, his father's handwriting, photographs of his mother's house in Wingene, of his brothers and sisters, relatives and pupils and books and magazines published by Gezelle. The museum garden is also worth visiting. It contains a Gezelle bust (1894) by the sculptor Jules Lagae and many rare trees and shrubs some of which have certainly been immortalized in Gezelle's poems.

Gezelle is rightly called one of the greatest poets in the Dutch language, of a quality which occurs at most once a century. He was a full-blooded Romantic with typical nostalgic, religious and nationalistic evasive accents and 'with a strong need for expression of (personal) feelings and (collective) values... Far too fast do we have the impression to see through his poems and easily grasp their meanings. Gezelle's poetry is the kind of literature very well capable of being pulled in. This is proved by its reception: Gezelle as a national poet, a religious poet, a mystical poet etc.' (Piet Couttenier). In and next to all this Gezelle has been one of the greatest virtuosoes of and with the Dutch language.

Lips of the Rose

Oh beauteous lips of the rose
and beyond all the limits
 of loveliness, which first
 a-blow, dost smile to me;
thy life is but too brittle
and must, woe, withered be
 ere morn will come: be whole
 and live within my soul.

There may thou, free and rich
with undepraved splendour
 and mirrored in the depth
 of memory be held
and live: though be thy stem
and root and all corrupted,
 though wind which all bereaves
 by playing with thy leaves.
(1896) translated by Christine D'haen

Though the report at his entry in the seminary said 'la vocation nous parait douteuse', he was ordained in 1854, became a teacher at the Roeselare preparatory seminary (1854-60), at the English College, the English Seminary and the Saint Louis' College (1860) in Bruges; he became the vice rector and teacher of philosophy at the English Seminary, a deacon in the Saint Walburga parish in Bruges (1865-72), Our Lady's parish in Courtrai (1872-93), the rector of 'Les Filles de l'Enfant Jésus' in Courtrai (1889-93) and finally the rector of the English Convent in the Brugean Carmersstraat (1899) where he died about noon Monday 27th November of the same year.

Gezelle undoubtedly spent his happiest years in Courtrai and not in Bruges, his native city. Hugo Verriest wrote about him in his collection 'Twintig Vlaamsche Koppen': 'He was misunderstood, betrayed, accused, slandered, pushed and kicked and had no defense against the invisible pressure and humiliation which threateningly hung in the air and around his head'. And Stijn Streuvels remembered a story told in the family when he was a very little child about 'Guido, who was the oldest child and the wretch, the boy who got the blows, the one who endured, the unlucky person, who was clumsy, always late and who had to undergo the punishments for evil things done by others'. Later, in his Brugean years, Gezelle was indeed often discussed, humiliated and mislead, especially after he had – at the request of his superiors – assumed the editing of the periodical ''t Jaer 30'. As a journalist and involved in local political controversies he was headed for trouble. In some of his poems he speaks about his misfortune.

Though fortunately a museum cannot impair a poet's greatness, the Bruges Gezelle Museum does seem a posthumous illustration of the poet's relationship with Bruges. In June 1862 Gezelle's 'Gedichten, Gezangen en Gebeden' were printed at Edw. Gaillard's office in Bruges, which proves that the poet could publish in Bruges if he wanted to. Yet, not a single important poem did he devote to his native city. In his posthumously published 'Laatste Verzen' (1901), looking back on the misery of all those years, he just remembers the city ramparts with the windmills from his childhood and the garden of his birthplace.

Next to the Gezelle Museum, there is also a statue (1930) of Gezelle by Jules Lagae near Our Lady's Church, and several memorial plaques on the houses where he was born (Rolweg), baptized (Saint Anne's Church), lived (Saint Leo College, Korte Riddersstraat and Verwersdijk) and died (Carmersstraat). The funeral service on 1st December 1899 was held in Saint Saviour's Cathedral, because Saint Anne's Church was too small. In April 1909 a mausoleum designed by Jean de Bethune was erected on the Steenbrugge graveyard. Behind the Gezelle Museum a so-called Gezelle quarter was laid out, with streets called after Albrecht Rodenbach, Hugo Verriest and Stijn Streuvels.

Note

★ The Gezelle Museum, Rolweg 64, is accessible from 9.30 a.m. to 12 and from 14 to 18 p.m. Closed on Tuesdays and from 5.1. to 5.2. Entrance fee: 30 BF. Parties and schools 15 BF. Family ticket 75 BF. Combination ticket (Gezelle Museum, Lace Centre, Potterie Museum, Saint Janshuis Mill and Folklore Museum) 120 BF. Museum shop. Bibliography: J. Ghyssaert, Guido Gezelle Museum, Brugge, catalogue, 1976; W. Muylaert. Guido Gezelle en Brugge. Het thema van de stad in zijn dichterlijk oeuvre (The City as a Theme in his Poetry), 1980; R. Annoot, G. Gyselen & L. Schepens, Guido Gezelle en West-Vlaanderen, 1980.

Groeninge Museum

or Municipal Museum of Fine Arts
Dijver 12

The Groeninge Museum was built in 1929-30 and designed as a museum by the architect Jos Viérin on the site of the former Eekhoute Abbey. Its name and also the name of the adjoining street, is a toponym occurring as early as 1200. The museum can be reached via Dijver 12 and via the Groeningestraat, where a white abstract sculpture by the Bruges sculptor Pol Spilliaert (1935) was put up in the greenery. The museum itself consists of a hexagonal entrance hall and fifteen rooms.

The collection of paintings has a much older and longer history and cannot be separated from the Academy of Fine Arts founded in 1716, now in the Katelijne-straat. A first collection of paintings was assembled there, among others by the Brugean painters who had to hand over a painting to their institute. This collection was put up in the Poorters' Lodge on the Jan van Eyck square, but was lost in the 1755 fire. A new collection was started, which moved between the Bogarden School of the Academy, the former Jesuit College along the Verwersdijk, the former Abbey of the Dunes along the Potterierei and the City Hall. From 1903 onwards, when the basis for the still existing society of 'The Friends of the Municipal Museums' was laid, the collection was not only better looked after but also repeatedly added to with important acquisitions and donations. The new museum's first curator was the Brugean painter Louis Reckelbus (1864-1958), who was succeeded by the art historian Aquilin Janssens de Bisthoven (1915) in 1958. The latter organized more than fifty large exhibitions during his term of office and published a standard book about the Flemish Primitives in this museum in 1951. In 1980 he was succeeded by the present curator, the art historian Valentin Vermeersch (1937), who also published important scientific works such as the monumental 'Brugge duizend jaar kunst' (Bruges. A Thousand Years

of Art) in 1981. Also a curator is Dirk De Vos (1943) who published a new illustrated guide of this most important museum of Bruges in 1979.

The Groeninge Museum is visited by about 150,000 people a year, for it shows a number of world famous paintings which have become expressions of universal art: the works by the 15th century Flemish Primitives. This name first occurs in the 19th century literature, expressing a kind of nostalgia for medieval purity. These paintings are exhibited in the rooms 1 to 5. Their inspiration is mostly religious, they try to represent reality as true-to-life as possible and take special care for details. Their symmetrically constructed pictures pay attention to the geographic relief, the background, the incidence of light and the shadow play. Blue, green and red are the predominant colours occurring in almost all the paintings in numerous intermediate colours and a sometimes very delicate transparancy. Let us pay attention to a few high points.

The first character we meet here is Jan van Eyck (about 1390-1441), probably from Maaseik. In 1425 he became the court painter and chamberlain of Philip the Good (1396-1467), one of the great princes of the West, who also entrusted him with a number of diplomatic missions. Duke Philip was indeed surrounded with valuable advisers such as Nicolas Rolin (1422-62), Louis of Gruuthuse (1422-92) and the Lords of Croy. He supported painters and musicians and his Burgundian Library contained more than eight hundred codices. The reputation of this prince, who may be considered as the founder of the Netherlands, and the splendour of the Burgundian court were both well established at the time when Jan van Eyck settled in Bruges in 1430. He did not become a member of the painter's corporation, but mastered a typical oil technique by which his paintings gained and preserved a luminous transparency.

His major work in this museum is the *Madonna with Canon Joris van der Paele* (1436), a large panel (122 × 158 cm on oak), indeed the largest known work by Van Eyck after the Sacrifice of the Mystic Lamb (1432) in Ghent. The canon, who ordered the work for Saint Donatian's Church, is an old and sick (?) man on the painting. He is wearing a white habit and is flanked by his patron Saint George who is taking off his helmet and introduces the priest to the Infant Jesus. The child is a chubby little fellow with an almost adult expression on his face, holding a parakeet in one hand and reaching for the flower Mary is holding with the other. The mother is wrapped in a deep red coat spreading in many fanciful folds. The fifth character standing on the left is Saint Donatian in a blue and gold brocade coat. All adult characters have been represented very large in a low, round church. In this way a compact painting has been created which is optically realistic, with the incidence of the light on the left and thus full stress on the voluminous white figure of the canon. Looking at this painting one should pay attention to the dialogue between the blue, red and white colours and especially

to the realistic reproduction of the materials (armour, tiles and carpet). The poet and critic Karel Van de Woestijne wrote in his essay 'De Vlaamsche Primitieven' (1902): 'The painting illustrates a new and great quality of his: the use of correct uniform colours all over the painting. Or rather: though specific and strictly natural, the colours always harmonize and can moreover be reduced to one fundamental colour glowing through all the colours of the same panel, here: gold (…) In this painting Van Eyck again clearly proves his insight in the ordonnance of a painting and his feeling for the rhythm controlling this composition according to inner laws'.

The second important work by Van Eyck in Bruges is the *Portrait of Margaretha van Eyck* (1439), the painter's wife, at the age of thirty-three. This is mentioned at the bottom of the frame, followed by Van Eyck's motto 'als ic can' (as best I can). It is a much smaller (32.6 × 25.8 cm) but very successful and intimate portrait, in which the transparency of the colours is even more apparent, though the whole portrait is covered with a veiling shadow. This panel has spread the artist's reputation in exhibitions all over the world.

Bruges has two statues of Van Eyck, a smaller marble one (1820) by Jan Robert Calloigne under the trees on the Burg square and a large metal one (3.20 m) by Hendrik Pickery on the Jan van Eyck square, unveiled by King Leopold II in 1878.

In 1974 the Bruges museum was able to acquire one of the four known versions (the others can be seen in Boston, Munich and Leningrad) of *Saint Luke painting the Portrait of Our Lady*, a full-scale copy from the end of the 15th century, by *Rogier Van der Weyden* (1399-1464), the Brussels city painter who was born in Tournai. The evangelist Luke (his book and symbol, the ox, can be seen in the vista) wrote most extensively about Mary. Therefore medieval iconography likes to represent him as her familiar portrait-painter. Here he is drawing with a silver stylus on the paper on a little board in his other hand. In this painting as well, the reproduction of the materials, even of the details, catches the eye: the texture of the black and red gowns falling down in broad folds, the grass and flowers of the little garden, the far and sharp view of a watercourse and a little town.

Petrus Christus (about 1415-1472 or 73) from East Flanders, a contemporary of van der Weyden, whose style somewhat reminds of van Eyck, is represented in the museum with the left wing of a little triptych, portraying *Isabella of Portugal*, the third wife of Philip the Good, who retired in the forest of Nieppe in La-Motte-au-Bois near Hazebroek in French-Flanders in 1457. She is represented here with her patron saint Elisabeth of Hungary who is carrying the three crowns of devotion, purity and regality. In 1983 a signed work by the same painter was

acquired, *The Annunciation* and *The Nativity*, two panels of a 1452 polyptych.

Hugo van der Goes (about 1430–about 1452) is an equally important painter from Ghent. The museum possesses one painting, one of the greatest 15th century creations, the *Death of Our Lady* from about 1470. It is a gripping scene, because of the frozen expression on the faces of the disillusioned apostles (mark the place and function of their hands), because of the distribution and contrast of the colours all over the surface (red, green and blue alternating) and of the soft bluish atmosphere of death hanging over the picture. This creation which speaks of a great empathy and personality, is a capital work in the oeuvre of the master of the Portinari triptych in Florence.

Six important works by the German *Hans Memling* (about 1435-1494) can be seen in the Memling Museum (see Saint John's Hospital) in Bruges. He can be called a Brugean, because he lived here for thirty years (perhaps in the Sint-Jorisstraat, where a memorial plaque was put up in 1939) with his wife Tanne (Anna) de Valckenaere, who outlived him for seven years, and their children Hannekin, Neelkin and Clayskin. Memling was buried in Saint Giles' church on 11th August 1494. His white marble statue (1871) by Hendrik Pickery stands on the Woensdagmarkt.

The Groeninge Museum possesses two important works by this painter, the second master of 15th century Flemish painting after van Eyck. The *Moreel Triptych* (1484) is called after the Brugean politician Willem Moreel († 1501) and his wife Barbara van Vlaenderbergh who gave the altarpiece to Saint James' Church for the altar of Saint Maurus and Giles. The picture of the two saints occurs on the middle panel, to each side of Saint Christopher who crossed the river with the Christ-child on his shoulders. On the side wings the donors have been pictured with their children and patron saints William and Barbara. All characters appear dignified and impassive against a rocky landscape which continues over the three panels. The details (trees and vegetation, attributes and clothes, clouds in a deep blue background) have been painted with exceptional delicacy, while the expression of the characters appears quiet, frozen and idealized. The two grisaille side panels of a triptych with *The Annunciation* (about 1470) are younger works by Memling: the angel and Mary are standing in stone niches. During World War II these wings were bought by Hermann Goering, in 1947 they were discovered in Germany and acquired by the Belgian State which has given them on loan to the Bruges museum in 1952. Room 3 also contains two anonymous portraits: Philip the Good painted after Rogier van der Weyden and Louis of Gruuthuse by the Master of the Princes Portraits, two people who were very important for Brugean politics and culture.

Gerard David (about 1460-1523) in room 4 is sometimes called the last of the Flemish Primitives. He came from Oudewater, Holland, to Bruges, where he was registered as a freeman in 1484, married Cornelia Cnoop, the daughter of a goldsmith, and settled for the rest of his life. In his paintings he combined the cool registration of the Haarlem tradition with the prevailing style in Bruges, mainly influenced by Memling. Two very important works of his can be seen here. After the death of its donor Jan des Trompes, *The Baptism of Christ* was given to the Brotherhood of the Tribunal for its chapel in Saint Basil's Church in 1520. It is a large triptych the middle part of which represents Jesus who is being baptized by John the Baptist in the river Jordan. A richly dressed angel to the left keeps Jesus' clothes and is watching the scene in a luxurious landscape which continues on the side wings. The details in the clothes and especially in the vegetation have been worked out remarkably well. The church appearing in the city in the background could be the Brugean Jeruzalem church. On the wings the donors have been portrayed: Jan des Trompes, who was a bailiff in Ostend and held different functions in Bruges, with his son Filips and on the other wing Isabella van der Meersch with four daughters. Both donors are accompanied by their patron saints John and Elisabeth of Hungary. On the back of the wings Trompes' second wife Magdalena Cordier is kneeling for the Virgin with Child.

One of the most gruesome pictures in this museum is no doubt *The Judgement of Cambyses* (14998) a scene of justice intended for the City Hall, probably as a symbol of justice and impartiality for judges and city councellors. The two panels represent the Persian story of judge Sisamnes who, seduced by bribery and corruption, passed an unfair judgement. His king Cambyses decides that he should be skinned alive. On the first panel we see the judge who is arrested (on the background probably the Poorters' Lodge), while Cambyses is enumerating his crimes on his hand. On the other panel the skinning has started; in the background his son Otanes who will succeed Sisamnes has already been vested with the father's skin. This dramatic scene was registered by David in a realistic and impersonal way. On the same level on both panels appears a row of marvellously painted heads of spectators, whose reactions speak volumes. The details of this work of art are of an unmatched wealth: the dogs, the red coat on the cobbled floor, the feet and the shoes, the knives and gestures of the executioners each deserve a separate study.

Also worth mentioning in the first five rooms of the museum are the *Last Judgement* by Hieronymus Bosch (about 1450-1516) in room 5 and a number of very successful works by anonymous masters, who have been given temporary names such as the Master of the Ursula Legend with the eight panels of his *Ursula Legend* and *The Church and the Synagogue* in room 3 and two panels with scenes from the life of Saint George in room 5.

Room 6 contains a number of anonymous works, but also important paintings of *Adriaan Isenbrant* (about 1490-1551) and *Ambrosius Benson* (about 1499-1550), two disciples of Gerard David's who already show some Italian influence. In fact, Benson came from Lombardy and can already be considered as a Renaissance artist, which clearly appears from his *Saint Magdalen*. The art of *Jan Provoost* (1465-1529) who came from Mons but became a Brugean burgher in 1494, was more original. About Easter 1520 Jan Provoost received and guided Albrecht Dürer in Bruges. The German master writes in the diary of his travels in the Netherlands: 'When I arrived in Bruges, Jan Provoost received me as a guest in his house and organized an exquisite supper the same night to which he invited many people in my honour. Next I saw that alabaster Virgin made by Michelangelo of Rome (…). I made a drawing of master Jan Provoost of Bruges, for which he gave me 1 fl(orin) with charcoal (…) Next they brought me to many churches and showed me all the good paintings which abound there. On Tuesday early in the morning we left. First, however, I made a stylus portrait of Jan Provoost and gave 10 pennies to his wife'. The only painting attributed to Jan Provoost with certainty, can be seen here: *The Last Judgement* (1525), a realistic work somewhat reminding of Hieronymus Bosch, but painted in a very emotional and lively fashion. The two side wings of a triptych have also been preserved. On one side the still unidentified donors with their patron saints Nicolas and Godelieve and on the back *The Miser and Death*, a striking memento mori picture. The *Crucifixion* by Provoost is also worth mentioning. The exuberant frame of Provoost's Last Judgement was perhaps made by Lanceloot Blondeel (1498-1561) and similar profuse ornaments frame Blondeel's own painting *Saint Luke Painting the Portrait of Our Lady* (1545).

Room 7 mainly contains work by *Pieter Pourbus* (about 1523-1584). He originally came from Gouda, Holland, married Blondeel's daughter and became the most important Brugean painter in the second half of the 16th century. Paintings of his can be admired in several Brugean churches too. He reached a compromise between the Italian influence of the time and the local tradition of people such as Gerard David. This already appears in his very large *Last Judgement*, which is realized in a more fluent style than Provoost and vaguely inspired by Michelangelo. Yet, Pourbus is above all a portrait painter. A fine example is the double portrait of *Jan van Eyewerve and Jacquemyne Buuck* (1551) painted on their marriage. Two prominent and well-dressed people have been portrayed in the house overlooking the Crane square, where barrels of wine are being unloaded with a crane and immediately tasted by the hospital friars. In the same room we get to know the paintings of the Claeissins family: Pieter the Older (1499-1576), Pieter the Younger (about 1540-1623) and the latter's brother Antoon (about 1538-1613). The history painting *Allegory of Peace in the Netherlands in 1577* by

Pieter the Younger is an interesting work with a difficult symbolism, however, made after the Ghent Pacification (1576) which reconciled catholics and protestants in the Netherlands. The beautiful double portrait of the *Archdukes Albert and Isabelle* by Frans Pourbus (1569-1622) was acquired in 1979. The clothes and especially the lace collars have been painted with extreme care.

Baroque painting is impressively represented in room 8 with the work of the Brugean painter *Jacob van Oost* (1601-1671). He was the Pieter Pourbus of the 17th century and became the dean of the painters' guild in 1633 after having worked in Italy for some time. The Caravaggio-like play of light and shadow in many of his works is an Italian influence. Many of the master's paintings can be seen in several Brugean churches; the museum shows a number of religious scenes such as *Jesus with the Crown of Thorns* and *Saint Martin* and a strange *Fortune-teller*. His *Portrait of a Brugean Family* (1645), a lively picture of parents and children on a sunny terrace, is a real masterpiece. The rich clothes finished with lace have been painted very accurately and with a deep vision of details. The expressions on the character's faces are plain, a mixture of seriousness and light-heartedness, calmness and roguishness. The far view on a softly undulating landscape, finally, is very conspicuous. Next to a few portraits by Jacob van Oost the Younger, two other Bruges painters are introduced to us in this room: Hendrik van Minderhout (1632-1696) a painter of seascapes and harbour sights such as *The Commercial Inner Harbour of Bruges* (1663) and Lodewijk de Deyster (1656?-1711) with mainly biblical scenes, such as *Mozes Protecting Jethro's Daughters* (1690) which is strongly influenced by Italy where he stayed for a long time. Paintings by the Deyster have also been preserved in Brugean churches.

An attractive and friendly painter gets a chance in room 9: *Jan Garemijn* (1712-1799), a drawing-room painter sometimes called the Flemish Boucher. He did indeed make paintings for many living- and drawing-rooms in halls and castles in Bruges and in the neighbourhood and in several Brugean churches religious work of his can be seen. He designed sculpture too and was for ten years (1765-75) the director of the Academy of Fine Arts in Bruges. He must have been a very active artist. He painted harbours, 'rocky landscapes', markets, local folkloristic scenes, townscapes such as *Het Pandreitje* (1778), tea parties in the ladies' circle, celebrations of archers' associations and many 'jolly conversations' such as *The Afternoon-Tea* (1778), all of these in lively colours. *The Digging of the Ghent Canal* (1753), a painting of 218 × 350 cm, is the most important work by this painter in the museum. It is an overwhelming scene with hundreds of characters, every single one of which has, however, been painted from life and can be appreciated in detail. The largest painting in this room 9 is *The Meeting of Jacob and Esau* by Erasmus Quellin and Pieter-Paul Rubens.

The so-called Brugean classicists are situated in room 10. In the middle the marble *Madonna with Child* by Jan-Robert Calloigne from about 1820. Josef Suvée (1743-1807), Frans Kinsoen (1771-1839), Jozef Odevaere (1775-1830) and Albert Gregorius (1775-1853) preferred portraits and historical paintings. They worked in a sober and rather detached way, in a cool and unaffected style strongly influenced by David from Paris. Of Kinsoen, sometimes called the Brugean Ingres, we should mention *Belisarius at his Wife's Deathbed* (1836), of Odevaere *The Death of Lord Byron* (about 1826), inspired by his Paris master Louis David's The Death of Marat, and by Suvée a Laocoon-like representation of the Greek athlete *Milon of Croton*.

From room 11 onwards we follow the transition towards contemporary painting. From the academic period Eduard de Jans (1855-1919) and Edmond van Hove (1851-1913) should be remembered, the latter fully active in the Neo-Gothic atmosphere practised in many fields and disciplines in Bruges. His *Self-Portrait* (1879) was clearly inspired by the Primitives, just like *Evening of Life* (1905), a *Portrait of Galilei* (1885) and above all *Historia, Tempus, Legenda* (1897).

In Room 12 impressionism, the art of light and feeling, is very well illustrated with an early, fresh work by Emile Claus (1849-1924) *The Leie in Astene*, a successful scene fully illustrating Claus' inspiration and technical qualities. He was certainly the most important Flemish impressionist. Just compare him to two 'Brugean' dark and misty paintings by the Frenchman Henri Le Sidaner (1862-1939) who often visited Bruges and lived along the Spiegelrei for one year (1899-1900).

Symbolist characteristics may be discovered in the very large *L'Homme-Dieu*, a last judgement from 1901-03 by Jean Delville (1867-1953) and in the bizarre *Reflet-Secret* (1902) by Fernand Khnopff (1858-1921). It is the only work of the important painter and draughtsman from the symbolist period in this museum. As can clearly be gathered from this painting Khnopff spent part of his youth in Bruges. *Nuit à Venise* (1895) by William de Gouve de Nunques is also a very mysterious painting which probably paraphrases the Venice of the North idea.

Rooms 13 and 14 are full of figurative paintings from 1900-1945. We meet Jakob Smits' (1856-1928) *Christ and the Peasants* (1903?), Rik Wouters (1882-1916) and James Ensor's *Le Parc aux Oiselles* (1918?), all of them rather isolated but very personal artists and at the same time the cream of Flemish expressionism, in the artistic landscape called The Second School of Latem. The collection was greatly added to in 1986, when fifteen paintings and one sculpture (Rik Wouters) from the Tony Herbert Collection from Courtrai were acquired. By Constant Per-

meke (1886-1952), the most important expressionist, we see *The Angelus* (1934), *Farm in Flanders* (1933), *The Porridge Eater* (1922) and others. Especially the latter painting is an impressive and powerful creation by the master from Jabbeke, a village between Bruges and Ostend, where he lived and worked in a studio which has now become the Provincial Museum Constant Permeke. The oeuvre of Gust de Smet (1877-1943) is equally important and interesting, as appears from the fresh little portrait of *Henriette* (1927), from *The Meal* (1931) and from *The Great Shooting Gallery* (1923). The very sensitive solitary Gustave van de Woestijne (1881-1947), the brother of the poet Karel, is represented by a very large painting, *The Last Supper* (1927), Albert Servaes (1883-1966) by a *Farmer* (1922) and Frits Vanden Berghe (1883-1939) by the splendid *The Lovers in the Village*. Of the painter Edgard Tytgat (1879-1957) the *Portrait of the Herbert Family* and especially *Loa-Loa. The Basque Song* (1938) are worth mentioning. Though Tytgat lived in Bruges for some time during his childhood, no traces of this have been left in his work. He is classified with the Brabantine expressionists, just like Jean Brusselmans (1884-1953) a more constructivist expressionist, who is amply present here with a series of typical stout creations. Next there is a *Self-Portrait* (1930) by Hippolyte Daeye, two paintings by Paul Delvaux (1897) *Le Lever* (1930) and *Sérénité* (1970), illustrating the important evolution in his art. The best known Belgian surrealist artist René Magritte (1898-1967) is represented here by *L'Attentat* (about 1932), an excellent example of the artist's themes and style. Finally in this room the work of two Brugean expressionists can be seen: by Henri-Victor Wolvens (1896-1977) *The Commercial Inner Harbour of Bruges*, a dark impression from 1937 and *The Deserted Party Table* (1935) an almost impressionist work from the beginning of his career, and two sunnier paintings *The Pier in Zeebrugge* (1954) and a very large *Beach in Koksijde* (1952). By Rik Slabbinck (1914) there is an early *Self-Portrait* (1939) also in very dark colours and a radiant colourful *Landscape* from 1952.

The most recent art is alternately exhibited in the last room: geometrical art, new figuration and realism, abstract and informal art, utopia and concept, minimal art, matter and system and finally the confrontation of the different tendencies. Of the lyrical abstract artist we should mention Pierre Alechinsky (1927) and Bram Bogart (1921), of the geometrical the Brugeans Luc Peire (1916) and Gilbert Swimberghe (1927) and also Dan van Severen (1927) and Gilbert Decock (1928). New figuration is represented by Joseph Willaert (1936), Etienne Elias (1936) and by two large works of Roger Raveel (1927): *Man from the Back* (1952) and *Your World in my Garden* (1968). In 1986 a series of twenty Raveel drawings from the 1951-79 period were acquired, most of them raised and worked with gouache and acryl. Fitting in with these, the youngest tendencies of fine art are represented by a Marcel Broodthaers (1924-75) cabinet with all his printed

publications.

The Groeninge Museum also contains the so-called Steinmetz Collection of 3,000 drawings and about 14,000 prints donated to the city in 1864 by the British Brugean John Steinmetz (1795-1883). More prints have been added to the collection, which is of course not permanently exhibited. Exhibitions of parts of this collection of drawings and prints, usually around particular themes, have regularly been organised, often in the Brangwyn Museum, each time with catalogues. An extensive and well illustrated catalogue (1984) was made of work by Garemijn, Le Doulx, Vermote and others. The Steinmetz Collection and the Museum Library are situated in the Museum Offices, Mariastraat 36B, together with the Educational Service of the Municipal Museums and the Municipal Archeological Department.

Note

★ The Groeninge Museum is accessible from 1.4 to 30.9 from 9.30 a.m. to 18 p.m.; from 1.10 to 31.3 from 9.30 a.m. to 12 and from 14 to 17 p.m. Closed on Tuesdays. Entrance fee: 80 BF. Parties 50 BF. Schools 30 BF. Family ticket 160 BF. Museum shop. Cafeteria. Bibliography: W.H. James Weale, Catalogue du Musée de l'Académie de Bruges, 1861; E. Hosten & Eg.I. Strubbe, Stedelijk Museum van Schone Kunsten. Illustrated Catalogue, 1931, 2d edition 1938, 3d edition 1948; H. Pauwels, Groeningemuseum, Catalogue, 1960, supplement 1964; D. De Vos, Stedelijke Musea Brugge. Catalogue of the paintings from 15th & 16th cent. 1979; D. De Vos, Groeningemuseum. The complete collection, 1983; C. Van de Velde, Stedelijke Musea Brugge. Steinmetzcabinet. Catalogue of the drawings, 2 volumes, 1984; V. Vermeersch, De Vlaamse Primitieven (The Flemish Primitives), 1988.

Gruuthuse Museum

or Municipal Museum for Archeology and Applied Arts
Dijver 17
The name and origin of Gruuthuse should be traced back to medieval brewery techniques. To flavour their wheat or barley beer, our ancestors used to add a mixture of dried plants (gale, sage, milfoils and pine resin) called 'gruit'. From the early middle ages the ruler held the monopoly in the sales of 'gruit' and levied gruit-duties, a right which was repeatedly challenged. Nobody was allowed to brew beer without having bought 'gruit' in the staple house of the lord. From the 14th century onwards 'gruit' was gradually replaced with hop, but on the new and even on the imported beer taxes were also levied by the Lords of Gruuthuse

and since then the term 'gruiter' has been used for any collector of taxes.

About 1225 the fief of Gruuthuse was acquired by the Van Brugge family, linked by marriage to the Brabantine Vander Aa family. Jan IV van Brugge's son was Louis of Gruuthuse (1422-92), the most famous scion of the Van Brugge-Van der Aa family. He had the major part of the Gruuthuse Palace built in the second half of the 15th century. He was a chamberlain and advisor of the Burgundian Dukes Philip the Good and Charles the Bold and also the governor of Holland, Friesland, Zeeland and the Count of Winchester. In 1461 he became a knight in the Order of the Golden Fleece. An anonymous portrait of Louis is preserved in the Groeninge Museum with the motto of his family 'Plus est en vous', which can also be seen in several places in the Gruuthuse Museum. Louis was a humanist greatly interested in art and literature, who possessed a library of hundreds of illuminated manuscripts, now mainly kept in the Paris Bibliothèque Nationale. One remarkable manuscript, the so-called Gruuthuse manuscript with 147 party songs, 16 love songs and 7 prayers almost all of them completed with the melodies, is still the private property of the van Caloen family on the Ten Berge castle in Koolkerke near Bruges. Some of the most beautiful middle Dutch lyrical poems have come down to us in this manuscript: the 'Kerelslied', 'Alouette', 'O cranc onseker broos enghien' and the very famous 'Egidiuslied', a courtly love complaint in rondeau form of Mergriete, the beloved of the poet's friend Egidius. This poem was quite probably written by the Brugean poet Jan Moritoen (about 1355) who, between 1408 and 1417, the year of his death, held several important functions such as almsmaster and member of the Bruges city council. With this Egidius and with Jan van Hulst (the dean?) he probably founded the Chamber of Rhetoric of the Holy Ghost, the oldest literary club of Bruges. Its members (about twelve) made and discussed songs, music and poetry; the Gruuthuse manuscript may have been their anthology or codex. It certainly contains the most beautiful 14th century Dutch poems and is one of the oldest pieces of evidence of literary art in this city. The name Moritoen survives in the association for adult education (Eekhoutstraat 66), organising literary studies in Courtrai and Bruges and other courses.

The Gruuthuse Museum is housed in the former mansion of these lords. At the end of the 16th century Louis' great-granddaughter Catharina van Gruuthuse and her husband Louis de Lorgenon, sold the house to the Spanish king Philip II. From 1628 to 1874 the house was used as a Mons Caritatis, a charitable institution where objects could be pawned at little or no interest. Afterwards the building fell into disrepair. Yet, in 1865 a 'Société Archéologique' was founded in Bruges by baron 't Serclaes de Wommersom, provincial inspector of primary schools, canon Felix de Bethune, professor at the Major Seminary, Felix d'Hoop, keeper of the State Archives, the British art critic James Weale who was to become the curator of the collections, Louis Gilliodts-van Severen, the treasurer of the

Société, Karel Verschelde, architect and secretary, the poet Guido Gezelle, vice-rector of the English Seminary, Henri Dobbelaere, glass painter, Charles de Poorter, curate of Saint Walburga's Church, the British architect William Curtis Brangwyn, Hugo Verriest, teacher at Saint Louis' College and Emile van den Bussche, assistant-keeper of the city archives.

The first 150 objects of the museum collections were brought together by this Archeological Society first from donations by the members themselves and later from acquisitions. They were later put up on the first floor of the Belfry. Having collected as much as two thousand objects by 1875, the Society asked the City Council to buy the Gruuthuse mansion for the Archeological Museum. The house was duly bought and restored by the architect Louis Dela Censerie, the interiors inspired by the French architect Eugène Viollet-le-Duc. The works lasted till 1898. In 1902, as a part of the famous exhibition of Flemish Primitives, manuscripts and textile were exhibited in the new rooms. In 1905, the 75th anniversary of Belgium's independence, an exhibition of Old Art from the Society's possessions was held in ten rooms of the Palace. These works of art have never been removed and constitute the basis of the present museum. On 17th December 1975 the Bruges City Council decided to take over the Gruuthuse Museum, since when it belongs to the Municipal Museums.

The museum holds an impressive collection of about 2,500 objects representing all artistic disciplines, exhibited in nine rooms downstairs, eight on the first floor and six on the second. All rooms have been given a name and number, a survey of which will be given below. As the collection is so extensive, thematic visits of the museum might be rewarding. Specialized publications about silver, tapestries, musical instruments and pewter may be used as guides.

The main work of art in room 1, called Room of Honour, is the polychrome *Bust of Charles the Fifth* (1520) attributed to the German sculptor Konrad Meit. The bust is of moulded and baked terracotta, the hat is made of wood. The emperor's face exhibits the characteristic features of the Habsburgers: the projecting chin – the so-called Neanderthal jaw, the full lower lip, the thin face and sharp nose. It stands on a Renaissance cupboard in front of a 16th century Bruges verdure tapestry. In the six showcases under the windows silver and pottery from the Brugean guilds, corporations, religious fraternities and chambers of rhetoric. On the round breast plate (1681) of the linen weavers (middle right) we read 'Linwaet, serveet en tyck, dat maek Vlandre ryck' (Linen, napkin and tick make Flanders rich). Also on view is a shield (1657) donated by King Charles II to the Saint George's guild: a round gilt silver plate with the king's coat of arms surrounded by the text 'Honi soit qui mal y pense' held by a lion and a unicorn. At the bottom we read: Carolus II Dei Gratia Magnae Brit Fran Scot et Hib rex Confr. S. Georgii Brugensis sodalis anno 1657 (Charles II by God's grace king of

England, France, Scotland and Ireland member of the Brugean brotherhood of Saint George anno 1657). Probably made by the Brugean silversmith Antonius Kerckhove. Other objects catching the eye in this room are: the large baroque table of honour, a solid oak cupboard and the impressive iron and copper fire set in the neo-Gothic fireplace. On the ceiling we see the letters L and M of Lodewijk van Gruuthuse and his wife Margareta van Borsele and their famous motto 'Plus est en vous'.

Room 2 is in fact a passage between the room of honour and the kitchen. The objects in this medical study remind of illness and nursing: dispensing pots, a herbal, large mortars, an 18th century first-aid kit and representations of an enema – a painting by Jan Garemijn – of a surgical operation and an anatomical lesson (1679); they also remind of death (ward) and funeral (memorial plaques).

The kitchen, room 3, was already situated here in the original Gruuthuse palace. The monumental fire place and the wealth of utensils draw everybody's attention: forks, tongs, grids, plates, irons, skimmers, screens, pans and kettles. Over the fireplace the Gruuthuse motto has been carved in the oak. The collection of 18th century meat grids is very elegant.

Next to the kitchen, in room 4 or the Gothic room, objects from the 15th and the beginning of the 16th century are exhibited: Gothic trunks, a tall armchair, a bed recess, a large fireplace from the first quarter of the 15th century with biblical figuration and above all remarkable stained-glass windows: a swim-bladder shaped window filling representing floating angels (early 15th century) and a colourful stained-glass window from about 1500 with Saint George and Saint Michael.

In the Gothic room, room 5, and in the two antiques rooms, rooms 6 and 7, sculpture is put forward. High points of the collection are an oak *Kneeling Angel* (Flanders, early 16th century) an example of Gothic control, and a dramatic *Christ, Man of Sorrows* (about 1500).

In room 6 a *Reading Madonna* by the Utrecht master Adriaan van Wezel (about 1417 – about 1490) catches the eye, and in room 7, a *Meeting of Mary and Elizabeth* (about 1500), a *Saint Martin* from the beginning of the 16th century and a strikingly lively retable fragment with colourful characters representing a Christmas scene. In a showcase a series of alabaster and ivory sculptures can be admired.

Via the Room of Honour we come in the entrance again, room 23, with a neo-Gothic ceiling, a painting The Virgin of the Arts by Edmond van Hove and a moving statue of Saint Micheal from 1553. The white marble bust of the British king Charles II (1659) by François Christophe Dieusart from Hainaut, who also

worked for Charles I and later at the Stuart's court, has been put in the middle of a black and white memorial ordered by the Saint George's guild in 1659. The figure wears the characteristic high collar and Louis XIV wig. The same statue by the same sculptor is to be found in the Saint Sebastian's archers guild.

The last room downstairs, room 22, is the armoury. Next to a portrait of Henry Stuart, duke of Gloucester, the room mainly contains weapons, instruments of torture, objects of justice and objects reminding of the four Brugean arms societies, Saint Sebastian's guild (longbow), Saint George's guild (arbalest), Saint Barbara's guild (arquebus) and Saint Michael's guild (fencers). Next to branding irons, hand, waist and leg irons, swords, rifles and pistols, helmets and cannons, a guillotine has also been put up here. It was bought second-hand in Hazebroek in 1796 and really functioned in Bruges. The most beautiful work of art however is the 15th century sandstone Saint Sebastian.

Finally, two paintings by Jan van Meunickhove (about 1620-1704) should be mentioned, representing the visit of the British king Charles II and his brothers Henry Stuart, the Duke of Gloucester and James Stuart, the Duke of York, to the Saint Barbara's arquebus guild in Bruges (Vlamingdam). The 23-year old James managed to shoot the popinjay and was proclaimed sire of the guild. The first painting shows him kneeling in front of Charles II to receive the sire's chain and the second represents the festive dinner.

On the first floor eight rooms are used for the exhibition of art objects. The stairs in room 22 lead to room 16, the tapestry room. The museum possesses a number of Brugean tapestries representing the *Seven Liberal Arts* in a large baroque frame, designed by the Antwerp painter and engraver Cornelis Schut (1597-1655). The largest of the tapestries, *The Apotheosis of the Liberal Arts* (518 x 336 cm) woven by Carlos Janssens about 1650-60, represents all these arts under the text 'Artes deprimit bellum a quibus sustinetur' (war suppresses the arts by which it is supported): from left to right the symbols of astrology, music, grammar, geometry, rhetoric, logic and arithmetic with the necessary attributes, the latter repeated in the lower frame by two putti. One of the seven, *Astrologia* (380 x 315 cm) from 1673, is represented in a separate tapestry. All these tapestries have varied and warm colours and resemble real paintings of wool and silk (6 to 8 chains per cm). They have very well been preserved. The rooms also contain three beautiful cupboards and two madonna sculptures.

Room 17, in fact a recess of room 16, is the oratory or prayer balcony, which is – together with the kitchen – one of the building's oldest parts. Louis of Gruuthuse had this barrel-vaulted prayer room connecting his palace with Our Lady's Church built in 1472. It enabled him, his family and his guests to attend the

services. The room has been decorated with religious objects (reliefs, a reading desk and a prayer stool) and a 16th century representation of Christ and Mary.

Room 15 gives a survey of European and Asian ceramics, pottery, china and faience displayed according to their origins. There is the German 'steingut' (Raeren, Frechen, Siegberg, Cologne, Westerwald), work from Brussels, Luxemburg and other regions and a beautiful collecton of so-called Torhout pottery from the 18th and 19th century, among which an elegant yellow brown little fire basket with lead overglaze. In other showcases oriental china can be seen. There is also a remarkable series of dispensary pots in blue and white Delft and a Delft tile picture with a flower-vase. Silver ware is exhibited in a separate case and the wall is almost completely taken up by the tapestry *The Wedding Procession of Gombault and Macée* (see p. 74).

Room 12, the baroque room, holds works of arts from the 17th and the first half of the 18th century. The most beautiful piece of furniture is the oak four-door cupboard with Flemish carving from the second half of the 17th century. Its doors refer to Spring, Summer, Autumn and Winter, while the six caryatids represent religious themes. The bed in the corner has been decorated with fine balusters. Over the table with spherical legs in the middle a Louis XVI chandelier, made by the Bruges brass-founder Jan Sanghez in 1754. On the wall a Brugean tapestry (about 1630) *The Sacrifice of Iphigeneia to Diana*. In the two drawing-rooms next to this baroque room, the rooms 13 and 14, objects in Louis XV style and art from the 18th and 19th century are exhibited.

America is the title of a broad little tapestry made in Brussels about 1700, representing a commercial scene in a port. Other objects in this room are the coffeepot, fire basket, water distillers and two little cabinet cupboards inlaid with ivory and tortoise-shell. Paintings by Brugean masters have also been put up here: 'Landscape with Roman Monuments' by P.J. de Cock, genre paintings by J.K. Verbrugghe, a self-portrait by Jan Garemijn. In the second drawing-room classicist paintings by J.A. van der Donckt and A. Suweyns can be seen, and a very successful walnut Dutch bombé chest on spherical legs from the end of the 17th century.

Room 8 is the Renaissance room with works of art from the 16th and first half of the 17th century, which was in fact the baroque period in the Netherlands, illustrated here with a couple of tapestries. One of these, containing typical reminiscences of the ancient classics, is the large Brugean wool and silk work from 1560-70 *The General's Address*. The main character, in full armour, is looking down on soldiers, women and relatives. Also from an unknown Brugean workshop is *The Fighting Scene* (233 x 216 cm) from the second half of the 16th

century, which probably represents an event of Roman history in a very dynamic figuration.

The Country Meal, also called *The Soup-Eating Woman* is a particularly attractive tapestry (310 x 250 cm, 4 to 5 chains per cm) from the beginning of the 17th century. The pastoral wool and silk work represents a man cutting bread, a shepherdess eating soup or porridge from a bowl in her lap and a few more shepherdesses. It is a beautiful, naive and colourful comic strip on a menues verdure background with mischievous and even naughty verse lines inserted. Translated from top to bottom they mean the following:

> To enjoy oneself to the full
> treasure nor riches are greater
> than to behold how teenagers
> shepherds and shepherdesses
> exchange funny words in jest.

> Take a bite Isabel
> a young girl should not keep from
> feasting before she has supper.

> You're a dear rogue
> to dunk your brown bread in my milk
> thus turning it into soup for me.

This tapestry belongs to the Brugean Gombaut and Macée series. These two shepherd figures must have been very popular at the end of the 16th century, as appears from the engravings by Jean Le Clerc (about 1585) and others. The characters probably have to be traced back to the poetry of the French court poet Henri Baude, born in Moulins about 1440 and to the work of René Belleau (1565). Bruges still possesses three of the tapestries of this series. The second (in room 9) is *Gombaut and Macée's Dance* from the beginning of the 17th century, a wool and silk tapestry with 4 chains per cm, measuring 310 x 450 cm. It represents a varied group of male and female dancers surrounded by several objects and animals, who have gathered around the piper under the apple tree in the middle. The story is told in seven stanzas, translated from left to right:

> Come on, shepherdesses, high the bodies
> be happy and jump about
> be merry as pleasure is guiding us.

> Well Robin and you Gombault

do move, you're not hot
or are you out of breath already?

Be off Alison and Helaine
I let you sweat in the wool
for I have you as I please.

Don't you think of the burden
and spare sinew nor muscle
for pulling is my full desire.

Is any diversion more pleasant
than on a lonely spot
Venus and Mars at the age of twenty
it is worth more than a thousand mark
no treasure is more precious.

While we enjoy ourselves
and are moved by joy
lift your leg, Margot, lift your leg.

Come, Gombault, let me help you
do not go away too quickly
wait, I bind my stocking.

The largest tapestry of the series (365 x 545cm, wool and silk, 4 to 5 chains per cm) is *The Wedding Procession of Gombaut and Macée* (in room 15) where we see the wedding dinner being prepared and the table being laid while the bride and groom approach, accompanied by musicians. Six old-French tercets explain the situation. They mean from left to right:

The devil let you come nearer
dog, to spill the bowl
and to spoil our soup.

Margot, you should hurry
everything should be ready, bread, wine and meat
the bride is already coming out of the grove.

Gombault, you are a good couple
you and Macée, she is a strapping woman
and you will get enough children.

Yes, thank God, with good courage
Did I guide her virginhood

let us embrace.

Macée, think seriously,
Your most beautiful days are still to come
for you have a handsome young husband.

Your fat breasts are well wrapped up
if you get pregnant tonight
people in Rome won't talk about it.

Gombault's Old Age (in room 8) is a smaller square tapestry (350 x 345 cm, wool
and silk, 5 to 6 chains per cm) also from the end of the 17th century. Chronologi-
cally it tells the end of the shepherds's story and here too a number of texts and a
moral have been included:

Macée, you have had your part
to prepare everything I cut myself
so that I cry alas!

Alas, he was so vigorous
but marriage so extinguished him
that he got caught in the net.

Do not leave him alone
support him above the pit
or else he will perish.

He was gone his way
and has fallen very deep now
he will never laugh again.

And the moral of the whole story can be read top right:

There, by acting like this
all pleasure will take an end
man gets old so fast
but if he dies happily
he will live after his death.

Gombault, who is old now, is sitting on his knees in front of the pitfall which is
covered with a net. Top left the wolf is fleeing. The pit and the net are symbols of
marriage. Though quite recently acquired (from 1965 onwards) this series of four
tapestries has greatly added to the museum's wealth.

The last room to be visited on the first floor is the coin cabinet, room 9. In about

ten cases one of the country's most important numismatic and sphragistic collections is shown, the centre of which is the donation of the numismatist and publicist Albert Visart de Bocarmé (1868-1947). Coins used to have the value of a means of payment guaranteed by the authorities. Medals, on the other hand, are no currency, but have been made to honour prominent figures or to commemorate important events. This room contains both coins and medals in gold, silver and bronze from all periods of art history and often made by outstanding and famous artists. There is a technical difference between the striking of coins, the imprinting of a die on a metal disc and finally the casting of coins. The latter technique was mainly used for medals, which are often cast in bronze. The chronological survey starts in Roman, Merovingian and Carolingian times. Later coins contain names, such as the florin, the first Brugean golden coin at the time of Louis of Nevers, and other fine specimens such as the denarius of Charles the Bold, the sterling of Gwijde of Dampierre, the golden noble of Philip the Good, the golden florin of Mary of Burgundy, the golden real of Charles the Fifth, the ducat of Philip IV, the cross thaler of Philip V, all kinds of crowns, shillings and pennies, the States thaler of the States of Flanders and the rare golden lion (1583) of Bruges. The survey ends with the apperance of the franc and of the decimal currency.

Medals and plaques also have their stories. The creator or engraver of most of them is known. The 1517 medal against the indulgence business, showing Luther in front of the Wittenburg church, is noteworthy. Also exhibited in this room are a series of coin balances and tools of the medal engraver (die and burin).

On the second floor five rooms and a loggia can be visited. Room 10, the instruments cabinet, exhibits weights and measures, measuring, weighing and orientation appliances and a series of instruments of the surveyer, the carpenter, the alchemist and the doctor. Compasses and gauging rods are on view and a series of beautiful clocks (among which a Frisian little wall clock), sundials and pocket watches.

In the musical cabinet, room 14, a painting by the Brugean painter Jan Garemijn, *Street Musicians* (1756), shows people playing the hurdy-gurdy. Part of the instruments in this room can still be played, but others have passed out of use. The most beautiful, oldest and most valuable piece is no doubt the *spinet* (in room 8) by the Antwerp builder Hans I Ruckers, the only polygonal instrument ever designed and realized in the famous workshop. It holds the motto 'Scientia non habet inimicum nisi ignorantem' (science has no enemy but ignorance) and is decorated with sea horse motifs on printed and varnished paper. On the 1624 Andreas Ruckers *harpsichord* we read 'Musica laetiteae comes medicina dolorum' (music a companion of happiness, a remedy against grief). There is quite a

collection of wind instruments (recorders, flutes, oboes, clarinets and bourdons) and of stringed and plucked instruments (guitars, mandolins). The calliope or mechanical music buffet from about 1890 can still play its little tune.

Next to the grand tapestries, the museum also possesses an important collection of small and miniature textile, on view in the last three rooms of this tour. The rooms 18 and 19 hold a large and precious lace collection, built around the 1890 donation by the Brussels baron and barones Amédée Liedts-Godin (the latter's marble bust by sculptor Pickery can be seen in room 19). Bruges and lace are commonly associated and plenty of lace is produced and exhibited here. Lace-making is taught in a couple of schools and in the Lace Centre, Peperstraat 3A (see next chapter). Both authentic lace and mechanical imitation lace are sold in many souvenir shops. Two types of lace are usually distinguished: Flemish bobbin lace which is made with bobbins on a lace pillow and the probably Italian needle lace, a work of art made with needle and linen thread on a paper pattern. Exceptionally successful specimens can be admired here: the so-called *Medici Collar* (1st half 17th century) in old Flemish bobbin lace, also called Van Dyck lace, a benediction veil in Brussels bobbin lace (early 18th century), representing the three saints Ursula, Catherine and Barbara with their attributes, a *shawl* in black Chantilly lace (end 19th century) and in room 19, a fine *fan* in Brugean flower work (19th century) and paper, holding a picture of the Wijngaard square and the Beguinage bridge. Next to these showpieces many other examples, also smaller and fragmentary ones, of several types of old Flemish, Valenciennes, Binche, Chantilly, Mechlin, Lier, Brussels and Brabantine lace are exhibited (passementerie, table-cloth, communion cloth, bonnet lappets).

Some textile works are much older than this lace: a Coptic fabric (6th-7th century), 15th century lampas from Florence and Spain, 18th century damask cloths, an embroidered 16th century antependium with 28 characters and a series of network creations such as *Our Lady with Child* (1610), a *Crucifixion* (17th century, Germany) and an impressive *benediction fabric* with the instruments of the passion (1599). In room 19 a painting by Matthias de Visch, *Portrait of a Girl,* shows a girl whose dress has a lace sleeve. In room 20, finally, mainly textile appliances are shown, such as blocks to print fabrics, spinning and winding instruments, lace pillows, bobbins, linen-presses and irons.

To conclude our tour of the Gruuthuse Museum we can go onto the loggia or balcony (room 21), via room 18, from where we have a view of the Reie, the Boniface bridge, the Arents Park and the choir of Our Lady's church.

The collection of about ten coaches and sledges exhibited behind glass in the Arents Park, also belongs to this museum. The inner court in front of the

museum's central entrance, from where we get a good view of the slimline tower of Our Lady's church, is really impressive. The outbuilding across the court is no longer used; a number of old tombstones have been put up against its walls. The four *garden sculptures* on the inner court were made by the Brugean sculptor Pieter Pepers (1730-1785) as decorative elements for the monument of Ferdinand Verbiest (1623-1688), the Flemish astronomer and jesuit missionary in China, in the castle domain Rooigem in Sint-Kruis. They symbolize astronomy, music, painting and architecture.

Finally, we should not forget to admire the palace's monumental *eastern façade* (1420) from the Arents Park. Rising from the water of the Reie, it is one of the city's finest and best preserved façades, caught in one artfully subdivided pointed arch.

Note

* The Gruuthuse Museum is accessible from 1.4 to 30.9 from 9.30 a.m. to 12 and from 14 to 18 p.m.; from 1.10 to 31.3 from 9.30 a.m. to 12 and from 14 to 17 p.m. Closed on Tuesdays. Winter closing from 5.1 to 5.2. Museum shop. Entrance fee 80 BF. Parties 50 BF. Family ticket 160 BF. Bibliography: West-Vlaanderen periodical, special issue about Gruuthuse, January 1957; V.Vermeersch, Gids Gruuthusemuseum, 1974; V.Vermeersch, Zilver en Wandtapijten (Silver and Tapestries), 1980; Catologue of the exhibition on the 25th anniversary of Gruuthuse as a municipal museum. Contains the complete collection of silverware and tapestries owned by the city in 1980; K.Beernaert, Jeugdgids Gruuthuse (Youth Guide), 1983; S.Vandenberghe, Gruuthusemuseum. Een overzicht (A Survey), 1984; M.Awauters, I.De Keyser & S.Vandenberghe, Catalogus van de Muziekinstrumenten (Catalogue of the Musical Instruments), z.j.; S.Vandenberghe, De tincollectie van het Gruuthusemuseum te Brugge (Catalogue of the Tinware Collection), z,j,; G.Delmarcel & E. Duverger, Brugge en de Tapijtkunst (Bruges and Tapestry), 1987.

Museum of the Holy Blood

Burg 13
see Burg, p. 11

Kantcentrum (Lace Centre)

Peperstraat 3A
Bruges and lace-making have been linked for centuries. People like to situate the

legend of the girl Serena and the origin of lace-making in the centre of Bruges. The innumerable souvenir shops recommend it in all kinds of materials, dimensions and patterns. Museums, such as the Gruuthuse Museum, preserve the most beautiful examples and paintings show that lace used to be appreciated for the sumptuous decoration of clothes and interiors.

Ever since the 16th century, though not always successfully, the art of lace-making has been taught and passed down in private schools, orphanages and in the 'lace-schools' of the almshouse and of several religious communities. In 1717 three sisters of the Antwerp congregation of apostolic sisters founded a lace-school in the Ganzenstraat in Bruges, mainly to keep young girls away from the streets and to give them a religious education as well as to teach them how to make lace so that they would be able to earn something in that period of poverty. The school was moved to the Ezelstraat later (1788-1804) and in 1835 to the Adornes premises or the Jerusalem complex. The school had its periods of flowering and decline, till, in 1970, the sisters received a message from the Ministry of Education that their school could no longer be subsidized as a technical school and should gradually be reduced...

The Kulturele Kring Sint-Anna, founded in 1963, organised a large and well received exhibition about 'Lace in West-Flanders'. Resulting from this exhibition and to saveguard the future of this beautiful form of applied art, the Lace Centre was founded in June 1970. This society without purpose of gain took over the existing lace-school and settled in the former school buildings in the Balstraat. In 1987 the premises were considerably added to in the Adornes building. The history of this flourishing institution covers more than two centuries and a development from tannery to lace-school and from technical to art education. Girls and boys can take up this course at the age of six; after a preparatory cycle (4 years), a primary (3 years) and a higher cycle (4 years), they can qualify in the higher secondary art school with restricted curriculum. Next to this, lace-teachers are trained in a three-year monitors' course which is unique in Belgium and attracts students from all over the country and from abroad: the Netherlands, Germany and Denmark. The centre also provides initiation courses for adults, open-lace-hours for amateurs, a workshop for modern lace-making and a shop where lace-patterns, cushions, bobbins, linen and cotton yarn and all kinds of requisites and information are sold.

The Lace Museum, opened in six restored almshouses belonging to the Adornes premises in 1987, very important to introduce you to the complete history of lace-making with a series of very beautiful and precious historical pieces as well as contemporary examples. Since 1977 the centre has also published the quarterly 'Kant' which has a circulation of about 7,000 copies all over the world. No wonder that tens of thousands of visitors and art lovers come to the Lace Centre each year.

Note

★ The Lace Centre in the Peperstraat is accessible from 10 a.m. to 12 and from 14 to 18 p.m., on Saturdays from 14 to 17 p.m. Closed on Sundays and Public Holidays. Entrance fee: 40 BF. Parties 25 BF. Combination ticket (Lace Centre, Folklore Museum, Gezelle Museum, Sint-Janshuis Mill and Potterie Museum) 120 BF. Museum shop. Bibliography: M. Bruggeman & W. Le Loup, Brugge en Kant. Een historisch overzicht (Bruges and Lace. A Historical Survey), 1985; M. Bruggeman, Brugse Kantgids (Lace Guide for Bruges), 1987.

Memling Museum

Mariastraat 38
(see Saint John's Hospital, p. 113)

Organ Museum

Zwijnstraat 3
(see 't Zand p. 46)

Potterie Museum

Potterierei 79
(see Potterie, p. 103)

Sint-Janshuismolen

Kruisvest
(see Mills, p. 140)

Sint-Jorisgilde (Saint George's Guild)

Stijn Streuvelsstraat 59
Archers' guilds tend to have rich histories and be flourishing institutions. Bruges too has some important examples. These guilds stem from the former municipal militia groups which were responsible for the order, protection and defence of the sovereign, the country and the city. They have been included in this artistic guide because they possess museum archives and several important works of art.

The 'Royal and Princely Chief Saint George's Guild Steel Bow Bruges' is one of the country's oldest cross bow guilds. Its history goes back to about 1300; the

oldest document dates from 1321. Its history mentions the names of famous battles in which these archers took part (Groeninge, Pevelenberg, Cassel, Beverhoutsveld, West-Roozebeke). The patent granted and sealed by Charles the Fifth on 22 nd July 1540 – to be seen in this museum – renews privileges of the guild and notes that its history covers two hundred years already.

In the Vlamingdam, opposite the Kapellestraat, the tower ruin in the neo-Gothic State Teachers College belonged to the guild's chapel. They also had their own garden and guild room for meetings, celebrations and shooting-practice. About 1400 there were too many members; the young archers formed a separate group which met in the Jonkhof in the neighbouring Sint-Jorisstraat. The two branches were reunited in 1768. The guild was disbanded in 1872, but the younger guild continued the tradition as a recreational club. Its premises – since 1940 a long-lease municipal domain in the Stijn Streuvelsstraat – include a beautiful green shooting range with a 36 meter shooting mast to practise in Summer and a guild house with a board's room, a bar and a shooting hall with four target alleys and a bowling alley for entertainment in Winter. Controlled by an executive committee and a chairman, the club has about 45 members now.

This little museum also holds a few valuable paintings. 'Saint George Killing the Dragon' is an undated work by the Bruges painter Jan Garemijn. Portraits of many of the guild's chairmen were made by painters such as Jozef Odevaere, Matthias de Visch, the 18th century Northern French C. N. Noël, Jan Baptist Herregoudts, Flori Van Acker, and Gaston Vallaeys. In 1783 beautiful medallion-shaped anonymous portraits were devoted to Albert Casimir, the royal prince of Poland and to Maria-Christina, the princess of Hungary and Bohemia on the occasion of their visit to the guild in 1781 when they signed the visitors' book. Their ancestors King John, Philip the Good, Charles the Bold, Maximilian of Austria, Philip the Fair and many others, says Jan van Praet, had also done this and that was the reason why 'a costly supper was served, where they drunk to the health of the Royal Highnesses while the guild's canons were fired and... the guild room was most beautifully decorated'.

An anonymous wooden statue is exhibited here and the Guild's visitors book with the signatures and most of the arms of all the kings of Belgium, the provincial governors and the mayors of Bruges. A number of jewels and requisites have also been preserved: a sire's chain, a golden dean's chain, a silver staff of honour of the Master of Ceremonies – 1952 smithery by Firmin Vandenbroucke –, decorated arrows, a tin guild's cup, 17th century and other standards and several medals.

★ The Saint George's Guild is accessible every day, except on Sundays, from 10 a.m. to 12 and from 14 to 18 p.m. Entrance fee 20 BF. Guided visits on demand. Bibliography: J. van Praet, Jaer-boeck der keizerlijke ende koninklijke Hoofdgilde van Sint-Joris te Brugge, 1786; A. Vanhoutryve, De Brugse kruisbooggilde van Sint-Joris. Historische schets XIIIde eeuw – 1782, 1968; A. Vanhoutryve, Koninklijke en Prinselijke Hoofdgilde Sint-Joris Stalen Boog Brugge, 1985.

Sint-Salvators Museum (Saint Saviour's Museum)

Steenstraat
(see Saint Saviour's Church, p. 118)

Sint-Sebastiaansgilde (Saint Sebastian's Guild)

Carmersstraat 174
This archer's guild also has a long history. According to the Brugean archives some of its members took part in the Battle of the Golden Spurs and even in the Crusades. The cross of Jerusalem does indeed occur in their coat of arms and can be seen in several places of the museum. Moreover, in the middle of the 15th century the guild settled on a plot at the end of the Rolweg, which belonged to Petrus Adornes. The oldest documents from 1416, 1425 and 1428 refer to both the guild's official recognition by the Bruges City Administration and to a papal bull bequeathing a little part of Saint Sebastian's skull as a relic. The account books and membership rolls have been preserved since 1514.

In 1573 the present Handbogenhof in the Carmersstraat was acquired; hence Marcus Gerards already included it in his map of Bruges. As early as 1578 a 60-meter high shooting tower was built and the typical slimline turret, which occurs on many of the museum's pictures and paintings and constitutes a nice element in the cityscape seen from the Kruisvest, dates back to the same century. The French Revolution was a difficult period for the guild. It was disbanded and its property was confiscated and sold. A few rich members were able to buy everything up again: Saint Sebastian's is the only guild of the country which recovered its property after the French period. The buildings were several times adapted, added to and restored, for example at the end of the 19th century according to designs by Louis Dela Censerie.

In 1656 the British King Charles II and his brother Henry Stuart, Duke of Gloucester, lived as exiles in Bruges. On 3rd August their names were entered on the membership rolls, an occasion which is commemorated in the anonymous portrait of Henry in a exuberantly decorated frame and an equally exuberant

sculpture of the sovereign exiled by Cromwell over the fireplace. The accompanying quatrain praises Bruges which gave rest and peace to the hero whose peace was dispelled by 'tduyvels crom-geweldt', devilish violence but also a pun on Cromwell. The special bond between the guild and the British Royal Family dates back to those years: all kings and queens have been honorary members, prince Charles since 1980.

The museum exhibits documents and privileges in showcases in a separate room, but also possesses works of art from the last three centuries. Among them, the portraits of about twenty deans. The oldest painting 'Alferius' (1641) was made by Antoon van Dyck. There are also paintings by Jacob van Oost, a 'Sebastian' (1768) by Jan Garemijn, the 'Rechte herstelling dezer Gilde' (1751) by Matthias de Visch and more recent work by, among others, Alex Hannotiau, José Storie and Robertine De Vooght (a group portrait of 'De Grote Eed' from 1947). Next, plenty of medals, chains and silver and cristal cups are exhibited, a silver arrow (1656) donated by the Duke of Gloucester, a Sire's Chain from 1553, plenty of china and a series of little canons and drums. The visitors' book, whose oldest signature is Charles II's, is also kept here.

The contemporary entertainment club has about one hundred members. They have the disposal of a large meadow with shooting tower, an open shooting-gallery between two rows of trees and an indoor target gallery with stained glass windows on both sides. The board and members are right in guarding their splendid and well-preserved patrimony.

Note

★ The museum of Saint-Sebastian's Guild is accessible on Mondays, Wednesdays, Fridays and Saturdays from 10 a.m. tot 12 and from 14 to 17 p.m. Entrance fee: 20 BF. Free for inhabitants of Bruges. Bibliography: H. Godar, Histoire de la Gilde des Archers de Saint-Sébastien de la Ville de Bruges, 1947; A. Vanhoutryve, Ghilde van Myn Heere Sint-Sebastiaen. Een kultureel-historische analyse, 1989.

Stadhuis (City Hall)

Burg 12
(see Burg, p. 11)

Stedelijk Museum voor Volkskunde (Municipal Folklore Museum)

Rolweg 40

A row of 17th century little almshouses of the cobblers' corporation, where old cobblers' servants used to live, now constitute the Municipal Folklore Museum. This so-called 'Schoenmakersrente' which was terribly ruined, was bought and restored by the City in 1967. Not only was this the start of a new museum in Bruges, but also for the revaluation of the whole picturesque neighbourhood of Jerusalem Church, Lace Centre, Gezelle Museum and Kruisvest. The real doing up and furnishing of these single-floor little houses as a museum followed in 1971-72. Folklore, the science studying the traditional spiritual and material culture of a society, started as late as the 19th century. From 1888 onwards the magazine 'Volkskunde' (Folklore) was published. In December 1936 the 'Bond der Westvlaamsche Folkloristen' (Society of West Flemish Folklorists) was founded in Bruges; the famous chemist-author Karel de Wolf was to be their chairman. A first exhibition of folklore and in fact the start of a real museum, was organised in the Concert Hall in the Sint-Jacobsstraat from 27th March to 11th April 1937. On 1st July 1939 the Museum for West Flemish Folklore was opened in the so-called Fencing-Room on the first floor of the Belfry; it was to know its periods of prosperity and decline until it was put up in the new buildings in the Balstraat and Rolweg. Curators in the Belfry were the painter Guillaume Michiels, succeeded by the folklore specialist Maurits van Coppenolle and next by folklorist Magda Cafmeyer. The actual Folklore Museum belongs to the Bruges Municipal Museums and is managed by Willy P. Dezutter.

A number of drawings and paintings in the entrance hall refer to the neighbourhood of Saint Anne's. 'Volkskundig boeket', a fantasy picture of the Folklore Museum by the Breton naive painter Jacques Le Flaguais (1921-1986) who lived in Bruges from 1976 onwards, is even available as a 1000 piece jig-saw puzzle (50 by 70 cm).

The museum presents 15 different aspects of former daily life. The visit starts in a Flemish interior (living-room and kitchen). There is a complete confectioner's workshop where demonstrations can be held. Special attention goes to the collection of 'patacons', colourfully decorated clay little tablets which used to decorate the 'vollaards' or New Year's cakes. A chemist's shop has been reconstructed and an old modiste's workshop. The cooper's job is also illustrated, for coopery was quite important in a city with dozens of breweries. There is a classroom from the 1900-20 period, a shoemaker's workshop and an old grocery shop. The pipes room contains a number of pipes from Achiel Van Acker's collection and in the upstairs room lighting devices, cards, miniature shoes, glasses and scissors are exhibited. Costumes and textile (samplers, pleaters, traditional costumes) are on view in room 6 and devotional items (fraternity shields,

pilgrimage flags, ex votos and paintings on glass) in room 11. Temporary exhibitions are organised on the first floor, there is the museum pub 'The Black Cat' with a cylinder piano and a beautiful inner garden with a bowling alley.

Note

★ The Municipal Folklore Museum is accessible from 1 .4 to 30.9 every day from 9.30 a.m. to 12 and from 14 to 18 p.m.; from 1.10 to 31.3 every day, except Tuesdays, from 9.30 a.m. to 12 and from 14 to 17 p.m. Museum shop. Cafeteria. Entrance fee: 50 BF. School and party tickets: 25 BF. Family ticket 125 BF. Combination ticket (Folklore Museum, Gezelle Museum, Lace Centre, Potterie Museum and Sint-Janshuis Mill) 120 BF. Bibliography: W. P. Dezutter, Het Stedelijk Museum voor Volkskunde te Brugge, Mededelingen I, 1973; W. P. Dezutter, Leidraad voor de bezoeker (A visitor's guide), 1983.

Jerusalemchurch, *interior*

Art in the churches of Bruges

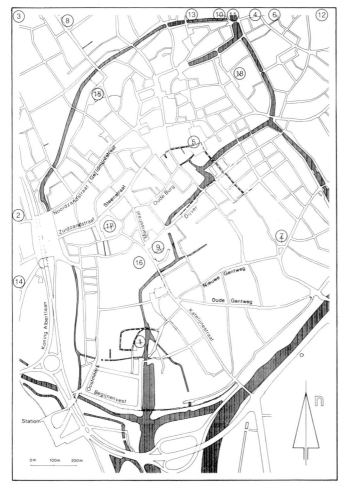

1 Begijnhof
2 Blindekens
3 Christus-Koning
4 Engels Klooster
5 Heilig-Bloed
6 Jeruzalem
7 Magdalena
8 Ongeschoeide Carmelieten
9 Onze-Lieve-Vrouw
10 Potterie
11 Bisschoppelijk Seminarie
12 Sint-Anna
13 Sint-Gillis
14 Sint-Godelieve
15 Sint-Jacob
16 Sint-Janshospitaal
17 Sint-Salvator
18 Sint-Walburga

Religion and churches have always been very important for the development of art. Take away the churches of Bruges and not only do we miss a number of remarkable monuments of architecture but also a considerable number of interesting works of art which have survived in these churches up to the present day.

Just like in the rest of this continent, the church was the first Maecenas and inspiration for mainly visual and applied art. Corporations and fraternities used to have their own chapels or altars, knights held their chapters and prominent citizens were buried in the churches. On each of these occasions paintings, sculpture and carving, organs, epitaphs, paraments and gold and silverware have been added to the church interiors.

Church buildings have always been important and even essential for the music which was performed and listened to as well. Numerous organ recitals and choir performances are still organised in churches and since 1963 the city's museums and churches are used every year for the concerts of the Flanders Festival, which has made Bruges into an international forum for Old Music.

Begijnhof (Beguinage)

There are two beguinages in The Netherlands (Amsterdam and Breda), there used to be one in Liège, but basically, the beguinage is a Flemish phenomenon. These cities still have a beguinage today: Aalst, Aarschot, Anderlecht, Antwerpen, Dendermonde, Diest, Diksmuide, Gent, Hasselt, Herentals, Hoogstraten, Kortrijk, Leuven, Lier, Mechelen, Oudenaarde, Sint-Truiden, Tienen, Tongeren, Turnhout and Zoutleeuw. In all of these cities the beguinage is a place of special interest, but the Bruges beguinage, being the most picturesque and one of the oldest examples, is an outstanding meeting-place for tourists. The origin of beguinages is misty and mysterious. Sometimes Saint Begga, Pepijn van Landen's daughter, is referred to and sometimes the Liège priest Lambertus li Beges. Anyway, from the 12th century onwards pious women started to live in communities; some of them (but not all) took the monastic vows, but alle beguines spent their days in prayer and charity, took care of the sick and old aged and made fabrics and lace. They lived in a community, in a beguinage with a market or street pattern, which was separated from the rest of the city and led by a grand lady or magistra.

The origin of the Bruges beguinage cannot be dated exactly either. The date 1245 in the stone over the entrance next to the Minnewater Lockhouse 'Prinselijk Begijnhof Ten Wijngaerde gesticht ten jare MCCXIV' (Princely Beguinage The Vineyard founded in 1214) refers to the recognition by Margaret of Constantino-

ple, the Duchess of Flanders, and by Walter of Marvis, the bishop of Tournai, of a community of 'beghinae clausae' which already existed at that moment. Indeed, because of its praiseworthy and exemplary way of life the community was recognized as a parish; in 1299 it was withdrawn from the jurisdiction of the Brugean magistrat and placed under the guardianship of Philip the Fair, since when it has been called 'princely'. The documents confirming the recognition already mention the toponym 'vinea' or vineyard which is still used.

The Bruges beguinage, which used to be larger than today, is a closed court, the houses built around a square. The entrance and exit are still closed at night. The visitor does not need the notice asking for silence and respect to become impressed. He starts talking in a subdued voice, he walks more slowly and stops now and again, for time has also stopped here. This court is a secluded and privileged place, a 'sauvegarde' as can be read over the entrance, a saveguard for heart and mind which has hardly changed in the course of the centuries. In the side façade of the former presbytery, Wijngaardplein 15, a plaque put up by the Scriptores Catholici in 1937 reads '1851 Pastor H. Hoornaert 1922'. Hector Hoornaert, one of the beguinage's priests, wrote the history of this beguinage in 1921: 'You cannot possibly pass the bridge (leading to the entrance) without halting for a while. Even the most indifferent passer-by must be affected by the harmony of lines and colours and the mysterious recollection of the spot. This little city has nothing in common with ordinary life: noise and commotion have been replaced with peace'. Since 1927 the beguinage is occupied by a convent of about 25 Benedictine nuns whose black and white costume more or less reminds us of the habit of the former beguines. The characteristic scene of their walks among the green of grass and trees against the background of the white façades has inspired poets and artists of all ages. The Prague poet Rainer Maria Rilke (1875-1926) visited Ghent, Veurne and Bruges during his 1906 trip through Flanders and devoted a poem to the Beguinage and the French poet and playwright Paul Claudel (1868-1955) often stayed here. In his diary he recalls how, sitting in the garden, an 'impression de paradis' descended over him. Was this the 'anima mundi', the feeling or more or less conscious soul in which all things participate, described by Marguerite Yourcenar in her novel 'L'Oeuvre au Noir'?

The simple and small three-aisled church dates back to 1605. An older church was destroyed by fire in 1584. As in many beguinages, Saint Elisabeth is venerated here, which appears from her picture over the entrance door, over the 17th century high altar, on the painting by the Bruges master Lodewijk de Deyster (1656-1711) and in a number of beautiful, somewhat naive 19th century stained-glass windows.

The church's most important work of art is a statue of *Our Lady of Spermalie* on the right side altar: a wooden polychrome and gilt sitting Madonna with the Infant Jesus standing on her knee from about 1240. Though not always expertly

restored, this Sedes Sapientiae statue still expresses a stern and solemn Romanesque austerity. It is the oldest statue of Our Lady in Bruges and belonged to the Brugean convent of Spermalie, Snaggaardstraat, whose sisters were dispersed all over the city during the troubles of the French period. The last sister of Spermalie died in the Beguinage in 1844 and left the statue behind.

Another exceptional though unpretentious virgin is Our Lady of Good Will, pictured in a tree trunk, which has been put up against the wainscoting on the left wall of the church. It is said to have been found in Duffel in 1637 and has been preserved in this church ever since.

The church contains an 18th century pulpit and a remarkable antependium at the high altar. The latter, a Lamentation of Christ, is an alabaster sculpture from the beginning of the 17th century. Though the artist is unknown, his work shows talented sensitivity and craftmanship.

In the beguinage itself a beautiful Renaissance sculpture of a sitting Virgin can be admired over the door of the Grand Lady's house. Under it the following text: 'Hier is 't Wijngaard van Maria. Mater Vineae Nostrae o.p.n.' (This is the vineyard of Mary...) and the quatrain

> 'O zoete Moeder Gods die duizend jaar voordezen
> Aan alle kristen mens uw jongste hebt bewezen
> Aanhoor in deze kerk het gemeente dat u groet
> En ons roemrustig hof van alle kwaad behoed'

> (O sweet Mother of God who a thousand years ago
> Conferred a favour upon all christians
> Give a hearing to the community greeting you in this church
> And keep our famous court from all harm).

Next to the beguinage entrance, on the side of the Wijngaardplein, a beguine's house is open to the public. The furniture and household goods in this reconstruction of a 17th century beguine's house give the visitor an idea of the way of life of the former beguines. As a little museum it is quite important because requisites for lacemaking and a number of really outstanding pieces of Flanders, Binche, Duchesse and rosaline lace are exhibited.

The original elmtrees in the court have been replaced with limes and Canadian poplars, a delicate rejuvenation operation which is still closely followed by the Municipal Plantation Service. For indeed, this inner court is attractive in all seasons. Especially early in Spring people come and admire the hundreds of daffodils in the grass, but in Autumn and covered with snow too, it is the favourite spot for painters and photographers. Ever since 1939 the Beguinage has been a listed building and it is city property now.

A secluded area in the city, the Beguinage is indeed a miniature picture of the

medieval dream Bruges has always cherished and wants to shepherd through this present day.

Note

★ The Beguinage and the church are accessible from 9.30 a.m. to 11.30 and from 14 to 17 p.m. High mass with sisters singing Sundays at 9.30 a.m. The Beguine's House from 1.4 to 30.9 from 9.30 a.m. (Sundays 10.30 a.m.) to 12 and from 14 to 18 p.m.; from 1.10 to 31.3 from 10 a.m. (Sundays 10.30 a.m.) to 12 and from 14 to 17 p.m. Closed on Friday mornings. Bibliography: H. Hoornaert, Ce que c'est qu'un Béguinage, 1921; R. Hoornaert, Le Béguinage de Bruges. Son Histoire, sa Règle, sa Vie, 1930.

Blindekens

The little known and inconspicuous chapel in the Kreupelenstraat, a side street of the Smedenstraat, is to be situated in Flemish history, namely the medieval conflict between Flanders and France on the one hand and the risings of the workers against the oppression and exploitation of the patriciate on the other hand. Flanders would eventually be added to France, Jacques de Saint-Pol or de Châtillon becoming the governor of Flanders. The conflict culminated in 1302 in the Brugse Metten (18th May) and in the Battle of the Golden Spurs in Courtrai (11th July). The French were defeated but bent on revenge: the Battle of the Pevelenberg on 18th August 1304, which was left undecided, was succeeded by the Treaty of Athis-sur-Orge 23rd June 1305 which was very humiliating for the Flemish population.

On the occasion of the Battle of the Pevelenberg, north of Douai in French Flanders, the so-called Pledge of Bruges was made. Either the warriors themselves, or their wives left behind in Bruges, it is still not clear, promised to offer a 36 pound candle to Our Lady of the Potterie each year to all eternity, if they would return to Bruges safe and sound. Each year on 15th August this pledge is still fulfilled in a procession from Blindekens to the Potterie – a remarkable example of an age-old tradition. In both churches an artistically important Virgin is venerated.

The original chapel of Blindekens would date back to the period of this Pledge, together with an adjoining hospice and hospital for the blind. Rebuilt in 1650-52 after it had been destroyed by the Beggars, it has not been changed since.

In the single nave chapel we see a 17th century pulpit with an elegant sculptured Virgin. Over the high altar a work by Jacob van Oost has been put up, 'Our Lady Refuge of the Poor' (about 1650). The most beautiful work of art, however, is the *Statue of Our Lady of Blindekens,* an oak polychrome miracle sculpture from

the beginning of the 14th century representing the Infant Jesus standing next to the sitting Madonna. It is one of the most beautiful Gothic Virgins preserved in Bruges.

Under this statue a calvary can be seen. The late Gothic stone relief sculpture was made about 1500 by an anonymous sculptor for Frans van Busleyden (+1502), a diplomat, archbishop of Besançon and dean of Saint Donatian's Church in Bruges. The calvary, first Louvain property, was donated to this chapel in 1812.

In the middle of the church a reduced copy of the threemaster Saint Michael reminds of the 1588 famine, when, as a miraculous answer to the prayers of the Bruges population, a boat full of grain entered the city. The copy was offered to this church and to the miraculous statue 'In remembrance of the miraculous abundance of grain after the invocation of Our Lady of Blindekens 14th August 1588'.

Note

★ The church is accessible from 9 a.m. to 11.30 and from 14 to 17 p.m. Bibliography: Van Blindekens naar de Potterie, een eeuwenoude Brugse belofte, 1980. (From Blindekens to the Potterie, an ancient Brugean pledge).

Christus-Koning (Christ King Church)

A plaque on the Belfry façade, left of the entrance, reminds of the 1926 dedication of the city of Bruges to the Sacred Heart, on which occasion the parish church of Christ King was founded. The parish was founded in November 1927 and the first stone of the church in the Gerard Davidstraat was laid 25th October 1931. A neo-Romanesque brick construction with a large dome covered with brass on the outside, the church was consecrated 18th July 1932. Jos Viérin was the architect. The inside of the dome and the choir walls have been decorated with colourful and solemn paintings by Jules Fonteyne.

Note

★ Outside the service hours the church is accessible on request.

Engels Klooster (English Convent)

The English Convent in the Carmersstraat was founded in 1629. The sisters are regular canonesses of Saint Augustine and belong to the Congregation of Windesheim founded in 1386 and re-founded in 1961. The convent in Bruges was

founded by a few sisters of the Saint Ursula convent in Louvain. First they acquired the Nazareth hospice on the Garenmarkt which was, according to Sanderus, a hospice for travellers. The construction of the present buildings started in 1647. The old cloister was built in 1649 by the architect Joris Arts, the refectory and the infirmary in 1650 and 1661. The late Baroque convent church was built in 1736-39 according to plans by the Brugean architect and sculptor Hendrik Pulinx. It is an octagonal building with a two floor nave and a impressive dome, the only domed church in West Flanders at that moment. The altar has been made of about twenty different kinds of rare Egyptian and Persian marble and was donated to the convent in 1738. Almost all the other works of art (stained-glass windows, paintings) date from the 19th century, except for the painting under the organ *Peter's Denial* by Gerard Seghers (1591-1651) and a *Transfiguration* by Jan Cassiers (1600-70) opposite, both Antwerp painters.

Mother Mary Augustina More, the convent's prioress from 1766 to 1808, was a descendant of sir Thomas More, Lord High Chancellor of England and author of the famous 'Utopia' which was published in Antwerp in 1515. She is commemorated on a stone in the church.

Guido Gezelle was appointed rector of the English Convent on 30th March 1899 and died here on 27th November of the same year. A commemorative plaque outside in the Carmersstraat reminds of this. Twice in the course of its history did governing English monarchs honour the convent with a visit: Charles II in 1656-59 and Queen Victoria in 1842.

Had William Wordsworth been walking in this neighbourhood when he wrote the following stanzas of his 'Incident at Bruges'?

> In Bruges town is many a street
> Whence busy life hath fled;
> Where, without hurry, noiseless feet
> The grass-grown pavement tread.
> There heard we, halting in the shade
> Flung from a convent-tower,
> A harp that tuneful prelude made
> To a voice of thrilling power.
>
> The measure, simple truth to tell,
> Was fit for some gay throng;
> Though from the same grim turret fell
> The shadow and the song.
> When silent were both voice and chords,
> The strain seemed doubly dear,
> Yet sad as sweet, – for *English* words
> Had fallen upon the ear.

Note

★ The church and convent can be visited on request. Bibliography: O. Daumont, Le cloître de Nazareth. Couvent Anglais à Bruges, 1935; L. Van de Walle, Het Engels Klooster te Brugge, z.j. (The English Convent in Bruges); Gids van de tentoonstelling: Jan van Ruusbroec, Thomas More, Guido Gezelle; Zes eeuwen Vlaams-Engelse geestelijke stromingen, 1972 (Guide of the exhibition: Jan van Ruusbroec, Thomas More, Guido Gezelle. Six Centuries of Flemish-British Spiritual Tendencies).

Jerusalem

The Jerusalem church or chapel is not a parish church, but the only church of Bruges which is private property, belonging to the earls Guillaume and Henri de Limburg-Stirum. It is dedicated to the passion of Christ and to the Holy Sepulchre. The single-naved brick building with a crypt and choir on the first floor, is crowned with a monumental octagonal tower. The latter has an open gallery and two corner turrets crowned with the sun and the crescent moon, a globe with Saint Catherine's wheel and a Maltese cross. The construction of this church, which is a unique example in Bruges and in the whole region, would have been inspired by the basilica of the Holy Sepulchre in Jerusalem. It was commissioned by, among others, the humanist Anselmus Adornes (1424-1483), a descendant of an important Genoese family which played an important part in the political, commercial and cultural life of 15th century Bruges. In 1470 he went to the Holy Land, after which the construction of this church, of a large residence (1452) and of twelve almshouses (six of which have survived in the Lace Museum of the Lace Centre situated here) was completed. Many of the church's works of art remind of the Adornes family, of the passion of Christ and of Jerusalem.

The most conspicuous work of art is the white sandstone *Calvary Altar* (1435) built against the brick wall of the crypt, between the stairs leading to the choir. It is crowned with three blue-stone crosses. Among the mountain's rocks the instruments of the passion have been represented: whipping post, scourge, whip, ladders, a hammer, nails, tongs, dice, a sponge, Christ's coat, skulls and hoofprints. The five latticed compartments above the altar used to contain relics. Above them, the coat of arms of the Adornes family.

The 15th century *Monumental Tomb* in the middle of the church represents Anselmus Adornes and his wife Margareta van der Banck in stone sculptured recumbent statues. Anselmus is wearing a full suit of armour. His wife, who died first, wears the Burgundian 'hennin' as a headdress and a beautiful draped gown. Anselmus was murdered in Scotland in January 1483 and was buried there. Only his heart was interred here in a lead box. The sides of the tomb have been

decorated with the coats of arms of both families. This 15th century well-conserved freestanding stone tomb was sculptured by the Brugean stonemason Cornelis Tielman, who was paid for it at the end of 1483.

The six large stained-glass windows in Gothic arches also contain portraits of members of the Adornes family, all of them kneeling and accompanied by their patron saints. Though often restored, these stained-glass windows date from 1482 and 1560 and are the city's oldest windows still in their original places.

In the left wall the gravestone of Anselm Optius Adornes can be seen, a Renaissance work from about 1630. The opposite wall, next to the pulpit, still contains a part of the memorial stone of Jerome Adornes from the end of the 16th century. The carving of the 1690 pulpit also represents several instruments of the passion.

Under the choir a brick crypt has been built with a copy of Jesus' grave in Jerusalem. It holds a remarkable tabernacle door in wrought iron (1713) in a wooden frame, made by the Ostend smith Pieter Ryckam. The stained-glass windows, the tower, the church and the sacristy were restored in 1965-72.

Note

★ The church is accessible from 9 a.m. to 12 (Sundays from 11 a.m. to 12) and from 14 to 17 p.m. Bibliography: N. Geirnaert & A. Vandewalle, Adornes en Jeruzalem. Internationaal leven in het 15e en 16e eeuwse Brugge, 1983 (Adornes and Jerusalem. International Life in 15th and 16th Century Bruges).

Magdalena (Magdalen Church)

One of the youngest churches in the city centre was built on the territory of the Friar Minors who settled here from about 1250 onwards but who had to flee in the 16th century, when the calvinists were especially aiming at the mendicant orders. Their church was closed in 1580 and next sold and demolished.

The new church was built in 1851-53 according to the designs of the city architect Pieter Buyck. The tower was constructed in 1860-61.

Together with the Jesuit Church of the Sacred Heart in the Vlamingstraat, which is no longer used as a church and is no longer accessible – demolition being considered –, this Magdalen church is the only neo-Gothic church in Bruges and even one of the first neo-Gothic churches on the continent built according to the principles of the British promotors of the Gothic Revival.

The Gothic Revival in the Church calls up memories of an exclusive and straightforward religious life and of the unrestrained 19th century social elite. Idealists wanted to concretize the current life values in a typical architecture and in art forms and restorations referring to the christian middle ages. They did so

on a broad scale which explains the large number of neo-Gothic buildings in Bruges and in the whole of Flanders. The works of art, mainly applied or functional art, were always of outstanding quality and made according to the principles of medieval craftmanship. They include frescoes, cast and wrought iron, stained-glass windows, religious prints and furniture carving; all of it bore the same neo-Gothic stamp.

The 19th century Gothic Revival was backed and promoted by British and French architects, authors and artists. The British architect Thomas Harper King translated in Bruges – he lived here for some time – Pugin's book with the typical title 'The true Principles of Ogival OR Christian Architecture' and also saw to it that Buyck's plans for the Magdalen church were changed in a resolutely neo-Gothic sense.

Only the outside of the present church is still original. A few years ago, during the 'Breaking of the Images' after the Second Vatican Council, the complete interior (the walls had had the compact and multicoloured neo-Gothic decoration) was white-washed. This explains the uniform impression one now has of this three-aisled cruciform church. The organ was removed from the gallery and put in the church choir. This choir is crowned and dominated by an original large neo-Gothic wooden Calvary, which reminds of the former church property, together with other sculpture elements here and there in the church, altar pieces by King and the pulpit.

Other neo-Gothic church buildings have recently disappeared in Bruges: the interior of the Jesuit chapel in the Korte Winkel, the Serweytens chapel, the chapel of the Saint Louis' college, the chapel of Hemelsdaele and others have simply been pulled down.

Note

* Outside the service hours the church is accessible on request. Bibliography: J. A. Rau, De Brugse Parochies, deel 1. Het leven in Sint-Anna, H. Familie, H. Magdalena, 1987 (The Brugean Parishes. Tome 1. Life in Saint Anne's, Holy Family, Saint Magdalen's).

Ongeschoeide Carmelieten (Discalded Carmelites)

The present church in the Ezelstraat was built on the grounds of the 14th century Hall of Uitkerke, a Winter Residence for several well-to-do families from the neighbourhood of Bruges. In 1633 Georges de Montmorency donated the premises to the discalded Carmelites, who had already been working in Bruges for some time and had distinguished themselves for lending succour to the plague victims in the beginning of the 17th century. The church was built between 1688

and 1691, mostly by the fathers themselves according to the designs of father Theodoor de Haze. A single-nave church with a large choir and two smaller aisles added in the 19th century, was the result. This monastery also suffered from the French Revolution: it was sold in 1797 but bought in again. In 1802 the church was re-opened for worship.

The white sandstone and brick large street façade is very conspicuous. The interior radiates warmth: the wainscoting and furniture were made by Jacob de Coster from Brussels who entered the monastery in 1678. Between 1690 and 1725 he made six beautiful confessionals, richly decorated communion rails and an equally successful baroque pulpit, resting on a well-sculptured prophet Elias. De Coster would also have been responsible for the high altar sculpture with Saint Joseph and the Infant Jesus on top and for the two porches next to the altar with skilfully carved doors. The enclosed porch at the entrance with the powerfully worked naked children in the midst of profuse foliage is an example of baroque sculpture.

Note

★ The church is accessible every day from 8 a.m. to 11.30 and from 15 to 18 p.m. Bibliography: F. Vromman, Kunstwerken in Brugse kerken en kapellen, 1986 (Art in Brugean Churches and Chapels).

Onze-Lieve-Vrouw (Our Lady's Church)

Our Lady's is a slimline church situated quite close to Saint Saviour's Cathedral. Tradition has it that it was founded by Saint Boniface. The oldest documents refer to an Our Lady's Chapel (9th century) under the patronage of Sijsele (the Reie then constituting the border between Bruges and the domain of Sijsele) and dependent on the Utrecht Saint Martin's chapter, which was rather strange as the whole region of Bruges then belonged to the diocese of Tournai. Later a Romanesque building appeared and in the middle of the 13th century the nave and western façade (Mariastraat) were built in the regional Scheldt Gothic style. The choir and choir aisle date back to the same century, while the aisles and the now beautifully restored flamboyant Paradise Porch were built in the 14th and 15th century.

The church's most typical element is no doubt the slimline monumental brick tower, which was not built on the axis of the church. Built in 1250-1350 with a 45 m spire from 1440, it is the city's highest, one of the highest brick buildings in Europe and one of Bruges' *Seven Wonders*. It is represented on the painting 'Septem admirationes civitatis Brugensis' (The Seven Wonders of Bruges) in the Beguinage collection attributed to Pieter Claeissins the Elder (1499-1576), a kind

of advertising leaflet for 16th century Bruges. The other six wonders are: The House with the Seven Turrets (Hoogstraat, disappeared), the Water House (disappeared), the Poorters' Lodge, the Water or Cloth Hall (Market square, disappeared), the Hall and the Belfry, the Hansa House of the Orientals and the German hanse (disappeared).

Our Lady's has had many important characters of European history within its walls. Two very important people have been immortalized here. The last great Duke of Burgundy, Charles the Bold, died near Nancy on 5th January 1477 in the battle against René, Duke of Lorraine and was buried in the Nancy Saint George's church. In 1550 Mary, Regent of the Netherlands and Charles the Fifth's sister, claimed the remains to have them interred in Our Lady's Church next to Mary of Burgundy, Europe's richest heiress, who outlived her father for only five years. She died in March 1482 in the Princes' Hall after a fall during a hunting party probably in the forest of Wijnendale, Torhout. Her husband, Maximilian of Austria was left behind with two little children, Philip I the Fair, who was three years and nine months old and Margaret of Austria, fourteen months. As can be read on her mausoleum, Mary was 'regrettée, plainte et plorée de ses subgetz et de tous autres qui la cognoissoient'.

All the church's visitors are right to go and admire the *Mausoleums* of Charles the Bold and Mary of Burgundy, for they are splendid monuments. From 1806 onwards the tombs were put up in the Lanchals chapel in this church, but in 1979 they were brought back to their original places in the presbytery. Excavations carried out on this occasion have revealed Mary of Burgundy's skeleton and a lead urn containing the heart of her son Philip the Fair who died in 1506. Some of the exposed graves with beautiful frescoes have been left open and can be seen in this presbytery and in one of the radiating chapels.

The *mausoleum of Mary of Burgundy* was commissioned by her husband Maximilian and completed in 1502. The reclining statue on top of the black marble sarcophagus was probably made by the Brussels sculptor Jan Borman. Renier van Tienen cast the statue in copper and it was gilt by Pieter de Beckere. Did the princess once sit here and leaf through the marvellous book of hours of Engelbert of Nassau (1451-1504), illuminated by the anonymous Master of Mary of Burgundy? Though the monument has richly been decorated with symbols, little angels, pedigrees, corner statues and coats of arms, people's attention is drawn by the princess's body, face, hands and clothes: a young, stately and beautiful woman who has often been described in many poems.

The *mausoleum of Charles the Bold* was finished in 1562. It was ordered four years before by his great-grandson Philip II to the brazier Jacob Jonghelinck and designed by Cornelis Floris, both from Antwerp. The order mentioned that it should be inspired by the monument for Charles's only daughter, of which it has indeed become a counterpart: a reclining statue on a blue-stone sarcophagus by

the Bruges stonemasons Joost Aerts and Jan de Smet, with an epitaph, statues of the evangelists on the four corners, coats of arms and pedigrees. The sculpture was already influenced by the Renaissance spirit and the figure was more idealized – the duke had died almost a hundred years before. He is represented in coat of armour and wears the chain of the Golden Fleece.

The two mausoleums in the presbytery face the very large *Passion Retable* (1535) of the high altar, a triptych by the Brussels court painter Barend van Orley, the only work by this master in Bruges. In 1561 Margaret of Parma ordered the Brugean painter Marcus Gerards to finish the painting, which was destined for the burial church of Mary of Burgundy's daughter Margaret of Austria in Brou near Bourg-en-Bresse in the French Savoie, but it never arrived there.

Over the choir stalls from the demolished Eekhoute Abbey (1770) thirty coats of arms have been put up of the knights of the Golden Fleece who held their eleventh chapter here in this church on 7th May 1468. So quite a bit of important history of Flanders and of Western Europe has been artistically immortalized on this spot.

Our Lady's possesses still another world famous statue, the *Madonna by Michelangelo* (1475-1564). This 128 cm high marble statue of about 1504-05 is the only work of art which left Italy during the lifetime of its creator. It has been admired for ages. Albrecht Dürer visited Bruges in the Spring of 1521 and wrote in his travel diary: 'Darnach sahe ich das alabaser (sic) Marienbild zu unser Frauen, das Michael Angelo von Rohm gemacht hat.' The statue was bought from Michelangelo for one hundred gold ducats by the Bruges cloth merchant Jan van Moeskroen or Giovanni Moscherone († 1522) whose family did business with Italy and possessed factories in Rome and Florence. In Autumn 1506 the work of art was shipped from Lucca to Sluis and in 1514 it came in possession of this church, where it was put up in the sacrament chapel. 'It is a beautiful young and richly dressed lady sitting on a rock and dreaming and looking in the distance, while the Infant Jesus, a well-nourished naked one-year-old little rascal, seems to be taking his first step and is stopped by his mother's left hand', runs the description of F. J. de Waele, who sees the Bruges Madonna as a prophecying and forward-looking woman, providens or prudens and would like to call her 'mater prudentissima'. The statue was twice stolen; first by the French occupiers in 1794 and next by the Germans in 1944. The latter put the statue and about ten of the church's paintings in the salt mines of the Austrian Alt-Aussee where they were found undamaged in 1945.

The church contains still more sculpture: the baroque marble *Choir Gallery* (1722) and several beautiful altars, but mainly the very large *rococo pulpit* made by the cabinet maker Jan Clauwaert and the sculptor Jan van Hecke according to the designs of the Bruges painter Jan Garemijn. It was finished in 1743. The large

stone figure under the pulpit symbolizes Faith, the Church Fathers on the sounding board and Truth, the second large figure at the very top, were made by Pieter van Walleghem.

In the Lanchals chapel one should certainly have a look at the *Pieter Lanchals monument*. This advisor of emperor Maximilian of Austria was beheaded on the Market of Bruges in 1488. Tradition has it that this Lanchals is at the basis of the dozens of swans elegantly floating on the Bruges canals, for, to revenge the execution of his advisor, Maximilian would have forced the Brugeans to keep swans (who also have a Lanchals, a long neck) on their waters. A swan also occurs in the coat of arms over the monument.

The *Prayer Balcony of the Lords of Gruuthuse*, enabling the lords to attend the church services from their residence, the present Gruuthuse Museum (1472), is a fine example of late Gothic sculpture. Their motto 'Plus est en vous' and their initials L (Louis of Gruuthuse) and M (Margaret of Borsele) can be discovered on the tribune. Two exceptionally sumptuous and rich baroque confessionals in the same choir aisle should also be mentioned. They were made by the sculptor Jacob Berger and cabinet maker Ludovicus Hagheman in 1697. The large pillar figures representing saints such as Peter, Anne, Catherine, John, Augustine and Jerome belong to Bruges' most beautiful sculpture.

The church preserves some fragments of disappeared frescoes and a large number of paintings, among which some very important examples of Flemish painting.

★ In the burial chapel of the Van Overvelt family is hanging an anonymous *Deposition from the Cross* from about 1490.

★ Especially beautiful is the central panel of *The Transfiguration on Mount Tabor*, usually attributed to Gerard David. The lower half of the painting with the apostles painted in a very emotional style and a meticulously reproduced landscape, is of an outstanding quality. The portraits of Anselmus Boëtius de Boodt (about 1550-1632), a 16th century Brugean doctor and jurist of international renown, and his wife Johanna and their children on the side-panels were made by Pieter Pourbus.

★ One of the church's most sensitive paintings is *Our Lady of the Seven Sorrows*, attributed to the Brugean master Adriaan Isenbrant, who is said to have been an apprentice of Gerard David's. It is part of a diptych (the other panel is preserved in Brussels) and should probably be dated about 1518. The painter has represented the seven sorrows of Mary's life in separate detailed realistic little scenes all around the figure of the Virgin; these scenes are real little paintings themselves. The Virgin is dressed in black, which puts the more stress on face and hands, and gets across as the incarnation of utter isolation, as a sensitive and dramatic personality.

★ Also by Pieter Pourbus in this church are *The Last Supper* from 1562 in the Lanchals chapel (much less successful than the similar work in Saint Saviour's Cathedral) and, probably the most beautiful work of his oeuvre, the triptych with *The Adoration of the Shepherds* (1574), also called the Damhouder Triptych because of the portrait of the Bruges jurist and knight Joost de Damhouder (1507-1581) on the side-panel. The city's registrar and pensionary, an advisor of Emperor Charles the Fifth and of Philip II, he published a number of important legal works and the 'De Magnificentia Politiae Amplissimae Civitatis Brugensis' (1564) which contains a lot of information about the history of 16th century Bruges.

Of the many other paintings should be mentioned ten *Passion Scenes* (1775-77) by the Bruges painter Jan Garemijn and, in the chapel of the chamber of rhetoric of the Drie Santinnen, the three patrons saints Barbara, Catherine and Mary-Magdalen (1763) by the same artist.

Have a look finally at the monumental triumphal cross on top of the 18th century Cacheux organ and at the statues of the twelve apostles (1618), each with his typical attribute, left and right of the nave.

The *Katte of Beversluys* is a special valuable among the church possessions, kept in the sacristy: a 3 kg golden monstrance decorated with precious stones, enamel and pearls, donated by Frans van Beversluys and his wife Magdalena van Westvelt, the founders of the almshouse De Pelikaan (1634-1714) along the Groene Rei.

Our Lady's is one of Bruges' most beautiful churches, a world in itself, its tower dominating the whole city. This church has also often been praised and described in literature, as by Stella Dorothea Gibbons (London, 1902) in her novel White Sand and Grey Sand (1958): 'It had only taken a few seconds for this exchange to occur, and the shots of the Market and Belfry were only now leaving the screen. The camera then took the audience along curving alleyways lined by small pale houses with stepped roofs; it went tracking across cobbles rounded with age and gleaming moist and dark after a shower; lingering, as if pensively musing, on the Bonifacius bridge, and looking down into the water gliding beneath; then, after wandering, as if scarcely interested, over the steeply rising roofs of the Choir immediately below, it suddenly soared straight upwards until it caught and held the heavenpiercing summit of the Sint Maria Kirke and the beholder almost gasped, experiencing such a goddy sensation of height as to be almost bodily, after the sensation of enclosedness while the camera had been loitering in the small, shady, walled garden below'.

Note

★ The church and the mausoleums are accessible every day from 10 a.m. tot 11.30 and from 14 to 18 p.m., on Sundays only from 14.30 to 18 p.m. The mausoleums also on Saturdays from 14.30 tot 16.30 p.m. Museum shop. Entrance fee: 30 BF. Bibliography: P. de Beaucourt de Noortvelde, Description historique de l'Eglise collégiale et paroissiale de N.D. de Brughes, 1773; West-Vlaanderen magazine, n° 82, Special Issue about Our Lady's Church, July-August 1965; F. Vromman, Kunstwerken in Brugse kerken en kapellen, 1986 (Art in Brugean Churches and Chapels).

Potterie

The hospital of Our Lady of the Potterie already existed in the second half of the 13th century along the present Potterierei and near the former Speipoort: a letter from the archbishop of Reims in 1252 speaks about a 'hospital or hospice for the poor In the Pottery'.

Just like in Saint John's hospital lay brothers and sisters provided lodgings, food and nursing to the sick, the poor and the passers-by. As early as the 15th century the care for the old aged was added to these, a function which is still being fulfilled today by Augustinian sisters. The name Potterie would have been derived from the potters living in this neighbourhood, who also had their corporation chapel in this church. The shipbuilders, whose yards were situated across the water, also used to come together in this church.

Three gables can be seen in the street. The right one is the back of the Our Lady's Chapel and was added only in the 17th century. The middle part, belonging to the church, is the oldest (1360) and the left gable (1530) originally belonged to the ward giving access to the church, but now forms a part of the museum.

Behind these gables a church with many works of art is hidden. In the left aisle a monumental choir gallery (1645) in black, white and coloured marble by Jacob Cocx catches the eye. A statue of Saint Augustine stands on top of this gallery. The two altars are dedicated to Saint Anthony (left) and to the 6th century Irish Saint Brendan. Their antependia are the church's and museum's showpieces. Examples of high quality Brugean textile work, they are very interesting and valuable. Left we see *The Birth of Christ*, a woollen tapestry of 6 to 7 chains per cm, 104 by 215 cm, from 1530, one of the oldest tapestries in Bruges. The nativity is presented in a fresh, almost childlike naive way in an open stable with, among others, minute shepherds in front and the anonymous donors of the work of art to the left and to the right, accompanied by their oversized patrons Saint Catherine and Saint Anne with Virgin and Child. The second textile work in front of the Brendan altar represents an *Enthroned Madonna* flanked by Saint John

the Baptist and Saint John the Evangelist. It is a wool and silk embroidery (101 by 209 cm) from about 1550 which already shows a few Renaissance characteristics: the figures are less stiff and the background has more depth. Some art historians have discovered the influence or even a design by Lanceloot Blondeel.

The choir behind this gallery contains a black and white marble altar (1673) with an *Adoration of the Shepherds* attributed to Jacob van Oost as an altarpiece. In the niche right of the altar a monument for Nicolas Despars (1522-1597) was made by the stonemason Joost Wittebroodt. Despars was a governor of this hospital, the calvinist mayor of Bruges for a short period (1578-84) and the famous author of the 'Chronycke vanden Lande ende Grafscape van Vlaenderen 405-1492', a historical chronicle which was first published in 1837-40. Despars died in the Ten Berge Castle in Koolkerke en was buried here.

The right aisle of the church, the Our Lady's chapel, also has a beautiful baroque altar from 1692, on top of which the famous tall statue of Our Lady of the Potterie, an exquisite white stone Gothic sculpture from the end of the 13th century. The standing Madonna, typical for the Gothic period, is holding the child up on her left hip and showing it to the public. Both the Virgin and the Child have been executed in fine style. In the same chapel the statue of Our Lady of the Pevelenberg, reminding of the Pledge of Bruges, can also be seen: a wooden somewhat excessively touched up Gothic statue from the beginning of the 14th century.

This chapel also commemorates the Blessed Idesbald van der Gracht (Veurne-Ambacht about 1100 – Bruges 1167), a Cistercian monk and the third abbot of the Abbey of the Dunes in Koksijde. In 1627 this abbey was transferred to Bruges, in the buildings of the present Major Seminary, in the neigbourhood of the Potterie. The last abbot of the Dunes, Nicolaas de Roovere, donated Idesbald's bones to the sisters of the Potterie in 1832. They were put up in their church in a neo-Gothic little chapel designed by Jean de Bethune in 1896. Three remarkable woollen miracle tapestries have also been put up here, each of them representing six miracles brought about by the invocation of Our Lady of the Potterie. The anonymous weavers making the tapestry about 1630 were able to draw their inspiration from a very valuable miracle booklet which is preserved here and is about one hundred years older (about 1520): the miracles are described in eight-line stanzas and represented in black and white drawings. Like in a modern strip cartoon this explanation has been added at the bottom of the suggestive and colourful figuration on these tapestries. The following 18 themes have been described and represented:

1. Miracle statue of Our Lady of the Potterie
2. Girl cured of dropsy
3. Child with lame arms and hands cured
4. Nicolas Pierssoen's blind daughter cured

5. Pieter Adriaens rescued from shipwreck
6. Victor Carré cured of smallpox
7. Lady Jacob Nausnyders delivered from possession by the devil
8. Andries Laurens' daughter unhurt by a fall
9. Trader Andries Bootart cured of cancer of the bones
10. Fisherman Pieter Brant gets a miraculous draught
11. Lady Celie cured of blindness
12. Ostend fisherman rescued from the storm
13. Katelijne Strompers gets stolen dinnerware back
14. Katelijne Smids cured of an abscess of the throat
15. Maria Scermers cured of paralysis
16. Elooi Vander Rake's child saved from suffocation
17. Pregnant women's prayers heard
18. Sick people praying for the statue of Our Lady

As an example of these naive ex votoes, the text, in translation, of the 12th miracle:

> 'An Ostend fisherman in the wild sea
> had during a tempest lost his ship's
> rudder and thought in bitter woe
> I'll certainly drown here
> Mary of the Potterie appeared to him
> who tried to comfort him
> By his sincere and great devotion
> he arrived unharmed in the port of Ostend'.

Other miracles attributed to the miracle statue have inspired the large stained-glass windows right in the chapel. And, with their back to the miracle tapestries against the partition between the two churches aisles, two more anonymous Brugean tapestries can be admired: the *Presentation of Mary in the Temple* (1639, 370 by 422 cm) and *The Annunciation of Gabriel to Mary* (1639, 368 by 380 cm).

The actual Potterie Museum, set up by the Social Welfare Council in 1982, is certainly worth visiting. Consisting of a large hall and a number of rooms, it not only visualizes this hospice's history, but also shows the rich artistic patrimony which has been collected here in the course of the centuries. Many paintings by anonymous masters can be seen, but also quite a number of books, outstanding sculpture, a marvellous collection of silver and gold ware, chalices, censers, monstrances and, finally, plenty of furniture, among which an eight-metre long Gothic table. Next to the silver collection hangs an anonymous tapestry *Scene from the Life of Saint Augustine* (1627, 215 by 323 cm).

★ Church and museum are accessible from 1.4 to 30.9 from 9 a.m. to 12.30 and from 14 to 18 p.m., from 1.10 to 31.3 from 10 a.m. to 12 and from 14 to 17 p.m. Closed on Wednesdays. Entrance fee 50 BF. Parties and schools 25 BF. Family ticket 125 BF. Combination ticket (Potterie Museum, Folklore Museum, Lace Centre and Sint-Janshuys mill) 120 BF. Museum shop. Bibliography: A. Maertens, Onze-Lieve-Vrouw-der-Potterie, 1937; A. Maertens, Geïllustreerde Gids, 1939 (Illustrated Guide).

Bisschoppelijk Seminarie (Episcopal Seminary)

The triangle of the Dunes Abbey is situated between the Potterierei, the Oliebaan and the Peterseliestraat. In 1627 abbot Bernard Campmans had to move the Cistercian Abbey of Our Lady of the Dunes founded in the 12th century in Koksijde to Bruges because of depopulation, silting-up of the Flemish coastal plain and religious troubles. The excavated ruins of the Koksijde abbey can still be visited there. This Brugean triangle had belonged to the abbey before, as a refuge of its branch abbey Ter Doest in Lissewege. Much of these buildings has been preserved, though they were confiscated during the French Revolution and the twenty Cistercian monks had to take flight and were never able to return. The buildings became an army depot, next an Ecole Centrale, where the foundation of the later Municipal Library was laid, next a Royal Atheneum (1818-32), while the church was for some time used by the protestants. When the Bruges diocese was re-founded in 1834, the Major Seminary (study of theology) was put up in these buildings; at the end of 1952 the preparatory seminary of Roeselare (study of philosophy) was moved and added to the Bruges seminary.

Of course today's buildings remind the visitor in many places of the Abbey of the Dunes and abbot Campman's great plans. The façade which was renovated in 1948-51, has three porches with sculptures (Saint Donatian, Charles the Good and the first abbot of the Dunes Robert of Bruges) by Alfons de Wispelaere. The rectangular abbey church facing the Potterierei was built in 1775-88. A French classicist construction designed by the architect Emmanuel van Speybrouck, it is a very simple blue stone building along the lines of the typical Cistercian architecture. The interior too is very simple. A red and white marble Louis XVI gallery catches the eye. The now unplayable organ (1790) was made by the Brugean organ builder Dominicus Berger. Left of the gallery an Assumption by Jan-Baptist Herregouts (1640-1721) has been put up and right a Finding of the Cross by Jacobus de Gheyn, jr. (1565-1629).

The most beautiful part of the present seminary is no doubt the *ambulatory*, consisting of four 50-meter long arched galleries. The landscape paintings were

made by the Brussels painter Jacques d'Artois (1613-86) and by the Brugean monks Balthasar D'Hooghe (1636-97) and Donatiaan van den Bogaerde (1644-95). The seminary possesses many more paintings (portraits of abbots, bishops and earls) spread over the reception rooms and the refectory. The most famous of these is the 15th century triptych *The Last Supper* by an anonymous Flemish Primitive, attributed to the Brussels (?) Master of the Legend of Saint Catherine and probably originating from the Koksijde abbey. It is a realistic painting representing Jesus and the twelve apostles (Judas turning his back to us) in a closed room with an irregular floor. The side-panels represent biblical prefigurations of the Eucharist, the Jewish Pesah and Elias in the Desert.

The seminary also possesses liturgical silver and gold ware (abbot's staff, monstrances and chalices) and an exceptionally precious collection of about one hundred illuminated *manuscripts*, mainly coming from the abbeys of the Dunes (Koksijde) and Ter Doest (Lissewege). A 12th century gospelbook from the abbey of Lo and a Brugean psalter from 1260-65 are just two of the oldest examples. Next to this two thousand or more printed books from the 15th or 16th century have been collected, among which 260 incunables (older than 1500) and 600 post-incunables. The actual seminary library is one of the richest of the whole region.

Note

★ Church and buildings are accessible on request. Bibliography: B. Janssens de Bisthoven, De abdij van de Duinen te Brugge, 1963, (The Abbey of the Dunes at Bruges); A. Denaux & E. Vanden Berghe, De Duinenabdij en het groot seminarie te Brugge. Bewoners, gebouwen, kunstpatrimonium, 1984 (The Abbey of the Dunes and the Episcopal Seminary in Bruges. Inhabitants, Buildings, Patrimony); W. Dumon, 150 jaar seminarie in de Duinenabdij te Bruge, 1984, (150 Years Episcopal Seminary in the Abbey of the Dunes at Bruges).

Sint-Anna (Saint Anne's Church)

Saint Anne's church as it can be seen now was largely built with benefactions of rich families and consecrated on 2nd May 1621. The previous church in the same place, dependent of the parish of Sint-Kruis, was damaged, sold and pulled down at the time of the Beggars. The new church is a simple single-naved brick construction. For the tower too, bricks have been used. The spire dates from 1761. Up till 1871 a graveyard was situated around this church.

The interior, forming a sharp contrast with the simple and even poor appearance of the church, makes a warm, rich and homogeneous impression. Saint Anne's is indeed called the drawing-room church of Bruges because of the oak

wainscoting all around the church. Three very beautiful confessionals from the second half of the 17th century have been integrated into this. They were made by the sculptor Jacob Berger and the cabinetmaker Jan van Gorp. The columns, consoles, cartouches and friezes give a nice rhytmical appearance to this interior. The almsmaster's bench (1686) with equally beautiful caryatids was made by the same two artists. The font (1630) was executed in black and coloured marble. As is mentioned on a commemorative plaque outside next to the entrance door, Guido Peter Theodoor Jozef Gezelle was baptized and made his first communion here. Baron Guido van Zuylen van Nyevelt, who was to be the godfather, did not show up. He sent his servant to replace him and a coach with two white horses to bring the company to church.

The church possesses 17 remarkable chandeliers and 36 paintings among which Bruges' largest painting (more than a 100 m2) *The Last Judgement* (1685) by Hendrik Herregouts on the back wall over the entrance door. The 1670 pulpit by the Bruges cabinetmaker Maarten Moenaert should also be mentioned. It is supported by finely sculptured children figures and the panels of the actual pit also represent some figures.

A five-arched black and white marble gallery separates the choir from the nave; cut in 1626 by the Antwerp artist Hans van Muyldert, one of Rubens's friends, it is the only part of this church which was not made by a Brugean craftsman. Six typical light-coloured rococo paintings by Jan Garemijn have been put up in the choir. The late Renaissance style of the stalls (1630-40) is continued in the church wardens' bench (1664-75), the panels, angels' heads, friezes and misericordes of both greatly adding to the church atmosphere. Finally two dressed statues from the end of the 18th century catch our attention: a Saint Anne with Virgin and Child and a Madonna.

The organ from 1707, the oldest of Bruges, was built by the Ypres organ-maker Jacob van Eynde, but only the rich carvings of the organcase are still original.

Note

* The church is accessible every day from 10 a.m. to 12. From Easter to the end of August also from 14 to 16 p.m. Bibliography: J. Haentjens, Sint-Anna. Parochie en kerk, 1956, (Saint Anne's Parish and Church); J. Verfaillie & L. Lannoo, Sint-Annakerk. Gids voor de bezoeker, 1976, (Saint Anne's Church. Guide for the Visitor); J. de Vincennes, Kerken te Brugge, 1964 (Churches of Bruges); L. De Mulder & M. Goetinck, Sint-Anna. Volksdevotie en ikonografie, 1987 (Popular Devotion and Iconography).

Sint-Gillis (Saint Giles' Church)

A number of important Brugean artists, such as Hans Memling († 1494), Pieter Pourbus († 1584) and Lanceloot Blondeel († 1561) have been buried in Saint Giles' church. An epitaph for the latter by the rhetorician Edewaerd de Dene has been preserved, the beginning of which reads as follows: 'Here is buried the flesh of Landslot Blondeel who first was a worker with mason's trowel and later became a great artist and painter'.

About 1240 knight Filips Ram is said to have donated the plot of land to build this church, when the parish of Saint Giles broke free from Our Lady's. At that moment Saint Giles was a rather rural area on the outskirts of the town and the present church does resemble a country church. Only about six blue stone pillars in the nave and parts of walls at the foot of the tower have been preserved of the first Gothic church which was built at the end of the 13th century. Later expansion and alternation have given the present church its substantial appearance; it has become a hall church with a nave and two aisles of the same heigth and length, with a sturdy tower (1750) of about sixty metres on the crossing.

The most important work of art in this church is to be found at the back right: the five-metre large so-called *Hemelsdaele Polyptych* (1564) by Pieter Pourbus and/or his son Frans, coming from the disappeared abbey of Hemelsdaele, the convent of which was pulled down in 1578. It is a strange work of art, perhaps a combination of others, consisting of a middle part (three panels) and a lower part or predella. Two more panels on each side represent the donors, the abbot of the Abbey of the Dunes Antoon Wydoot and the abbess of Hemelsdaele Anna Stormers, both accompanied by their patron saints Anthony and Saint Anne with Virgin and Child. The middle part is a Christmas scene, an Adoration of the Shepherds; the right panel represents the hommage of the Magi, the left one the Circumcision of Christ and the predella the Flight into Egypt.

Near the baptismal font paintings by the 18th century Jan Garemijn have been put up, representing the redemption of slaves which was for many years the concern of the Order of Trinitarians and of the later Brotherhood of the Trinity which existed in this church as well for a certain period. They are moving scenes with many characters, boats and buildings, all of them painted in the soft colours of the rococo period.

The aisle has an oak wainscoting from the end of the 17th century and a confessional with two angel figures. The left and right choir also have confessionals from the same period. To conclude this survey of the church's sculpture, the 1680 pulpit should be mentioned, a donation by mayor Cobrysse, on which the four evangelists have been represented. The new neo-baroque concert organ front right of the church was installed in 1976.

Note

★ The church is accessible every day from 9 a.m. to 11.30. Bibliography: E. Rembry, De bekende pastoors van Sint-Gilles te Brugge, 1896, (The Noted Parish Priests of Saint Giles' Church in Bruges); F. Vromman, Kunstwerken in de Brugse kerken en kapellen, 1986 (Art in the Brugean Churches and Chapels).

Sinte-Godelieve

The chapel of this convent in the Boeveriestraat 45 does not have a conspicuous façade but a carefully tended interior. The name of Godelieve Convent comes from the still existing convent of Benedictine nuns of the same name in Gistel. This convent was founded about 1100 and well-restored in 1953. The sisters were driven away in the Beggar's period and fled to Bruges where they had several addresses till, in the beginning of the 17th century, they could dispose of a house in the Boeveriestraat. In 1626 a new Godelieve Convent was founded there with Lutgarde Van de Kerckhove as the first abbess. The chapel dates back to this period.

The stalls – which are no longer used by the sisters during Sunday mass, as they sit in front of the chapel choir – were made by the sculptor and cabinetmaker Arnout Pulinx, the father of the sculptor and architect Hendrik, in 1726. They have been decorated with large medallions by an unknown artist representing the saints Benedictus, Maurus and Placidus on one side and the saints Godelieve, Scholastica and Barbara opposite.

The pulpit is also a fine example of 18th century sculpture with again medallions on the pit: Placidus, Scholastica and Godelieve. The chapel's best sculpture is the foot of the pulpit: Saint Benedictus holding the book with the rule. His head and hands are excellent plastic work. Against the wall next to the pulpit a late Gothic Madonna statue can be seen.

Over the 18th century baroque altar hangs a large painting called *The Coronation of the Virgin in Heaven* by Jean-Baptist Herregouts (about 1640-1721). On the altar also made by Arnout Pulinx, an ebony tabernacle with silver mount and next to the altar two beautifully sculptured oak doors.

Godelieve (Boulogne, France about 1045 – Gistel 1070) is a Flemish saint. She married Bertolf, the Lord of Gistel who repudiated her at his mother Iselinde's instigation and had her strangle and drown by his servants Hakka and Lambert. The spot in Gistel where this would have happened has become a place of pilgrimage and a convent. Godelieve was canonized in 1084 already. She is often represented with a cord or piece of cloth around her neck, as in the chapel's medallions and over the entrance gate. She used to be invoked for eye and throat troubles.

In 1987 the recollection centre 'Ter Fonteyne' was started in this Convent.

Note

★ The church is accessible on request. Sunday mass at 9.30 a.m. Bibliography: M. English, Godelieve van Gistel, 1944; M. English, Sinte-Godelieve en haar beevaart te Gistel, 1951 (Saint Godelieve and her pilgrimage in Gistel); A. Hoste, Het levensverhaal van Sinte-Godelieve, 1984 (The Biography of Godelieve).

Sint-Jacob (Saint James's Church)

Because of the expansion of the city and the growth of the population during Bruges' flowering period, a new church became necessary. Saint James' Church was founded as a branch of Saint Saviour's about 1420. During the Burgundian period many businessmen, foreign delegations and distinguished families did indeed settle in this neighbourhood. In the nearby Prinsenhof (Princes' Hall, the present building dates back to the end of the 19th century) Philip the Good celebrated his marriage to Isabella of Portugal and founded the Order of the Golden Fleece, Philip the Fair was born and Mary of Burgundy died. Prominent people such as Thomas More and Erasmus were regular visitors. Erasmus, for that matter, who visited Bruges at least six times, asked in one of his letters to Jan Fevyn, canon of Saint Donatian's, whether he could not come and live in Bruges, if possible in a comfortable house such as the Princes' Hall... This new and growing district was not far removed from the Hof ter Buerse and the city's money and trade centre either. Small wonder that the population in this district grew quite quickly, for many want to live in the shadow of the great. This explains why Saint James' was expanded to more or less its present three-aisled form as early as the 15th century. The rich families of the neighbourhood made donations and the corporations founded chapels in this church, which has an open and welcoming nature. Many works of art and milestones in each art discipline can be admired.

The most important of the about eighty paintings in this church is the triptych with the *Legend of Saint Lucy* in the Saint Anthony chapel. It was painted in 1480 by an anonymous Flemish Primitive (temporarily called Master of the Lucy Legend) in the style of Hans Memling. On the central panel the exceptionally elegantly painted girl Lucy appears before the severe and cold looking Roman judge because she was converted to christianity. The left wing represents her youth in a fresh, Arcadian world and the right wing the miracle: though sentenced to be housed in an brothel, neither the judges, nor the executioners or a couple of oxen were able to remove her from the spot.

Pieter Pourbus also has a number of important works here. *Our Lady of the*

Seven Sorrows is a triptych from 1556 with in the middle a sad-looking Mother of Sorrows crossing her arms. Seven medallions all around represent the seven sorrowful events of her life. On the side panels the donors Joos van Belle – the painting is also called the van Belle triptych – and Catharina Huylaert, backed by their patron saints Judocus and Catherine. In the church's oldest part, the sacrament chapel, with a remarkable sacrament tower, and in the 15th century prayer chapel of the Portinari family, a second less successful painting by Pourbus can be seen. It is the epitaph painting *The Resurrection or the Zeger van Male Family*, dated 1578 by the painter. Zeger van Male (1504-1601), represented with his two wives and sixteen children, was a businessman and held several public functions in the city council. He must have been a friend of Pourbus's. While the painter portrayed many Brugean prominent people, van Male left behind two important chronicles 'Den Speghel Memoriael' and the 'Lamentatie', in which he writes a lament about the decline of Bruges at the end of the 16th century: 'It must be a sharp sword to break the hunger. We are thin as rakes. Look with compassion (…) at the city of Bruges, how it is sick and tired, with penny and candle in its hand, a living dead'.

This chronicler was buried in the Saint Anthony's chapel where a copper memorial plaque can be seen, as well as *The Legend of Cosmas and Damianus*, a painting by the Brugean Renaissance artist Lanceloot Blondeel.

Another high quality anonymous painting hangs in the presbytery, the triptych *Dei Para Virgo* from about 1510, attributed to the Master of the Holy Blood.

The showpiece of Saint James' is the *pulpit*, sometimes called the most beautiful pulpit of Bruges. It is an oak sculpture made by Bonaventura de Lannoy in 1685-89 and donated to the church by the mayor of the Franc of Bruges Jan Baptist Cobrysse, who also gave a pulpit to Saint Giles' church and founded almshouses. The supporting figures of Saint James' pulpit show the four continents which were then known: Asia, Africa, America and Europe. The four panels of the actual pulpit carry high quality sculpture: the Infant Jesus with his hand on the globe, Saint Anne, the Virgin and Saint John with a little lamb. The handrail is profusely decorated with foliage and putti and ends downstairs in two halffigures symbolizing Love and Hope.

The chapel of *Ferry de Gros* is another of the church's artistic high points. The sepulchre was in fact founded by Jan de Gros (+ 1484) in whose house in the Grauwwerkersstraat the imprisoned Maximilian of Austria was put up in 1488. Jan was the secretary and treasurer of Charles the Bold and Mary of Burgundy, was knighted in 1473 and later also became the treasurer of the Order of the Golden Fleece. The coloured niche grave in this chapel, one of Bruges' most beautiful and certainly best preserved sepulchres, reminds of his son Ferry de Gros (+ 1541), also a treasurer of this Order. Next to him his wife Philippine

Wielant (+ 1521) and under the latter his second wife Françoise d'Ailly (+ 1536). On top of this anonymous sculpture (1622-30) occurs the motto of the de Gros family 'Tout pour estre lealle'. The French author Maurice Barrès (1862-1923) may have had this grave in mind when he wrote his book 'Les deux femmes du bourgeois de Bruges' (1894) after a visit to Bruges. It tells the story of a Brugean citizen who brings back a pagan wife from one of his travels in the south in order to educate her in the correct faith. Our Lady's Church also holds a triple grave of the Lord of Zedelgem Adriaan van Haveskerke and his wives, the Flemish Johanna van Idegem and the southern Catharina de Valladolid. The de Gros' chapel is decorated with a *Madonna* medallion of enameled pottery from the second half of the 15th century, attributed to the Florentine artists Lucca or to Andrea della Robbia.

Of course this beautiful church contains a few monuments referring to Saint James as well: paintings (1694) by Dominicus Nollet such as 'The Vocation of Peter and James', 'James' Martyr's Death' and 'Scene from James's Life'. A splendid polychrome stone statue of Saint James stands in the Sacrament's chapel and a 17th century late Renaissance statue in the nave. All of these refer to the traditional pilgrimage to Saint James of Compostella for which this church probably functioned as a stopping-place.

Note

★ The church is accessible from 8.30 a.m. to 12. In July and August also from 14 to 17 p.m. Bibliography: J. De Vincennes, Kerken te Brugge, 1964, (Churches of Bruges); Sint-Jacobs Erfgoed, tentoonstellingscatalogus, 1975, (Saint James's Patrimony, Exhibition Catalogue).

Sint-Janshospitaal (Saint John's Hospital)

Saint John's Hospital, one of the oldest hospices in Europe, was founded in the course of the 12th century. In 1188 a rule was made for the community then already living there. The oldest parts of this eight-centuries old complex are the entrance (Mariastraat), the tower and the central ward (14th century) facing the Reie. The Saint Cornelius chapel dates back to the middle of the 15th century. In the 14th century a monastery for friars was built, the wards were expanded and a brewery, graveyard and bathing establishment were installed. In 1539 a convent for the hospital sisters was added. In 1634 the last of the Saint John's friars died. In 1796, in the French period, the Administration of Civil Hospices was founded and Saint John's was added to these. Later the Commissie van Openbare Onderstand (COO) got control of this administration and later, up to the present day, the Openbaar Centrum voor Maatschappelijk Welzijn (OCMW), both of them a

kind of Social Welfare Council. In 1820 the church was closed off from the ward. In 1976 this complex stopped functioning as a hosital and Saint John's hospital moved to new premises in Sint-Pieters, Ruddershove.

Saint John's Hospital is one of the most visited buildings of Bruges. The old wards with their numerous paintings and pieces of furniture, the remarkable old dispensary and the typical custodian's room are indeed worth visiting. Of prime importance however, are a few capital works by *Hans Memling*, who was called 'the most competent and excellent painter of the complete christian world of the day' by the chronicler Jacob de Meyere in 1540. Memling, who has been given all kinds of titles, of which 'the late Gothic dream' is certainly the most beautiful one, has thoroughly been studied and extremely appreciated since the beginning of the 19th century mainly. He was born in Selingenstadt near Frankfurt am Main, in Hessen, Germany about 1435. He is thought to have learned how to paint in a Cologne workshop and probably also with Rogier van der Weyden in Brussels, for he was slightly influenced by the latter. In 1465, one year after van der Weyden's death, Memling was registered as a citizen of Bruges. He lived in the Sint-Jorisstraat and was to become one of the city's richest inhabitants. About one hundred works, spread all over the world, still testify to his great talent. Bruges possesses eight of the master's paintings, two in the Groeninge Museum and six in the chapel of the Memling Museum of Saint John's Hospital. Four of these six works were actually ordered by friars and sisters of this hospice.

The best known painting at the back of the chapel, the *Ursula Shrine*, was ordered by the hospital sisters Josine van Dudzele and Anna van de Moortele. It was probably finished in 1489, for then relics were transferred from an old reliquary to this new one. The present shrine is a gilt wooden empty little box shaped like a church. The polychrome little statues on the four corners represent Saint John (with the poisoned cup still occurring in the stamp or logo of the present Saint John's hospital), Saint Agnes (with a lamb at her feet symbolising the hospital sisters' dedication to the Lamb of God), Saint Anne and Saint Justus, the patron saints of the donors. The little paintings on the shrine itself are more important, however. They represent the strip cartoon of Saint Ursula, a wide-spread and popular legend in Memling's time and after. Ursula was a Breton christian princess who was to be given in marriage to a pagan English prince. She would only consent if the prince was converted to christianity and allowed her to go on a pilgrimage to Rome, accompanied by eleven thousand virgins. One side of the shrine represents the trip: the disembarkation and salute in Cologne (first panel) with a number of recognizable Cologne towers in the background; the arrival at Bâle (second panel), the visit to Rome and the reception by pope Cyriacus (third panel) and to the right the baptism of the British prince and his train of pilgrims who are also converted to christianity. The story continues on the other side of the shrine. The fifth and sixth scene belong together: the disem-

barkation of the group in Cologne and the martyr's death. The boats are harassed with arrows by the Huns. On the sixth scene Ursula, who refuses the Hun King's proposals, is pierced with an arrow. The city arms of Cologne still contain, next to the crown of the Three Kings, eleven little flames which refer to these eleven thousand virgin-martyrs. On the shrine's small sides Memling painted Our Lady and the two donors on one side and Saint Ursula protecting her companions with her cloak on the other. The medallions in the roof of the shrine represent the glorification of Ursula and the coronation of the Virgin in heaven, both flanked by angels making music.

The *Ursula shrine* is a unique and world famous work of art. The artist speaks a powerful and exact language in this special kind of painting. The figures' restrained and controlled expression and the transition from an almost playful and Arcadian start to a tragic and dramatic end really fascinate the spectators. After five centuries the colours have remained fresh and the composition still strikes us as a clever condensation of characters, architecture and landscape. Lori van Biervliet wrote in her essay about 'Ursula in Bruges' (1984): 'The Bruges hospital fund grew with prosperity equal to the town's importance. But never was the capital of the institution better invested than in Memling's art. As van der Weyden's Last Judgment is linked to the Hospice de Beaune in Burgundy, the Memlings in Bruges incontestably belong to Saint John's, where undoubtedly the Shrine of Saint Ursula is the most brilliant pearl of the treasure-room. The paintings imply an interesting history of legends, relics and popular belief in medieval times'.

Three more triptychs in this chapel show Memling's talent. In the middle the large triptych *The Mystical Marriage of Saint Catherine* (1479), also called the altarpiece of Saint John's, because it was ordered for the main altar of this chapel. The middle panel shows a stately, harmonious and very symbolic scene: the Madonna is sitting on a high and richly decorated throne, the Infant on her knees. In its left hand the child is holding an apple and with its right hand it is putting a ring on the left ring finger of a sitting woman representing Saint Catherine. Her traditional symbols, the sword and the weel, are lying at her feet on a warm, colourful carpet. The other sitting figure is Saint Bartara also with her attribute, the tower, in the background. She is reading a book. The ladies are flanked by two of the hospital and hospice's patron saints: Saint John the Baptist with a lamb as an identification element and to the right Saint John the Evangelist. Next to the Madonna are sitting an angel making music and an angel holding a book. The group has been put in front of a colonnade behind which a landscape can be seen. The side panels tell scenes from the lives of the patron saints: the decapitation of the Baptist and John writing the Apocalypse on the isle of Patmos. The upper half of this panel represents figures and symbols from the Revelation in an extremely moving rhythm as in a dream of the author: the four Riders of the Apocalypse –

lust for power, famine, war and death – work mischief in the world, while God is throning in a radiant rainbow surrounded by elderly people making music. At the back of the sidepanels the donors have been immortalized: the hospital friars Jacob de Keuninck and Antoon Segher and the sisters Agnes Casembroot and Clara van Hulsen, the four of them patronized by their patron saints.

On the right wall of the chapel two smaller triptychs have been put up. *The Adoration of the Magi* (1479), also called Jan Florein's triptych, after the kneeling friar on the left who was the donor of this work of art. The adoration in the middle is a fixed diagonal composition with Mary gazing in a sweet but unaffected way and all other figures experiencing the scene in the same unaffected and dignified manner. The symphony of colours circles about the Virgin's blue cloak. The left panel represents the nativity itself and shows the little child lying on a part of Mary's cloak. The right panel tells the Presentation in the Temple, in which the temple might well be a picture of Saint Donatian's Church on the Burg. On the back of these side panels Saint John the Baptist and Saint Veronica have been portrayed in front of a deep and vast landscape which spreads over both panels.

The Lamentation of Christ (1480) is another small Memling triptych ordered by Adriaan Reins, friar of this hospital. On the central panel the body of Christ, which is mourned by Mary dressed in blue, by Saint John (left) and Mary Magdalen (right) at the foot of the cross with tongs and nails still lying about. In the background an undulating landscape with the city of Jerusalem. The other panels represent the donor Adriaan Reins and his patron saint and Saint Barbara, carrying her attribute, the tower. In the background the legendary Saint Wilgefortis or Saint Ontcommere, the holy woman with the beard, who wanted to become ugly in order not to have to marry and who for this reason was disowned and crucified (her attribute) by her father and finally Mary Egyptiaca, an Egyptian penitent who for forty years subsisted on three loaves of bread in the desert and who was worshipped in Bruges in the middle ages.

In the adjoining Saint Cornelius' chapel two more splendid works of Memling can be admired. The *Sibylla Sambetha* (1480), from the former Brugean Saint Julian's hospice, is a marvellous, fascinating and skilfully painted lady's portrait, added to the Memling collection in 1815. It is a mysterious picture of a beautiful impassively gazing woman in Burgundian attire, representing a sibyl or visionary who predicted the coming of Christ in the Old Testament. A number of well painted details catch the eye, such as the veil hanging about the head, the jewel on the triangular little breast, the rings at the fingers the tips of some of which touch the panel's rim.

The diptych *Madonna with Child and Maarten van Nieuwenhove* (1487) was also moved from Saint Julian's hospital to Saint John's in 1815. The two figures are sitting in the same room. The Madonna is at a table and is offering an apple, a

symbol of the redemption, to the naked Child with an almost adult expression on its face which is sitting on a delicately painted brocade cushion. This triangular composition is typical for 15th century painting. Especially the Madonna's face is beautifully represented in an atmosphere of noble self-control. Through the window on her right a fresh landscape can be seen with a winding road leading to a city in the distance. On the left the arms of the Van Nieuwenhove family, with their motto 'Il y a cause' (everything can be explained). The other panel shows the donor, the 23 year-old Maarten, a sturdy figure with a large nose, heavy lips and an open, confident look. He is certainly not praying, this realistically painted man who was to become one of Bruges' mayors. His patron Saint Martin has been represented in a little stained-glass window over another piece of shining beautiful scenery.

Next to these Memling panels, high points of the history of painting, the Cornelius chapel also contains a remarkable oak entrance door, beautiful lavishly decorated 17th century sculpture and an exceptional 15th century niche tabernacle or sacrament-tower. Older still, from the end of the 14th century, is a large and stately *Statue of Saint Cornelius*, which was expertly restored in 1985. The late Gothic polychrome statue represents the saint in a stately attitude with staff and pope's tiara and his attribute, the horn.

Outside in the Mariastraat, the Gothic *Madonna Portal* is the hospital's original entrance gate. Illuminated at night, it is one of Bruges' rare open air sculptures. It dates back to about 1270 and is one of the rare Flemish sculpures resembling the famous sculptured portals of the French cathedrals. The work of art was restored shortly before the first World War.

It should be noted that the famous Flemish poet, novelist, painter and film director Hugo Claus was born in this hospital's maternity ward in 1929.

Note

★ Chapel, Memling Museum, sick wards, old pharmacy and governors' room are accessible from 1.4 to 30.9 from 9 a.m. to 12.30 and from 14 to 18 p.m.; from 1.10 to 31.3 from 10 a.m. to 12 and from 14 to 17 p.m. Closed on Wednesdays. Entrance fee 80 BF. Parties 50 BF. Schools 30 BF. Family ticket 160 BF. Bibliography: J. Penninck, Het Sint-Janshospitaal te Brugge, 1965; A. Van den Bon, Het achthonderd jaar Sint-Janshospitaal van de stad Brugge. Zijn geschiedenis in alle mogelijke aspekten, met de klemtoon op de geneeskunde, 1974 (The eight hundred years old Saint John's Hospital in Bruges. Its history under every aspect, with stress on medicine); H. Lobelle & J.P. Esther, Sint-Janshospitaal Brugge 1188-1976, 2 vol., 1976; E. van der Elst, L'Hôpital Saint-Jean de Bruges de 1188 à 1500, 1976; C. van Hooreweder, Hans Memling in het Sint-Janshospitaal Brugge, 1984 (Dutch, French, English and German edition); H. Lobelle-Caluwe,

Memlingmuseum Sint-Janshospitaal,1985.

Sint-Salvator (Saint Saviour's)

Saint Saviour's is the cathedral of Bruges and probably the city's oldest church foundation. The city outline seen from a distance is determined by the Belfry and Our Lady's and by this impressive Saint Saviour's church and its remarkable tower. Pope Innocent VIII called it a 'dignum et sumptuosum opus' (a worthy and sumptuous work) in 1489. The church does indeed contain works of art from all ages. Not only does it show the marks of Romanesque sturdiness, but also the elegance of the Gothic style, the playfulness of the Renaissance period and the self confident triumph of the baroque. Strong and very clearly profiled bundle pillars add to the church's tall and graceful appearance.

The present church is 99 by 49 metres and is 28 metres high, its tower reaching 80 metres. Its history is long and eventful. As early as the 9th century a house of prayer would have existed in this spot, dedicated to Saint Saviour and to Saint Elooi, who is said to have founded the first wooden little church here about 660. The oldest sandstone sections in the Romanesque foot of the monumental West tower date back to 1127; about 1295 a new church was started according to the French Gothic model. The choir, the first two bays of the choir aisle and part of the northern transept date from about 1300. In 1430 the 48 choir stalls were put in. The Knights of the Golden Fleece used these stalls for the 13th chapter of their order in 1478. The coats of arms over the chairs date from 1727.

Saint Saviour's cathedral possesses about forty altars. The present *high altar* was built in 1638-42 according to a plan by Jan Cox from Ghent. The gallery from 1679-82 by Cornelis Verhoeve used to divide the choir and the nave, but was moved to the back of the church in 1935. The large and elegant statue of *God the Father* certainly catches the eye. Made in 1682 by Arthus Quellinus the Younger (1625-1700) from Antwerp, it is a high point of baroque sculpture in Bruges and one of the sculptor's best works. The organ and organ case followed in 1718-19. The instrument, built by Jacob van Eynde from Ypres and repaired in 1935-36 and again in 1986-87, comprises 56 stops on three keyboards and a pedal.

In the nave full attention goes to the *pulpit* by Hendrik Pulinx, jr. Its base, a statue (1785) by Laurentius Tamine, represents Saint Elooi holding a plan of the church.

In the so-called Low Period many of the church's riches were stolen by the French occupiers (1798). The next year the whole building and its contents were put up for auction as national property, but citizens were able to buy them in and safeguard this artistic patrimony. In 1834 the church became the cathedral of the re-founded diocese of Bruges. To remind of Saint Donatian's church in the Burg, which was also pulled down in the French period, Saint Donatian became

the church's second patron saint. In the 19th century the present marble tiles were laid. On 19th July 1839 the umpteenth fire (1116, 1183 and 1358 also) raged through the building, causing a damage of six hundred thousand gold francs. In 1844-46 the neo-Romanesque tower top, without the spire, was executed by the contractor William Dowsing Chantrell, advised by his brother, the British architect Robert Dennis Chantrell according to the designs of the city architect Pieter Buyck (1805-1877); it was then popularly called the 'milk stool'. As late as 1871 the spire was added and the tower's present silhouette was completed.

The church and church museum possess a rich patrimony consisting of several kinds of treasures. Some 120 paintings can be seen, about ten of which are remarkable highpoints of Flemish painting. Most of these hang in six rooms of the church museum. In chronological order:

★ The *Tanner's Panel* or 'Calvary with Catherine and Barbara', still anonymous, dated about 1380, and so before Jan van Eyck.
★ The double panel *Christ on the Cross* with the Virgin and the donor dates from 1430.
★ A top-class work in this church is the tragical scene of the *Martyr's Death of Saint Hippolytus*, a triptych painted by Dirk Bouts (the middle and right panel) in 1470 and completed after his death (1475) by Hugo van der Goes (left panel). One panel represents emperor Decius and his train and the other the donors Hippoliet Berthoz, a counsellor of Philip the Fair, and his wife Elisabeth van Keverwyck, watching the martyr being quartered.
★ The *Legend of Saint Anne*, a panel of about 1525, represents the marriage of Joachim and Anne, the birth of Our Lady and Joachim and Anne offering in the temple in three successive porches.
★ The *Mother of Sorrows* (about 1490), a panel with an elaborate edge inscription, may well have been painted by the Brugean painter Jan van Eeckele.
★ A specially painted and sawed panel in the church nave represents the *Portrait of Charles the Good*, the count who was murdered in Saint Donatian's church on 2nd March 1127. It may date back to the 15th century.
★ The so-called *Passion Scenes of Bruges* from about 1510 represents Christ Bearing the Cross, a Calvary and a Mourning of Christ on one single painting, again by an anonymous, possibly Brugean master.
★ Pieter Pourbus is represented in this museum with a *Last Supper,* the so-called Triptych of the Sacra Brotherhood from 1559. The left panel shows Melchisedech's offering and the right Elias under the juniper-tree.
★ *Saint Anne and the Virgin Have the Episcopal Gown Brought to Saint Hubert* (next the sacristy door) is a baroque work from 1688 by Jacob van Oost the Younger. An *Adoration of the Shepherds* by Jacob van Oost the Older, next to the entrance door of the church museum, offers an interesting play of light and

shadow.

Also remarkable in this museum are a *Nativity of Christ* (1536) by Pieter Aertssen, a *Descent from the Cross* (1609) by Antoon Claeissins and a *Holy Virgin in between Luke and Elooi* (1545) by Lanceloot Blondeel. We also admire a splendid silver reliquary of Saint Elooi (1612) by the Brugean silversmith Jan Crabbe, an embroidered antependium from 1642 and a few remains of the 14th century funeral paintings found in this church.

Dozens more, often very large paintings can be seen here by Lodewijk Claeissins, Pauwel Ryckx, Jan-Erasmus Quellinus, Cornelius Verhoeve, Lodewijk de Deyster, Jan van Orley, Jozef Odevaere and many others. The youngest painting, a Way of the Cross by Hendrik Wulffaert, dates from 1865.

The church holds plenty of examples of applied art as well, which are on view in the church museum: bells, ivory, pottery, paraments, standards, manuscripts, books, miniatures, arms and mourning plaques, stained-glass windows (all from the 19th and 20th century) and outstanding copper and tinwork. Moreover, Saint Saviour's possesses many valuable gold and silver objects, such as ciboriums, chalices, candlestands, chandeliers, lanterns, torches, medals, medallions, monstrances, pyxides, plates, dishes, censers, canon boards, holy-water basins, reliquaries, shrines, altar and procession crosses. The museum also shows a number of exceptionally old works of art such as a *crozier* in gilt copper and blue enamel from Limoges (1st half 13th century) and the little statues of the *Virgin with the Angel Gabriel* (12th century) in gilt bronze and enamel from northern France or the Meuse region.

Eight large and valuable tapestries (before 1730) by Jaspar van der Borght (six chains per cm) according to designs by Jan van Orley, both from Brussels, hang in the choir and the transept. They evoke scenes from the life of Christ: the adoration of the shepherds, Jesus with the scribes in the temple, the Cana wedding, Christ with the pharisee Simon, the miraculous draught of fishes, the entry into Jerusalem, the bearing of the cross, the resurrection. Bishop van Susteren gave them to the former Saint Donatian's cathedral.

The church museum preserves the *Memorial Plaque of Princess Gunhilde,* probably the oldest evidence for the historical ties between Bruges and England. The leaden plaque dates back to 1087, the year of the princess' death, and was discovered in Saint Donatian's, together with a coffin with her bones, in 1786.

This church is also well known for a number of great sculptures and splendid church furniture. High points are the following:

* The doors (1450) of the chapel (1372) of the *shoemakers'* corporation, a wealth of late Gothic oak sculpture.
* In the same chapel the Romanesque oak *Eekhoute Cross,* from the lost abbey of

the Eekhoute (about 1250).

★ The *Memorial Stones* of among others dean and chancellor Jan Carondelet (alabaster, 1559), bishop Johannes Caimo (18th century), bishop Hendrik van Susteren (by Hendrik Pulinx, marble, 1742) en bishop Jan-Baptist de Castillion (marble, by the same artist, 1758).

★ In the Sacrament Chapel the *Madonna* (1776) by Pieter Pepers.

★ The *Communion Rails* with finely sculptured panels (18th century).

★ The 32 *misericordes or little seats* of the stalls (1430-40), primitive but lively sculpture hidden under the tip-up seats.

★ In the Sacrament Chapel the polychrome *Memorial Monument of Jan Lernout* (1545-1619) or Janus Lernutius and his wife Maria Tortelboom. The style of the monument (1620) is late Renaissance or early baroque. Lernout was a Brugean humanist and neo-Latin poet. He played a role in the city council of Bruges. His contacts all over Europe enabled him to guide many scholars to Bruges, among whom Justus Lipsius from Louvain, who was his guest twice. Famous by Lernutius are his songs, the 'Carmina' (printed by Plantin, 1579) and also 'Initia, Basia, Ocelli et alia poemata' (1614), kisses for the beloved and praise of her eyes.

★ The retable sculptures to be admired are the *Passion Retable* from the end of the 15th century in the Cross Chapel and the unparalleled *Saint Anne's Retable* in the Peter and Paul Chapel, splendid late Gothic oak work (1510-20).

This church has come up in many literary works and has functioned as a setting for much poetry and dialogue. Important concerts are organised here and numerous church services and civil ceremonies for national holidays and November remembrance days.

Note

★ The church is accessible every day from 7.30 a.m. to 11.30 and from 14 to 18.30 p.m. The church museum from 14 to 18.30 p.m., except on Wednesday afternoons. In July and August also from 8.30 to 11.30 a.m. Museum shop. Entrance fee: 30 BF. Bibliography: K. Verschelde, De Kathedrale van Sint-Salvators te Brugge, 1863; West-Vlaanderen magazine, special issue by Joseph Dochy, 1959; L. De Vliegher, De Sint-Salvatorskathedraal te Brugge, vol. 1, Geschiedenis en architectuur (History and Architecture), 1981, vol. 2 Inventaris (Inventory), 1979.

Sint-Walburga (Saint-Walburga)

The present Saint Walburga's church, on the Sint-Maartensplein (Saint Martin's square), is the former jesuit church of Saint Franciscus Xaverius of the period

before this society was abolished by emperor Joseph II in 1773. Yet, the parish of Saint Walburga was founded as early as 1239 by the bishop of Tournai, the diocese to which Bruges belonged then. Tradition has it that Saint Walburga founded this chapel while she was visiting Bruges together with Boniface in the 8th century. The latter is sometimes called the founder of Our Lady's Church. The present church's history has been really eventful, for at the end of the 18th century, during the French rule, the church was confiscated and for some time used as a temple of the Law.

This most important baroque religious building in Bruges was designed by the Bruges architect and lay brother jesuit Pieter Huyssens (1577-1637), a very active man who also built churches in Maastricht (the present theatre building), Antwerp (the Carolus Borromeus' church), Ghent (the church of Saint Peter's abbey), Namur, Dunkirk and others. On the 400th anniversary of his birth (1977) a commemorative plaque by the calligrapher sculptor Pieter Boudens, was unveiled in the church choir.

The monumental white stone west façade on the Saint Martin's square really catches the eye. An example of Counter Reformation or so-called jesuit baroque, it drew its inspiration from the Gesù church in Rome. It has two floors, a large fronton, many protruding and receding parts and plenty of decoration. Unlike the Antwerp Carolus church, Saint Walburga's never got a tower. The present tower is an extremely simple late Gothic construction. The three-aisled basilica church was skilfully restored in 1967-73 and again in 1980 and has a fresh, attractive and solemn interior. It is regularly used for concerts.

The artistic patrimony is rather uniform, without real peaks. There are paintings by the Bruges artists Pieter Claeissins (1532-1623), Jan Garemijn (1713-1799) and Jozef Odevaere (1776-1830). More important, however, is the sculptured furniture which was almost entirely ordered from Antwerp sculptors. The baroque high altar (1643) consisting of different kinds of marble was made by the sculptor Jan Cockx. On top a 19th century statue of Saint Walburga. The side or Our Lady's altar in black and white marble dates from 1657 and would have been designed by the Antwerp sculptor Pieter Verbruggen, who also made the Saint Roch altar on the other side of the high altar.

The elegant white marble 24-meter long *communion rails* (1695) were made by the latter's son Hendrik Verbruggen. Consisting of eight panels and ten oval medallions, it is one of Bruges' most beautiful communion rails. The freestanding oak *pulpit* is the church's most valuable work of art. It was made in 1667-70 by Artus Quellinus the Younger (1625-1700), according to a plan of the jesuit Willem Hesius (1601-1690). Documents show that Quellinus was often at loggerheads with his patrons, who had determined the whole iconography to the last detail and wanted an accurate execution. The basis is a woman symbolizing Faith. The sounding board is supported by two angels blowing the trumpets.

The panels of the actual pit represent the four evangelists, separated by elegantly sculptured little angels. The handrail with foliage and putti is a masterwork of carving, suggesting water, fire, earth and air.

The organ (1736) on the gallery was built by the French organ builder Cornelius Cacheux (1687-1738) and improved by the Lille organ builders Frémat and Carlier; it should urgently be restored.

After having been the vice rector and a teachter of philosophy at the English-Belgian seminary, the poet Guido Gezelle became a curate of this Saint Walburga's church in 1865. He was to stay here until 1872 and lived in the Korte Riddersstraat 5 and for a short time Verwersdijk 20, where commemorative plaques have been put up. During these seven years, next to his pastoral work, the poet Gezelle was very active as a journalist and also got involved in the tricky business of local politics. From 1864 onwards he was the editor of the periodical ''t Jaer 30 of politike wegwyzer voor treffelyke lieden' (The year 30 or political guide for respectable people), substituted by ''t Jaer 70' in 1870. Of greater importance is the fact that, during this Walburga period, Gezelle saw to the redaction, publication and administration of the weekly 'Rond den Heerd, Een leer- en leesblad voor alle lieden', a periodical which would be published till 1902 and played a positive role in the adult education of the 19th century.

Note

★ The church can be visited from 14 to 18 p.m. in July, August and September.
Bibliography: J. Van den Heuvel e.a., Sint-Walburga, een Brugse kerk vol geschiedenis, 1982 (Saint Walburga, a Brugean Church full of History).

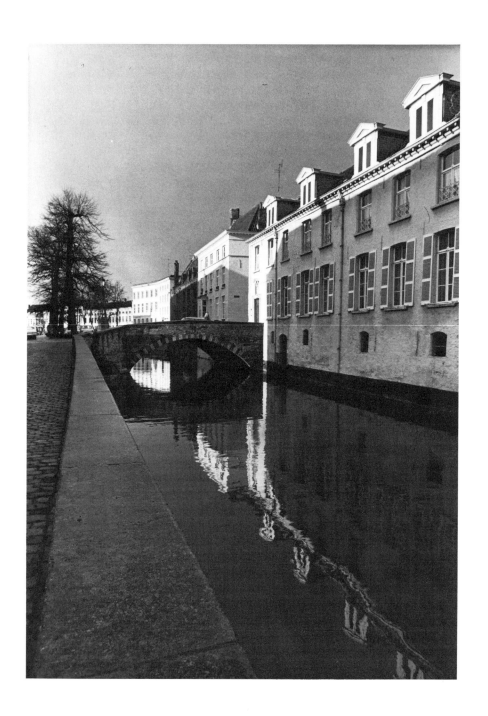

Towerbridge and Golden 'handrei'

Art in the street scene of Bruges

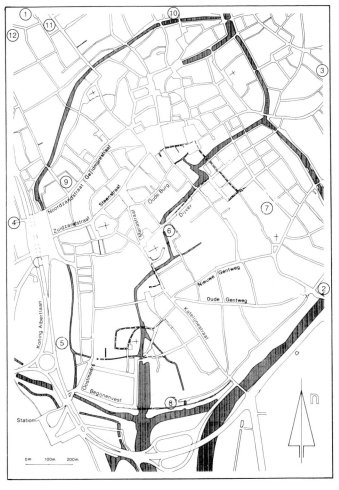

Stadspoorten
1 Ezelpoort
2 Gentpoort
3 Kruispoort
4 Smedenpoort

Parken
5 Koning Albertpark
6 Arentspark
7 Koningin Astridpark
8 Minnewaterpark
9 Sebrechtspark
10 Sincfalpark
11 Lodewijk van
 Haeckeplantsoen
12 Graaf Visartpark

125

Bridges

Is not 'Brugge' a fitting name for a city with so many bridges? And does not the word 'bruggia' of 'bryggja' which meant jetty in old-Norse and is at the basis of the present city name according to language historians – already contain the stem brug? Guido Gezelle wrote in 1865 'that he had been told that the city of Bruges was nothing more than a bridge over the Reye at first, situated at today's Blind Donkey Bridge. To protect this bridge – bridges being quite expensive then – and to prevent the wicked people, the Vikings, from crossing there, one of our authorities added a borough or burg to this bridge and put up soldiers in this stronghold. Gradually, to serve the soldiers and coming and going people, little shops and pubs were added, and so on, still Bruges finally was like Bruges today...'

There are still plenty of bridges in Bruges, about eighty. The first ones, at the time of the city's first (1127) and second (1297) ramparts, were made of wood, but at the end of the 14th century the first stone bridges were built, strong and sturdy, but elegant at the same time. Some of these oldest bridges are just perfect.

The *Augustinian Bridge* (about 1425) between the Spanjaardstraat and the Hoedenmakersstraat, was named for the Augustinian fathers from Mechelen who settled in the nearby Jan Miraelstraat in 1250. The bridge has three arches spanning the Reie and stone benches along the rail; these were not meant to sit on, but to display and sell goods to people entering and leaving the city. The *Fleming Bridge*, between Vlamingstraat and Sint-Jorisstraat, built by Jan and Arnold van Uitkerke and Jan Petyt in the same period, also still has these typical brick display benches. Next to the latter bridge, we can admire a marvellous example of the art of Gothic masonry hanging over the Augustinian canal: the bay of Herman van Oudveld, the dean of the silver and goldsmiths in the 16th century. The little building was carefully restored in 1974. Other bridges date back to the same period: the *Wulfhage Bridge* between the Wulfhagestraat and the Beenhouwersstraat, also called Key Bridge after a brewery in the neighbourhood, and the *Mee Bridge* next to the Meestraat, which may have been built by the famous mason Jan van Oudenaarde. The beautiful corner house at this bridge is the scene of Norbert-Edgard Fonteyne's (1804-1938) first novel 'Pension Vivès', a strange, somewhat far-fetched story of an equally extravagant boarding house situated on this beautiful spot... in the author's imagination. The *Lions Bridge* in the Leeuwstraat would already have been a point of defence at the time of Bruges' first ramparts. The present stone bridge from 1627 was built by Jan de Wachtere. The two

elegant lions in the rails were sculptured by Jeroom Stalpaert in 1629.

At the *Carmelites' Bridge* across the Lange Rei to the Carmersstraat, a stone bridge from the 14th century, a white friar sculptured by Jan Franck is sounding the water. The inscription 'A.D. 1976 werden 7 bruggen van Brugge herbouwd', means that in 1976 seven bridges in Bruges were rebuilt. Next to it the arms of the city section of the Carmelites.

On the Dijver, between the Wollestraat and Eekhoutstraat lies the *Nepomucenus Bridge*, formerly called Eekhoutbrug because it led to the abbey of the Eekhoute, now completely disappeared. This bridge would have been in stone from the 14th century onwards. On the bridge the statue of John of Nepomuk (now in Czechoslovakia) who was the archbischop of Prague's vicar and confessor to queen Joanna in the 14th century. Because he dit not want to break the secret of the confessional to king Wenceslas, he was first tortured and next bound and thrown from a bridge into the Moldau. Hence, he is represented on many bridges in central Europe. The Brugean statue was made by sculptor Pieter Pepers in 1767. On the pedestal the Latin motto 'En pie mutus en os non accusant' (Behold this pious mute, whose mouth did not accuse) is composed of the 25 letters of Sanctus Joannes Nepomucenus.

Façades

Bruges is a remarkable city because its art can be said to be lying in the streets. Has it not been called a museum city? So many façades from all ages have been built, preserved and restored. Many have also disappeared and are still disappearing, however.

It does not hold good to enumerate them all. A number of specialized publications * can be consulted to this end. When walking through Bruges, the visitor should look up, to the first and second floors, and an instructive part of the history of architecture will be revealed to him.

Our selection is ordered chronologically and also refers to the list (see p. 161) of 'protected monuments' in Bruges (blue and white sign on the façade).

* L. De Vliegher, De Huizen te Brugge (The Houses of Bruges), 1975; P. Devos, L. Constandt & J. P. Esther, Brugge, Herwonnen Schoonheid. Tien jaar monumentenzorg te Brugge (Recovered Beauty. Ten Years of Monuments' Conservation), 1975; J. Ballegeer, Langs Brugse beelden (Brugean Statues), 1976; B. Beernaert e.a., Brugse Gevelgids (Guide for Brugean façades), 1982; J. Ballegeer, Gids voor Oud Brugge (Guide for Old Bruges), 1986.

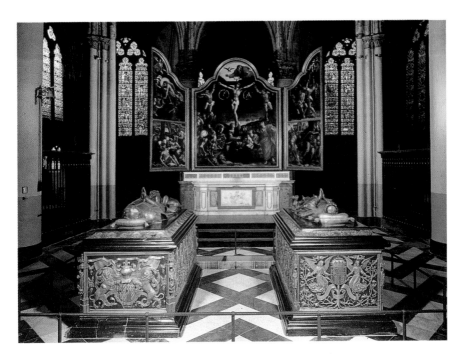

Choir of Our Lady's Church with the memorial monuments *of Mary of Burgundy (1490-1502) and Charles the Bold (1558-62) and the* Calvary Triptych *(1534) by Barend van Orley, completed by Marcus Gerards.*

Jerusalem Church, *corner Peperstraat and Balstraat, 1470-82, restored 1966-72.*

Pieter Huyssens, Saint-Walburga's Church, *Sint-Maartensplein, detail façade, 1643, restored 1967-73*.

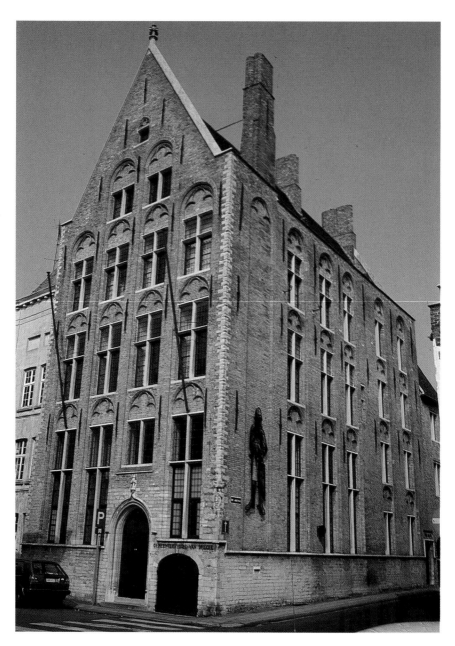

House De Croone, *corner Sint-Jansstraat and Wijnzakstraat, ± 1500, restored 1967-68.*

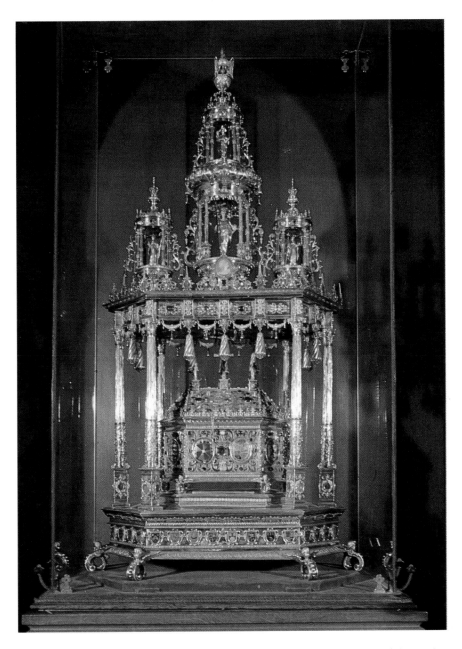

Jan Crabbe, Reliquary of the Holy Blood, *goldsmith's art, 1617, Museum of the Basilica of the Holy Blood.*

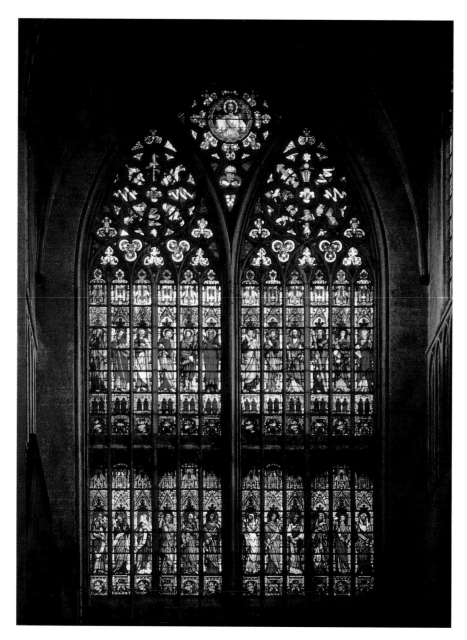

Jean Bethune, Stained-Glass Window, *19th century, Saint Saviour's Cathedral, transept.*

Gust de Smet, Henriëtte, *painting, 1927, Groeninge Museum.*

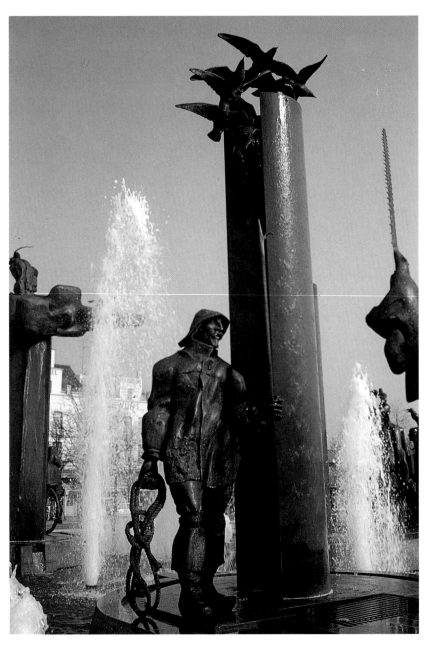

Livia Canestraro and Stefaan de Puydt, Fountain Monument, *bronze, 1986, detail fisherman*
't Zand.

Romanesque (11th-13th century)

Not a single complete Romanesque building has been preserved in Bruges, only fragments and ruins of churches: the tower of the 12th century church in Dudzele on the outskirts, the basis in brick and sandstone of the Saint Saviour's West tower from about 1200 and Saint Basil's chapel (middle of the 12th century) on the Burg with the typical campanile. The latter chapel, the lower part of which is also called the crypt of the Holy Blood, is certainly the most perfect example of Romanesque architecture. Almost nothing has been left of ordinary houses for in this period only churches and some civilian buildings were erected in stone. Remains of the first sandstone city ramparts (1127) can be seen along the Potten-makersrei.

Gothic (13th – 16th century)

A few intact original buildings from this period have been preserved. The Halles and the Belfry, the City Hall, Saint John's Hospital, the Potterie Hospice, the stone bridges and the city gates were all first built in Bruges' flowering period. Existing churches such as Saint Saviour's and Our Lady's were added to and adapted to the new times and Gothic style. New churches were founded: Saint James's, the first Saint Walburga's, Saint Giles', Bruges' only hall church, and Our Lady's in Lissewege near Bruges in so-called coast-Gothic style. Convents and abbeys were founded by the Dominicans (1233), the beguines (1245), the Franciscans (1246), the Carmelites (1266), the Augustinians (1276) and the Car-thusians (1318). Civilian buildings followed: the White Wool Hall (1399), the Poorters' Lodge (1407), the Palace of Gruuthuse (15th century) and the Hall of Watervliet (16th century). Both the foreign hanses and the authorities of the city and the Franc of Bruges built their halls in the style of the moment.

Of the private houses, two houses with the wooden façade characteristic of the time have been preserved. In *Genthof* 7 above the first brick floor, two pointed wooden façades protrude (restored in 1967) and the house next to the *Korte Winkel 2*, from the first half of the 16th century, has a three-step wooden protrud-ing façade. On Marcus Gerards' city plan (1562) the house still has a gable end.

Three different types of stone façades were developed in the Gothic period. Often combined and mixed, they occur as screen, pointed and stepped gables.

First there is the façade with window bays framed in continuing niches. Examples are the Poorters' Lodge and the stately Reie façade of the Gruuthuse Palace, to be seen from the Arents Park, one of Bruges' most beautiful façades and also private houses in the *Jerusalemstraat 56, 58 and 60* from the middle of the 16th century. The tracery over the doors and windows in rich, fantastic and varied patterns, is of outstanding beauty. They were restored in the 19th century.

In the second type all bays are framed in a single niche from the bottom to the top. The house *Huidenvettersplein 14* from the middle of the 16th century, the former city office for beer taxes, is a good example. Its corner still has a pin for the gates which used to close off this little square. *Molenmeers 30-34* also dates back to the 16th century. The façade of n° 30 (1657) represents Faith, Hope and Love in the top tympanums and the façade next to it the Seven Physical Works of Charity.

In the third type the niche framing all the windows bays is interrupted with dams. Examples are the house called De Gecroonde Leerse (1527) in the *Steenstraat 40*, a five-bay façade marvellously restored by the Kredietbank in 1980-85. There is a large exhibition and reception room on the second floor. This former corporation house of the shoemakers is the oldest façade of the street. Other examples: *Pieter Pourbusstraat 5-7*, two brick stepped gables from 1530 (restored in 1933-37) with again exceptionally fine tracery in the tympanums and *Sint-Jansstraat 8*, a painted and seriously altered 16th century façade.

Façade crownings were typical for that period. Screen façades can be seen in the *Genthof 1-3* where the façade of the five-bay houses from the middle of the 16th century has been painted, and tracery has been applied in the high tympanums. The Black House (a cinema) in the *Kuipersstraat 23* from the end of the 15th centrury is a four-bay façade with a miniature stepped gable on top; the little pointed arches over the windows have been decorated with trefoils. The beautifully restored screen façade in the *Oude Zomerstraat 2* (about 1500) has two bays and simple but nice tracery over the windows.

Examples of *pointed gables* are the Old Customs House in the Jan van Eyck Square and the splendid house De Croone in the *Wijnzakstraat 5*.

Bruges has many *stepped gables* and there are also plenty of imitations from later ages. Successful original examples are *Boomgaardstraat 7* from about 1500 with three bays, the house 'In den Stuer', *Cordoeaniersstraat 5*, with a brick stepped gable from 1518, as can be read on a tablet, restored in 1923 and the house in the *Kuipersstraat 27*, also with a 16th century brick façade, the ground floor of which was altered in the neo-Gothic style in the 19th century.

Renaissance (16th century)

Bruges continued to build Gothic houses for much longer than other cities did and the Renaissance started only slowly. There were political and religious troubles in the city and its economic prosperity was declining quickly. The Civil Recorders' House (1534-37) and the façade of the Chapel of the Holy Blood (1529-33), both on the Burg, date from this period, and also the Hall of Pittem (1549) in the Heilige Geeststraat, now the bishop's residence. A number of extremely successful private houses from this period have been preserved. The

house *Oude Burg 24*, skilfully restored in 1984, has a brick crenellated façade (1564) with very characteristic zig zag tracery over the windows and lion's heads under the crenellation. *Nieuwstraat 6* has a painted screen façade (1565), also with geometrical meander freezes. *Oude Burg 33* has a brick and stone façade (1571) with medallions (perhaps Ceres and Mercury) and has been finished in a quite austere and simple way. The house *Steenstraat 25* used to be the carpenters' corporation house and was built by Jan de Wachtere according to the plans of Jan Stalpaert, the corporation's dean at that moment. This façade, with bas-reliefs in the tympanums, the corporation arms and a two-part fronton on top interrupted by a vase, does seem quite ornate. Another fine Renaissance façade, is to be found *Sint-Jakobsstraat 27*: a 1639 façade renovated in 1882 (when the entrance porch was made as well), which now belongs to the Conservatory.

Baroque (17th century)

Building gets more dynamic and decoration, opulence and embellishment are more important in the 17th century. In Bruges Saint Walburga's church (1619-41) was built in this period, the Abbey of the Dunes (1628-42), the Carmelites' Church (1688-91), Blindekens (1651), the Bogarden chapel (1676), the interior of Saint Anne's Church, the Provost's House (1662-66) and the Palace of Justice (1722-27). Private houses also followed the fashion: façades were decorated with stone strips, round or oval oculi, reliefs with religious or allegorical motifs and volutes and were often painted in fresh colours and finished with rich portals. Examples are numerous: *Spiegelrei 5*, the house called De Witte Monnik from 1636, *Braambergstraat 25* from 1629, now the Chamber of Commerce, has a typical brick five-bay façade and two more bays in the Meestraat, brick tracery over the windows and a cornice with satyr consoles. *Braambergstraat 34* from 1664, the house called De Zwaan, is a painted volute façade. In the protrusion above the first floor, the four evangelists are represented, above this the four seasons and over the oculus the swan. The house called De Witte Pelikaan *Vlamingstraat 23* from 1672 has four bays with the four seasons in the tympanums and the pelican on top. This painted façade is further decorated with strips and two oculi. *Lange Rei 13* from 1716 is a younger, equally painted baroque bottle-shaped yellow and red façade with a scene of the Holy Trinity above the first floor. The façade was restored in 1977. *Predikherenstraat 25* from 1692 has a brick nine bay façade with a beautiful stone entrance door and plenty of edge blocks around the windows, and is crowned by a nice volute gable.

Next to bottle façades and volute gables, the baroque period has also practised the bell façade, to be seen in *Huidenvettersplein 10*, the former corporation house of the tanners. It is a huge complex with dormers and turret facing the Rozenhoedkaai, with a façade from 1776.

Rococo and Classicism (18th century)

During the 18th century the triumphant baroque was gradually weakened into the graceful and charming rococo or Louis XV style, succeeded, from 1750 onwards, by classicism or Louis XVI style, which sobered down to the point of sometimes becoming austere. Both styles, also combined, have been practised in Bruges.

In this period the late baroque domed church of the English Convent was built, the Carthusian church in the Langestraat which is more classicist already and the church of the Abbey of the Dunes tending towards the French classicist style. The austere and cold column gallery of the Fish market dates from 1820.

The carpenters' corporation house from 1764 in the *Steenstraat 38* now belongs to the Kredietbank premises, together with the adjoining house of the shoemakers (1527). Both houses and their rear façades were excellently restored by the architect Luc Dugardyn in 1980-85. The first, 18th century architect of the house would have been master carpenter Emmanuel van Speybrouck. The seven bay façade is almost 18 metres broad and has been built in blue freestone. Rivalry must have played a role at the time, for the carpenters probably wanted to outdo the shoemakers next door and the bakers and masons across the street. The façade's spacious and horizontal appearance is stressed by the frames above the first floor windows and by the protruding cornice crowned with a triangular fronton. The dimensions are in perfect harmony, the golden section and the prime numbers having been applied. A second example from 1709 is situated *Sint-Annarei 22*. The six bay façade has been plastered. Over the entrance door with steps and railing, which is not in the exact middle of the house, a balcony with balustrade. In the middle of the high mansard roof two large and two small dormer windows have been inserted. In and outside the house quite a number of film shots have been made, among others for 'L'Empreinte du Dieu' from the novel by the French writer Maxence van der Meersch – his grand parents were Brugeans –, for 'The Nun's Story' with Audrey Hepburn, and mainly for 'De Vorstinnen van Brugge' a (1972) television film by Maurits Balfoort after several stories by Maurits Sabbe.

Louis XVI style may be found exemplified in the house on the *Sint-Maartensplein 5*, a very broad nine bay façade from 1778-85. Next the house *Dyver 7* from 1775, also nine bays broad with a beautiful entrance with doorstep. This 'house with the crystal window-panes' also appears in literary work by Marcel Matthys, Willem de Mérode and others. Also worth mentioning is the 1776 entrance gate at the bridge of the Beguinage, the house *Steenstraat 20* from 1716, the 18th century plastered bell façade crowned with a triangular fronton *Simon Stevinplein 21* and the orangery from the second half of the 18th century of the house *Oude Burg 21*, facing the water of the Dijver.

The Neo Period (19th and 20th century)

The 19th century was the time of the Gothic Revival in Bruges. Public and private buildings were executed according to the True Principles (1841) of A. Welby Pugin, the great theorist whose ideas were promoted here by Lord Jean de Bethune and his school. The British architect Thomas Harper King lived in Bruges, translated and adapted Pugin's book and was involved in the construction of Saint Magdalen's church (1851-53) and others. The Chantrell brothers, also British, finished the spire of Saint Saviour's church. In this period and in this spirit of revival of the Gothic style, the following public buildings were constructed: the jesuit church of the Sacred Heart (1879-85), the State Teachers' College (1880-83), the Minnewater Hospital (1885-92), the Government Palace and Post Office (1887-1921). The latter three buildings were designed by Louis Dela Censerie, who was very active in Bruges at that time, also for restorations, which were invariably carried out in the neo-Gothic style. New private houses were built among others in the *Filips de Goedelaan 7-8* with carefully made tracery over the windows and bay, *Minnewater 4* and *Vlamingstraat 62* (1899) with a small and a large stepped gable and a stone bay over the entrance. The neo-Gothic style did leave its imprint in Bruges. In his novel 'Who was Oswald Fish?' (1981) A. N. Wilson claimed the following: 'Every Gothic architect, even a Gothic architect manqué, wants to see Bruges'.

Other neo-styles were also practised. The *City Theatre* (1868) and the house *Hoefijzerlaan 21* are neo-classic buildings. Neo-baroque are for example the house on the corner of the *Elf Julistraat* and *Koningin Elisabethlaan* and also *Filips de Goedelaan 22* with a characteristic portal and a volute façade.

The end of the 19th century and the beginning of the 20th century are characterized by eclecticism, an attempt to combine elements or details from older architectural styles with something new. This comes out very well along the ring-road (from the Bloedput towards the Guldenvlieslaan, Filips de Goedelaan, Koningin Elisabethlaan, Ezelpoortplein, Komvest): every possible neo-style can be seen here, either in a pure form or combined with other styles.

Modern architecture is hardly represented in Bruges. Art Nouveau or Jugendstil, Art-Déco and New Realism occur sporadically only. *Scheepsdalelaan 2* (1932) is an Art Déco façade by the architect J. Koentges in which a variety of materials and colours have been used. New Realism is represented by the Municipal Groeninge Museum from 1930 by the architect Jos Viérin and the house *Guldenvlieslaan 58* from 1937 by the architect Kaplansky.

Restoration and new architecture

After the second World War only, after decades of neo-styles, did an original characteristic architecture come into being in Bruges. In the centre of old cities the direct environment of the new building must of course always be taken into account. And next to this pressing question, restoration itself will always remain an exceptionally difficult task. The International Charter of Venice (1964), laying down the norms for the preservation and restoration of historical monuments, says that restoration should stop where hypothesis and a fortiori fantasy begin. The City Administration for the Conservation of Monuments and Urban Renewal (Oostmeers 17) correctly looks after this, for monumental buildings were created at a particular juncture and belong to the city landscape; they belong to a particular environment and should be preserved in it. They keep testifying to history and cannot be dissociated from it.

Most restorations so far have been successful. They have contributed to cheering up the city's appearance and prove to the many tourists that the city's monument conservation policy is very strict. Since 1965 a large number of public and private buildings have been restored with city subsidies: the Belfry and the Halles, the Provost's House, the Cross Gate, the Jerusalem Church, Saint Walburga's Church, the Speelmans Chapel, the Castle of Male, the tower ruin of the Romanesque church of Dudzele and the tower of Our Lady's Church in Lissewege.

Many civilian buildings have been restored as well: the White Wool Hall or House of the Genoese, the Hall of Watervliet, the house De Croone, the Shoemakers' row (now Folklore Museum) and the pigeon tower of the Zeven Torentjes. Two splendid mansions in the Naaldenstraat also figure on the list: the Hall of Bladelin (n°19) where the treasurer Pieter Bladelin once lived and also the banker Tommaso Portinari. After the restoration the inner court got back its spacious basket arch bays; two early Renaissance medallions of Lorenzo de Medici and Clarice Orsini have been integrated in the wall. A niche over the entrance in the building's Naaldenstraat façade was restored in 1988. In the Hall of Gistel (n°7) the monumental 18th century staircase from the demolished Saint Louis' college has been integrated.

New architecture is a problem in all old cities, and we may suppose that in all ages the building of new houses has been accompanied by discussions and controversy. Bruges' approach is illustrated in about six examples from the last few decades, three of them situated in the city centre and three in the outskirts, where buildings have been designed and erected more freely.

The new Municipal Public Library *De Biekorf* is an impressive and important realisation both for its appearance and for its cultural implications and impact.

Like other ecclesiastical and public libraries, the city library of Bruges has had a long and eventful history. Its historical core is the library of the Cistercian Abbey of the Dunes in Koksijde, founded in 1175, which was moved to Bruges along with the abbey which had to leave the coast in 1628 and settled in the new premises at the Potterierei, the present Major Seminary. During the French Revolution in 1798, all abbey and convent libraries were requisitioned by the authorities and centralized in a 'Bibliothèque Publique', attached to the 'Ecole Centrale du Département de la Lys' situated there. When these 'Ecoles' were abolished by Napoléon in 1803, the library was acquired by the city and put up in part of the Gothic Hall of the City Hall. In 1884 this library was moved to the Old Customs' House on the Jan van Eyckplein and about one hundred years later, in 1986, to a new complex between the Kuipersstraat and the Sint-Jakobsstraat, the first building really conceived as a library.

The Brugean 'bibliothèque publique', a child of the French Revolution, was first chaired by the 20-year old Jamaican Britisher William Frederic Edwards (1796-1808), who promptly changed his name into Guillaume Frédérique. The next librarian was the city secretary Pierre Jacques Scourion (1808-1838), next the keeper of the province archives Joseph Octave Delepierre (1838-1870), next the lawyer Gustave Julien Claeys (1870-1907) and finally the priest Alfons De Poorter (1908-1939). From then onwards the librarians have had the responsibility for and administration of the library as their only task: Walter Bossier (1939-1962), Jan Vandamme (1962-1987) and today Leen Speecke.

The present Municipal Public Library's collection and policy cannot be compared to those of the former libraries. First of all, it has twelve branch libraries, all of them offering a wide choice of books.

The Bruges City Library has developed from a reading room into a Public Library and record library and the number of loans has now reached more than one and a half million a year. In 1976 the construction of the new library, designed by the architects Luc Dugardyn and Luc Vermeersch, was started in the cultural heart of the city (City Theatre, Boterhuis and Music Conservatory are nearby) on the site of a former department store and a couple of houses, the façade of which have been preserved. It has become a massive but at the same time open and light red brick verticalist construction to be reached via the Sint-Jakobsstraat and the Kuipersstraat (main entrance). Two inner courts with greenery have been integrated; the dominant colours inside are grey and Burgundian red. Downstairs the building holds a nursery, the adult fiction lending library, the newspaper corner, the magazine (more than 500 titles) department and the record library. On the first floor are situated the non-fiction lending department, a spacious reading room with about 80 places and the youth library with a little theatre and storytelling room. The second floor of this building with 6,000 m^2 useful surface includes the bookbindery, the repository and the safe for valuable

books and manuscripts. The book collection is regularly added to and several important acquisitions and collections, such as the Guido Gezelle archives and the Minister of State Achille Van Acker's library (30,000 works) have enriched the library.

The library has been decorated with a large number of contemporary works of art. The marble sculpture (1984) in the hall by Pol Spilliaert is called *Formed by the Wind*. In the entrance work by Roland Monteyne and *The Joint Reader* (1977) by Marcel Eneman. In the reading room an eight panel painting (1982-83) by Albert Rubens, a wood and acryl composition *Sonate* by Ludo Verbeke, four ceramics (1984) by Lukas Vandeghinste and a black and white work (1984) by Lut Lenoir. In the lending libraries works of art have been put up by Paul Gees, *Horizontally Bent* and *Horizontally Carried*, a sculpture by Paul Van Rafelghem called *The Doubly Bearing*, *The Ruler* by the sculptor Joz De Loose, works by Willy De Sauter, a *Fallen Astronaut* (1986) by Roger Bonduel, *Twofoldness* (1971) by Eric Algoet, *Xenos* (1974) by Gilbert Swimberghe, *Ciel noir et figure linéaire* (1981) by Charles Szymkovicz, three works by Ania Staritsky and *Le pepit Barrage* (1973) by Pol Mara. In the youth department four stained-glass windows by Jos De Mey and a metal *Barred Cat* (1975) by Karel Dupon have been put up. In the record library *Topos IV* and *Topos V*, white lacquered compositions by the sculptor Renaat Ramon. The library also possesses structures by Gaston De Mey and work by Philippe Boutens, Alice Frey, Rik Slabbinck and Willem Van Hecke. The books have indeed been put up in a meaningful environment of modern art. On 4th March 1987 the society 'Friends of the Biekorf Library' was founded to organise literary and historical lectures, exhibitions and other happenings in and around this new library.

Note

* The Municipal Public Library (adult lending library, record library and reading room) is accessible on Monday and Tuesday from 9.30 a.m. to 12 and from 14 to 19 p.m.; on Wednesday, Thursday and Friday from 9.30 a.m. to 12.30 and from 14 to 20 p.m.; on Saturday from 9.30 a.m. to 12.30 and from 14 to 18 p.m. The youth department from Monday to Thursday from 14 to 19 p.m., on Friday from 14 to 20 p.m. and on Saturday from 9.30 a.m. to 12.30 and from 14 to 18 p.m. Bibliography: J. Vandamme, Het Bibliotheekwezen in Brugge voor 1920, (History of Bruges' Public Library up to 1920), 1971.

As light and airy a construction, designed by Fernand Sohier, is the Cultural Centre *De Dijk* along the Blankenbergse Steenweg of the former village of Sint-Pieters-op-den-Dijk. Not only does it put up a branch library, but also an active little theatre where cycles of contemporary theatre are presented by Nieuw Thea-

ter and Fris Kabaret. Since 1982 a five-metre high *Cyclops*, a steel, yellow lacquered sculpture by Renaat Ramon, has decorated this centre's entrance. Exhibitions of visual arts are also sporadically organised here.

For the building of the new *Court-House* (1979-1984) in the Langestraat, Kazernevest, Voldersstraat and Koopmansstraat, the architects Vivian Desmet and Jozef Depuydt were less hampered by any historical context. All judicial services which had for centuries been put up in the Palace of Justice on the Burg and in other neighbouring premises, have now been centralized in this new complex. Especially seen from across the canal, the complex provides a massive sight with its severe red brick verticalism and sharply contrasting black roofs. The remnants of an old Carthusian abbey found under the barracks which were pulled down for the new court, have nevertheless been preserved and integrated. This has produced a conspicuous and interesting combination and confrontation in the Langestraat. The Assize Court Hall has been decorated with stained-glass windows (1980) by Michel Martens.

The construction of the *Steeghere* (1977), a short-cut with shopping arcade and flats between the Wollestraat and the Burg, has been a much more delicate problem, because of the façade facing the Burg between the 16th century Criminal Recorder's House and the neo-Gothic building on the corner of the Breydelstraat from the 1930s. The architect Luc Vermeersch has decided in favour of an arrangement of surfaces stressed with materials and colours: brick and concrete in the façade, crowned by slate for the play of roofs. The central little gable's glazing provides a contemporary answer to the adjoining neo-Gothic stepped gable.

The *Zilverpand* (1979), designed by the architect Piet Viérin, is still another example of architectural integration in the centre of town. This shopping centre with about one hundred social flats upstairs and an underground car park, has been built on the site of the former Saint Louis' College which has moved to the Magdalenastraat in Sint-Andries, on which occasion the college's neo-Gothic chapel was pulled down. In the Noordzandstraat, Dweersstraat and Zilverstraat a number of façades have been preserved, but the façades facing the inner courts are all new. Time and again sculptures are exhibited in these courts.

The *National Bank of Belgium* moved to new premises outside the city in the Filips de Goedelaan next to the Donkey's Gate in 1987. The impressive building's red façades and black roofs, by the architect Arthur de Geytere, provide an interesting sight among the surrounding greenery.

Almshouses

Historically and even etymologically (the Dutch word 'godshuis' literally means 'God's house') almshouses were charitable institutions where the old aged were looked after and nursed 'for God's sake'. They were founded by individual benefactors or by the corporations, who had to help their old, sick or poor members from their so-called 'poor box'. Thus almshouses were founded by the masons (Noord-Gistelhof 1-9), the tailors (Oude Gentweg 126-130, from 1756), the bakers (Zwarte Leertouwersstraat 22-26 from 1770) and the shoemakers (Balstraat 27-41).

In Bruges 48 of such almshouse complexes have been preserved, the oldest from the 15th century, such as the foundations Donaas De Moor from 1480 or Van Campen-Sux and Van Peenen-Gloribus from 1436 in the Boeveriestraat, and the youngest from the 20th century. During the French Revolution, in 1796, they were taken over by the 'Administration of the Civil Hospices', in 1914 by the 'Commission of Public Welfare' and since 1976 have come under the OCMW or Social Welfare Council.

These usually modest, one-storey little houses which often carry the founder's name on their façades, can be found all over the city, especially in what is called West Bruges (Boeveriestraat, Hendrik Consciencelaan, Gloribusstraat, Van Voldenstraat, Greinschuurstraat, Kammakersstraat, Kreupelenstraat) and in the neighbourhood of the Katelijnestraat, Oude and Nieuwe Gentweg. Some were created in existing houses, such as the foundation Van Volden in the Boeveriestraat from 1614, now an OCMW social service centre, and the almshouse De Pelikaan (1634) along the Groene Rei. Other complexes are especially built rows of similar little houses each with its own entrance, such as the Shoemakers' row, (the new Folklore Museum), and the almshouse De Moor in the Boeveriestraat. Other houses, often very picturesque ones, have been grouped around inner gardens, an open garden such as the almshouse De Vos in the Noordstraat, closed as in almshouse De Meulenaere, in the Nieuwe Gentweg 8-22, also called The Twenty-Fours, because it was originally intended for 24 widows, or, finally, accessible via a passage such as the Roomsch Convent in the Katelijnestraat 9-19, a foundation from about 1330.

We pick out three of these almshouses which have some value for the art lover as well, though almost all of them can be entered, at least up to the garden. Like most almshouses the *Almshouse De Vos* in the Noordstraat 4-14, which can be seen from the street over a low wall, has its elegant private chapel, here with a beautiful baroque volute façade (1713).

The foundation of the *Sint-Joosgodshuis* in the Ezelstraat 83-95 would date back to the end of the 14th century, but the name was given by canon Joos de Bul, who supported and added to the foundation. His arms and patron have been re-

presented on the door needle of the porch.

The *Almshouse De Pelikaan* along the picturesque Groene Rei 8-12 has a beautiful façade and entrance door with a bas-relief pelican over the door and the date 1634 as well as the text 'Dischhuis de Pelikaen gesticht ten jare 1714' (Charity house the pelican founded in the year 1714). The founders were Frans van Beversluys and his wife Maria Magdalena van Westvelt who lived in their house 'In den gouden Pelikaen' in the Predikherenstraat behind this almshouse. Frans was a tax collector of the Franc of Bruges and his wife had a cat... One day she hung her most valuable jewels on the animal and put it in front of a mirror. It was so scared that it disappeared at once. Maria Magdalena is said to have made the promise of giving a monstrance to Our Lady's Church, if the jewels were found back. And indeed, the cat came back and, legend or not, in 1725 the woman gifted Our Lady's Church with a splendid work of art, a 3 kilo gold monstrance by the Bruges goldsmith Jan Beaucourt, which is 64 cm high and decorated with 150 diamonds, hundred of pearls and precious stones and enamel. The valuable monstrance is preserved in the church sacristy and is still called 'The Cat of Beversluys', though 'cat' also refers to 'chaton', which was the term for the mounting of precious stones. So legend and technique are intertwined in the name of this priceless work of art.

Art Galleries

Only the Groeninge Museum exhibits some contemporary art, while in all other museums and churches the youngest art is 19th century. This does not mean contemporary art should not be alive in Bruges. Every two years (1990...) in Spring, the City Council organises a large survey of Brugean contemporary painting, sculpture and related arts called *Sant* in the Halles. Since 1984 there is also the annual open-air exhibition of three-dimensional art *Aspekten* in the Sebrechts Park (Beenhouwersstraat and Oude Zak). For both art happenings catalogues are published each time.

Some traders integrate contemporary art in their shops. *Interior Design* (Oostmeers 7) has put up works of art of world famous artists among its furniture and wallpaper and also organises occasional exhibitions. *Callebert* (Markt 5), *Broes* (Mariastraat 14, Simon Stevinplein 12, Sint-Amandstraat 29) and *Die Swaene* (Noordzandstraat 19) all offer examples of contemporary design, various kinds of art objects and lithoes. *Limited Editions,* (Genthof 10) is a progressive shop selling posters and special prints.

Bruges also has a number of one man galleries, where artists permanently exhibit their own creations: the painter, ceramist and graphic artist *Renaat Bosschaert* (Sint-Annakerkstraat 6) who publishes carefully edited bibliophile works and sometimes organises thematic exhibitions, and the painters *Dieperinck*

(Hoefijzerlaan 34), *Fohan* (Ezelstraat 98) and *Marcaine* (Langestraat 31).

The range of real, more or less permanent art galleries, is quite varied. *'t Leerhuys* (Groeninge 35), which started in 1976, has by now become famous for its concerts, literary evenings and exhibitions of contemporary Belgian or foreign visual arts. *Marnix Neerman* (Sint-Annarei 23 B) exhibits the work of six or seven famous painters and sculptors. And the following galleries show all kinds of contemporary art: *Atelier Christine Steel* (Kleine Kuipersstraat 2A), *Kunsthuis Loosveldt* (Katelijnestraat 150), *In den Wulf* (Walplein 23), *De Lege Ruimte* (Blokstraat 32), *Minotaurus* (Ezelstraat 100), *Bruges-la-Morte* (Krom Genthof), *Panta Rei* (Spiegelrei) and *De Valckenaere* (Lissewege). Traditional figurative art gets a chance in *Maria Van Bourgondië* (Schaarstraat).

The *Kredietbank* (Steenstraat 38), the *Bank Brussel Lambert* (Markt 18-19), the *Generale Bank* (Saaihalle, Vlamingstraat) and *Spaarkrediet* (Vlamingstraat 62) regularly organise exhibitions in their historical premises, which do not pass unnoticed.

Mills

Marcus Gerards' panoramic plan (1562) has 25 mills standing on the Bruges ramparts. Antonius Sanderus mentions 27 in his 'Flandria Illustrata'. In 1863 23 of these still existed, all of them with typical legendary or topographic names.

In the following years about twenty mills disappeared, however, leaving only three in 1879. Today there are still three mills, but only on the rampart between the Cross Gate and the Damme Gate. The one closest to the Cross Gate is called *Bonne Chiere* (good show), a standard mill from Olsene (1844) and re-constructed in 1961, it has never functioned. The *Nieuwe Papegaai* (The new parrot) is a 1790 oil mill, acquired by the city of Bruges in Beveren on the IJzer in 1970. The *Sint Janshuismolen* (Saint John's House Mill), finally, was built by a group of bakers in 1770 who had, the year before, bought the Mill Mountain on which a mill had stood before. This mill was acquired by the city of Bruges in 1914 and can grind grain since 1964. It is the only mill which can be visited and has been equipped as a kind of museum.

Note

* The Sint-Janshuismolen is accessible from 1st May to 30th September. Bibliography: C. Devyt, De Sint Janshuismolen op de Kruisvest te Brugge, 1970 (The Saint John's House Mill on the Cross ramparts in Bruges); C. Devyt, Westvlaamse windmolens, 1966 (Windmills of West Flanders); L. Devliegher, De molens van West-Vlaanderen, 1984 (The Mills of West Flanders).

Parks

Bruges makes great efforts to preserve and add to the city's parks and gardens. Their surface has grown from 110 ha in 1970 to 550 ha today. Bruges is in fact surrounded with a green belt, the seven-kilometres long ramparts, the most famous of which are called: Gentpoortvest, Boeverievest, Begijnenvest, Kazernevest, Komvest, Kruisvest. They are remnants of the city's second walls (1297-1300) or of the 17th century fortifications, which can still be recognized on the protruding bastion with the bust of the 19th century Bruges sculptor Hendrik Pickery or at the Powder Tower next to the bridge over the Lake of Love. These ramparts, designed and planted at the end of the 19th century, form one large and attractive park with plenty of different trees and shrubs. A walk on these ramparts brings you right around the city and past the four existing city gates.

Between the Boeverie Gate and the Blacksmith's Gate, along the Hendrik Consciencelaan near the Fonteinstraat, stood as early as the end of the 14th century, a 'little stone house', probably the predecessor of the present little building called the Old Waterhouse. It used to be a kind of distribution centre and reservoir for the city's water supply and worked till the 18th century.

Inside the city as well a number of beautiful and carefully tended parks can be visited. The *Arents Park* is in fact the former vegetable garden of the Gruuthuse Hall. The classicist mansion built across the Reie now holds the Brangwyn Museum. In front of the museum entrance a number of coaches and sledges have been exhibited. The park is called after the premises' last proprietor Aquilin Arents de Beerteghem. The house and garden were expropriated by the city and thrown open to the public in 1909. The Park is accessible from the Dijver, the Groeningestraat and the Boniface bridge. The latter was built as late as 1912, when the whole park was designed and laid out according to the plans of the architects L. Viérin and U. Salmon. In the same year two massive columns from the disappeared Water Hall on the Market square were put down here. In 1987, finally, bronze sculptures by the artist Rik Poot (1924) from Vilvoorde were mounted on sturdy plinths. These 'Four Riders of the Apocalypse' (1981-1987), grand and delicate creations, are typical for this artist's expressionist works, the segments of which manage to combine power and tenderness. These figures from the end of the Bible, the Book of Revelation, written by Saint John between 81 and 96, have been represented by artists of all times. In the nearby Memling Museum we see them scattering disasters over the world from the upper half of 'The Mystical Marriage of Saint Catherine' (1479). A century before, the Duke Louis I of Anjou had the miniatures of his court painter Jan of Bruges or Boudolf or Hennequin converted into cartoons for the one-hundred metre tapestry 'La tenture de l'Apocalypse' (1378) on view in the castle of Angers. And who is not familiar with the splendid engraving by Albrecht Dürer 'Knight, Death and

Devil' from 1513? The four riders symbolize the lust for power, war, famine and death.

The *Queen Astrid Park* near Saint Magdalen's Church was acquired by the city in 1850 and laid out (3 ha) on the site of the former monastery of the Friar Minors. Its lay-out in 18th century English country-style was designed by the landscape architect Egidius Rosseel from Louvain. Around a central pond in which the Neptune sculpture 'The Man with the Sea Slug' by Godfroid Devreese was put up, winding promenade walks bring you past well-tended flower-beds and numerous plane-trees, copper beeches, weeping willows, bean trees, tulip trees and magnolias. The park also contains a children's play area. The bandstand dates back to 1859 and the queen's bust was created by the Brugean sculptor Alfons De Wispelaere. At first the park was called 'The Friars Minors' Garden', next 'The Botanical Garden', the 'Park' or the 'Pleasure Ground'; in 1935, on the occasion of Queen Astrid's death, it was given its present name. It is popularly called the park of faith (Saint Magdalen's church), hope (the neigbouring prison) and love (the cuddling couples under the trees).

The *King Albert Park* between 't Zand and the railway station has been laid out on the strip of land which was used for the coast railway line until the 1930s. Since 1949 this well-tended landscape park with sloping lawns has constituted a welcoming entry to the city. The bronze equestrian statue of King Albert by the Brugean sculptor Octave Rotsaert was inaugurated in 1954. Nearer to the station stands the sculpture 'Boy with Pelican' by the animal sculptor Josue Dupon.

The *Sebrechts Park*, accessible via the Beenhouwersstraat and the Oude Zak, was probably the 15th century vegetable garden of the Black Sisters of Saint Elizabeth and was acquired by the Brugean surgeon Jozef Sebrechts (1885-1948) in 1928. The doctor and his wife have been portrayed in the wall medallion next to the entrance gate in the Oude Zak by the sculptor Octave Rotsaert. In 1980 the buildings and the Park were acquired by the city and the park was given its present name. Each July and August an open-air exhibition of contemporary three-dimensional art called 'Aspekten' is organised here by the City Council. The park itself has some fine examples of yellow ashes, medlar trees, honey trees and magnolias in Spring.

The *Graaf Visart Park* was named after count Amédée Visart de Bocarmé (1835-1924) who was the mayor of Bruges for a period of forty years in the 19th century. Situated between the Karel de Stoutelaan and the Maria van Bourgondiëlaan, it was first laid out as a miniature traffic square, but is now used as a local play area.

The *Lodewijk van Haecke Public Garden* between the Ezelstraat and the Raamstraat contains an impressive marsh cypress, a Japanese walnut tree and a black mulberry tree. Designed in 1983, it was named after the popular priest of the Chapel of the Holy Blood (see Burg).

The *Minnewater Park* (1979) is situated on a plot of land which had been used as bleaching meadows ever since the middle ages (see Wijngaardplein). The *Baron Ruzette Park* is a small stopping place opposite the Saint Joseph's Hospital along the Komvest (ring-road).

The *Sincfal Park* (Sincfal of Sincfala being the old name of the Zwin), accessible via the Sint-Claradreef and the Kalvariebergstraat, was created in 1977 on the site of the former convent of the Rich Clares (1262) where the Capuchins had their monastery between 1867 and the 1960s. The church and monastery were pulled down and a number of welfare houses were constructed around a little park with Summer linden trees, oak trees, yew trees and ashes.

Note

★ Bibliography: W. Adrianssens e.a. Green Bruges, 1987; E. Vandevyvere, Watervoorziening te Brugge van de 13e tot de 20e eeuw, 1983 (Water Supply in Bruges from the 13th to the 20th century); A. Janssens de Bisthoven, Geschiedenis van het Arentshuis, in Catalogus van de Brugse Stadsgezichten, 1977 (History of the Arents House. In Catalogue of the Brugean Cityscapes).

Pumps

The public water supply system in Bruges was constructed in 1923. Before this date the population had to make do with public pumps. Though mainly functional, some of these were skilfully decorated, especially in the 18th and 19th century. Of the pumps which have been preserved, the following are worth mentioning: the monumental wrought-iron pump and lantern in the Collaert Mansionstraat against Saint Giles' Church probably from 1851; the double pump on the Eiermarkt in the plinth of a rococo work of art (1761) by Pieter Pepers: the polychrome coat of arms of Bruges is held by a lion and a bear; the pump in Groeninge against the wall of the Arents Park, decorated with a cast-iron swan made by Eugène Simonis and with the letters S P Q B (Senatus Populusque Brugensis, the Authorities and People of Bruges) and the date 1857: this pump was moved from Saint Magdalen's Church to this street in 1952; the pump in Onze-Lieve-Vrouwe-Kerkhof-Zuid with a stone Virgin with Child (1938) by Alfons De Wispelaere, a copy from a work by Pieter Pepers; the pump with an aboveground well and a wrought-iron super-structure (1902) by Alfons Verniewe in the Sint-Jakobsstraat; the neo-classic 1877 pump with low-relief lions' heads by the stonemason Henri Dumon on the Sint-Jansplein and finally the pump (1741) with bronze rococo dolphin by Joris Dumery in the Groeninge Museum formerly situated next to the Smedenkapel and the obelisk-shaped neo-classic pump by Jan Robert Calloigne in the middle of the Fish Market.

Note

★ Bibliography: E. Vandevyvere, Watervoorziening te Brugge van de 13e tot de 20e eeuw, 1983 (Water Supply in Bruges from the 13th to the 20th century).

City Gates

The oldest city ramparts were already defended with six bastion gates which have disappeared: the Old Mill Gate, the Saint James's Gate, the Fleming's Gate, the Sandy Clay Gate, the Our Lady's Gate and the Burg or Blind Donkey Gate. Traces of the latter can still be seen in the Blinde Ezelstraat: 'Hier was 't de Zuydpoorte' (Here was situated the South Gate).

The second ramparts (1297-1300) were hardly changed until the end of the 18th century. They included the present city gates and a few (the Dudzele or Saint Lenard's Gate, the Boeverie Gate and the Saint Catherine Gate) which were pulled down in the 19th century after they had lost any strategic function and emperor Joseph II ordered that they should be destroyed.

Four city gates, monumental works of art, have been preserved.

The *Ghent Gate*, a sturdy military bulwark with two massive towers, was originally built on the second city ramparts. It was first called 'porta juxta scoenamis', the gate next to Scoenamis, the name of a little castle also called Beaupré or Beaupriet (beautiful meadow) which was known until the 17th century. The name Ghent Gate appeared about 1336. The names of the bricklayers working on the gate in the 14th and 15th century have been preserved: Mathias Sagen, Cornelis van Aelter, Jan van Oudenaarde, Maarten van Leuven, Jan de Maech. The latter worked on it in 1513-14. Thus the gate occurs on Marcus Gerards' map. In 1448 a stone statue of Saint Adrian, invoked against the plague, was put up on the gate's city side. Originally sculpted by Jan van Cutsegem, it was re-made by Michiel Poppe in 1956. On 3rd May 1382 the soldiers of Ghent and Philip of Artevelde entered the city by this gate after having slain the Brugeans on the Beverhoutsveld, but by the same gate the Germans left Bruges in 12th September 1944 after the second German occupation (memorial plaque on city side).

Between Bruges and Sint-Andries we pass the *Smedenpoort* (Blacksmith's Gate) also built in the 14th century, when the second ramparts were constructed, by Jan Slabbaert, Mathias Sagen and others. It was called Magdalen Gate after the Magdalen leper's hospital on 't Zand, later transferred to Sint-Andries outside the gate, where a street is still called Magdalenastraat today. The Blacksmith's gate is the only two-way city gate. Whether real history or legend is unknown, but here the governor Jacques de Châtillon and chancellor Pierre Flotte are said to have escaped by swimming from the Brugse Metten rising in 1302. Another

story is told about the bronze skull on the city side of the gate. It reminds of a certain Frans van der Straeten from Eeklo who was beheaded because he wanted treacherously to hand over the city to the French via this gate. By judicial decision his skull was put up as a warning, but replaced by a bronze specimen in 1911. The last restoration of this Gothic building dates back to 1948, for the withdrawing German troops had blown up the gate in 1944.

The *Ezelpoort* (Donkey's Gate) is one of the most beautiful city gates. Built in the 17th and the early 18th century, when a fronton was added to the façade, it was last restored in 1906 and is falling to ruins. It will be restored by the National Bank of Belgium who have had their head office in the neighbouring Filips de Goedelaan since 1987. Emperor Joseph II used this gate to enter the city in 1781, and so did Napoleon in 1803. The Dutch troops fled through this Donkey's Gate on 27th September 1830 and Leopold I, Belgium's first king, entered by it on the 17th July 1831.

The *Cross Gate*, originally built on the 1297 ramparts as a military construction with a strong gate and drawbridge (the names of Jan van Oudenaarde, Mathias Sagen and Maarten van Leuven occur again) has often been changed since. By this gate the 'Klauwaerts' entered Bruges to kill the French in the night of 17th-18th May 1302, the night of the Brugse Metten rising. On 19th October 1918 the Germans left Bruges by this gate at the end of the first German occupation (memorial plaque on the city side). The Cross Gate was thoroughly restored in 1969-72.

Of the other city gates only the names have been preserved. The *Boeveriepoort* was more or less situated on the spot where today a viaduct links Bruges with Sint-Michiels. It disappeared in 1863. The *Katelijnepoort* (Catherine Gate) reminds of the Saint Catherine parish which existed outside the gate in Assebroek and has been re-founded. The last remnants of the gate disappeared in 1782 and 1862. It was by this gate that the Brugeans left the city for the Battle of the Golden Spurs and came back triumphantly. Philip the Fair and his jealous wife Joanne of Navarra entered the city here in 1301. And Louis XV (1745), emperor Napoleon (1810) and King William I (1829) made their entry in the city via this gate. On the spot now called *Dampoort* (Damme Gate) three gates stood: the Spei Gate (1297), the Saint Lenard's Gate (1265) and the Koolkerke or Saint Nicolas Gate (1268), all of them pulled down in 1872. Yet, these were the gates by which famous couples entered the city with full lustre after having celebrated their marriages in Sluis and Damme: Philip the Good and Isabelle of Portugal (1430), Charles the Bold and Margaret of York (1468)... Sic transit gloria mundi.

PANTHEON

of a limited number of people from Bruges or closely linked to it from the artistic and cultural world of today and of the past, of whom more or less accessible traces such as works of art, portraits, statues, commemorative plaques, books and houses can be seen in the city.

Anselmus ADORNES (Bruges 8.12.1424 – Scotland 23.1.1483). Most famous scion of the Adornes family, the founders of the Jerusalem Chapel. Member of the City Council and Mayor (1475-76). Pilgrim to Jerusalem and famous author and orator. Councellor of Charles the Bold, Mary of Burgundy and the Scottish King James III. Diplomat and merchant. He was the consul of the Scottish traders in Bruges. He traded with the Germans, but mainly with the Scots. Was knighted by James III of Scotland, given the Order of the Unicorn and appointed curator of the privileges of the Scottish traders in the Low Countries. On the monumental tomb in the Jerusalem Church he is wearing the chain of the Scottish Order of the Unicorn. Was murdered during a stay in North-Berwich in Scotland (on the reclining statue of the monument the sword sticks out of his right side) and buried in Linlithgow. His heart was interred in Bruges. Played an important role in the cultural life of the Burgundian period.

AERTS. Family of sculptors and architects, among whom Willem (Bruges † 8.4.1537). Together with Jacob Dodekin he designed the façade of the Hall of the Franc of Bruges, and, together with Benedict Vanden Kerckhove and Christiaan Sixdeniers, the former Criminal Recorder's House on the Burg and the winding staircase to the upper church of the Chapel of the Holy Blood. Joost (Bruges † 1577) designed the black stone sarcophagus (1560-61) of Charles the Bold's monumental tomb in Our Lady's Church. The tomb of Olivier Vredius in the same church is attributed to Rochus (Bruges 1721 or 1739).

Jan BEERBLOCK (Bruges 10.1.1730 – 10.10.1806). Painter. Studied at the Municipal Academy with Matthias de Visch and others. Painter of cityscapes, interiors and genre painting. His 'View of the Old Wards' (1778) of Saint John's Hospital (Memling Museum) is a remarkable historical and iconographic document. More than 25 prints in the Steinmetz Collection with important Brugean squares, chapels and monasteries, always beautifully decorated.

BENING. Family of miniaturists. Almost no work by Alexander or Sander (Bruges † 1519) has been preserved. His son Simon (Ghent 1483 – Bruges 1561) worked in Bruges and became a member of the Saint John's and Saint Luke's Corporations, of which he was the dean in 1524, 1536 and 1546. He brought the art of miniature to real and trend-setting prosperity. By order of Charles the Fifth he illustrated the Book of Arms of the Golden Fleece. He also provided the miniatures in the 16th century Hennesey Book of Hours of Our Lady (Royal Library, Brussels) and the Golf Book (British Museum, London). He collaborated on the Breviarium Grimani (San Marco Library, Venice). In 1987 a facsimile edition of his 'Flämischer Kalender' was published in Lucerne. His daughter Livina worked as a miniaturist at the British King Henry VIII's court from 1545 onwards.

Ambrosius BENSON (Lombardy about 1495 – Bruges, buried 12.1.1550). Became a

burgher and freeman in 1519. Painter of religious scenes and monumental portraits inspired by his master Gerard David. In the Groeninge Museum: 'Triptych with Madonna and Child' (1533), 'Rest on the Flight into Egypt', the middle panel of a triptych from about 1530, 'Saint Magdalen' (1530?), 'Madonna with Child' (1520-25) and an excellent portrait of Otho Stockoven (1542).

BERGER. Family of Brugean sculptors and organ-builders. Jacobus I (?-1701) was the sculptor of confessionals with allegories and of the almsmasters bench (1688) in Saint Anne's Church and of confessionals in Our Lady's Church (1697). Andries Jacobus (1712-74) built the late baroque organs of Blindekens (1737) and the Beguinage (1754). Dominicus I (1747-97) built the organ in the Abbey of the Dunes (1790), now Major Seminary.

Robert Laurence BINYON (Lancaster 10.8.1869 – Reading 10.3.1943). Studied at Saint Paul's School and Trinity College in Oxford. He took up office with the London British Museum, where he was the curator of oriental paintings and prints from 1913 to 1933. In 1933-34 he was a 'Professor of Poetry' at Harvard University, where he succeeded T. S. Eliot. Published several poetry collections, such as 'Bruges' (1919), a 50-copies edition of an art file with six poems by Binyon, illustrated with wood engravings by Y. Urushibara, after designs by Frank Brangwyn, published by Morland Press, London. Two of these poems + print are exhibited in the Bruges Brangwyn Museum. In the same year he published 'The Four Years. War Poems' including the well-known poem 'For the Fallen' often recited at war commemorations. He also published essays and wrote a splendid translation of Dante's 'Divina Commedia'. His style is usually called academic and the poems are traditional and partly cerebral.

Pieter BLADELIN the Younger (1408-1472). Councellor (1440) and major domus or treasurer (1444) of Philip the Good. Treasurer (1446) of the Order of the Golden Fleece. Collaborated meritoriously on the foundation of the little city of Middelburg (province of East Flanders) about 1452 by reclaiming the polders. The Hall of Bladelin in the Naaldenstraat, a house with turret built in 1451, reminds of him. In 1466 it passed into the hands of the de Medici family and it was acquired by their representative in Bruges, Tommaso de Portinari, who continued his banking activities there until 1497. From 1829 onwards it was the girls' boarding-school and lace-makers' school called the 'Foersche School' (after the priest Leon de Foere). Since 1949 rest home of the Sisters of Our Lady of the Seven Sorrows.

Lanceloot BLONDEEL (Poperinge about 1498 – Bruges 4.3.1561). Painter. Freeman in Bruges in 1519. Also designer of sculpture, maps, stained-glass windows, organcases and tapestries. Designed the Renaissance mantelpiece of Charles V (1528) in the Provincial Museum of the Franc of Bruges on the Burg. Drew a plan for a direct connection of Bruges with the sea. Paintings in the Groeninge Museum: 'Saint Luke Painting the Portrait of Our Lady' (1545) and in Saint James' Church an altarpiece with the saints Cosmas and Damianus. Lived in the Sint-Jorisstraat. In the cornerhouse façade balcony Elf Julistraat 41 (1909) four of his activities have been represented: geometry, architecture, sculpture and painting.

Frank BRANGWYN (Bruges 12.5.1867 – Ditchling, Sussex 11.6.1956). English painter, draughtsman, graphic artist and designer of furniture and interiors. Son of architect and painter William Brangwyn. Was articled to William Morris. The life of

workers, fishermen and harbour areas constitutes the main theme of his paintings and etches, which are remarkable for their vibrating light, magical colours and sometimes oriental enchantment. Made more than a thousand works of art, a large part of which was donated to his native city in 1927, 1936 and later and is preserved in the Brangwyn Museum, Dijver. Since the exhibition 'Brangwyn, Bruges and West Flanders' in 1968 and an important retrospective exhibition in 1987 with a complete catalogue of his works, the Arents House has again been used as the Brangwyn Museum.

Jan BREYDEL (Bruges about 1264 – about 1330). Brugean popular leader. Powerful, rough and impulsive temperament. Butcher and merchant from a rich family. At the head of the city militia taking the castle of Male and of the Brugse Metten rising. Did not take part in the Battle of the Golden Spurs, but provided meat and food for the warriors. Was the Brugean representative of the Flemish Estates General in Courtrai in 1304 and a member of the Brugean delegation on the talks in Beauvais about the Treaty of Athis-sur-Orge. Fulfilled several diplomatic missions (Brabant, Hull) and stood surety for a loan to the city of Bruges. Statue (1887), together with Pieter de Coninc, on the Market Square.

Jan Robert CALLOIGNE (Bruges 25 or 31.5.1775 – Antwerp 28.8.1830). Sculptor and draughtsman. Studied in Ghent, where he won a first prize with a bust of Jan van Eyck, in Paris where he won the Prize of Rome in 1807 and in Italy. Director of the Bruges academy. His statue of Jan van Eyck on the Burg and his classic colonnade on the Fish Market date from 1820.

Livia CANESTRARO (Rome 1936 – Snellegem). Sculptor and draughtswoman. Powerful and monumental work. Realized, together with Stefaan Depuydt, a number of new statues for the City Hall façade and the large fountain monument (1986) on the Zand. A bronze symbolization of music and a few other sculptures to decorate the façade of the former Anglican Church, now the Joseph Ryelandt Hall (Ezelstraat) of the Conservatory, in 1987.

William CAXTON (Kent 1422 – London 1491). Printer, letter designer (he had six different types cast) and author. Settled in Bruges (1441-1476) as agent of the English merchants. Learned the printing profession in Cologne (1471-72) and founded a printing press in Bruges together with Colard Mansion. About 1475 he printed three important books in Bruges: 'The Recuyell of the Historyes of Troye', the first English book ever to be printed, which he himself had translated from French, and next 'The Game and Playe of Chesse' and 'Quatre derrenieres Choses'. He returned to England in 1476, where he built a printing press in Westminster and published almost a hundred books mostly translated from French, Greek and Latin by himself.

CHARLES THE GOOD (Karel de Goede) (Denmark – Bruges 2.3.1127). Count of Flanders (1119-27) in succession to Baldwin VII Hapkin. Popular for his righteousness and his stimulation of trade in the cities. Murdered in Saint Donatian's Church. Portrait on a painted and sawed-out panel (15th century) in Saint Saviour's Cathedral.

CHARLES THE BOLD (Karel de Stoute) (Dijon 1433 – Nancy 1477). Son of Philip the Good. Duke of Burgundy (1467-77). One of the most important generals of his time, ambitious and clumsy. Fallen in the battle near Nancy. Monumental tomb (1562) in Our Lady's Church.

CHARLES I STUART (London 1630 – 1685). King of England, Scotland and Ireland. Was defeated by Oliver Cromwell's army at Worcester in September 1651, after which he

and his mother went into exile. He stayed in Bruges in the disappeared House with the Seven Turrets in the Hoogstraat, one of the seven wonders of Bruges, from 22nd April 1656 to 15th March 1659. He became a member of the Saint George's Guild of cross bow archers (Sint-Jorisstraat), of the Saint Sebastian's Guild of longbow archers (Carmersstraat) and of Saint Barbara's arquebus archers (Schuttersstraat). He visited the English Convent. After his restoration (1660) and return to England he granted the fisheries privilege to Bruges in gratitude for the hospitality: fifty Brugean fishermen were allowed to cast their nets in the English territorial waters in perpetuity.

Robert Denis CHANTRELL (Newington S. London baptized 24.1.1793 – Norwood Surrey 4.1.1872). Painter, engineer and architect, mainly of churches. Involved in the construction or restoration of about forty churches in Yorkshire between 1818 and 1860, all of them in the neo-Gothic style of which he was one of the theorists. The damage of the fire (19-7-1839) in Saint Saviour's Cathedral was repaired by the contractor William Chantrell, brother of Robert who controlled the works. The (truncated) tower on top of the original towerpart of the church (1843-46) was built according to his neo-Romanesque design. The spire was added in 1872 only. He also designed an extension of the aisles and a new west façade, but these were never realized.

Geoffrey CHAUCER (London about 1340 – 1400). English poet, justice of the peace, servant of English kings and earls, tallyclerk of the port of London and father of the English language. Wrote among others 'The Canterbury Tales' (started about 1376), stories by the pilgrims to the Canterbury grave of Thomas, a splendid example of a literary frame tale, inspired by Boccaccio's 'Decamerone'. During his diplomatic missions, mostly on secret service, Chaucer must often have been on the continent. In 1376 and 1377 he must have been in Bruges, which he mentions in 'The Tale of Sir Topaz' and in 'The Shipman's Tale'.

Petrus CHRISTUS (Baarle East Flanders about 1415 – Bruges about 1472). Became a burgher of the city in 1444. Painter, slightly influenced by Jan van Eyck. In the Groeninge Museum: 'Isabelle of Portugal with Saint Elisabeth', the left panel of a triptych from about 1456-60 and two panels of a polyptych with 'The Annunciation' and 'The Nativity' (1452).

CLAEISSINS. Family of Brugean painters. By Pieter I. Claeissins the Older (1499 or 1500 – 1576) in de Groeninge Museum 'Crucifixion', in Saint Saviour's Church 'Resurrection of Christ' (1537) and in the Beguinage 'The Seven Wonders of Bruges' (1540). By his son Pieter II Claeissins the Younger (about 1540-1623) in the Groeninge Museum the 'Allegory of Peace in the Netherlands in 1577', 'Portrait of an Elderly Woman' (1598) and a Map of The Franc of Bruges (1597) and in Saint Saviour's Church the two wings of a triptych 'Members of the Board of the Shoemaker's Corporation'. By another son of his Antheunis (about 1538-1613), an apprentice of Pourbus's and like Pieter II city painter of Bruges, in de Groeninge Museum 'Banquet' (1574) and 'Mars Flanked by Art and Science' (1605) and in Saint James's Church 'The Members of the Brotherhood Worshipping the Holy Sacrament' (1590).

Jef CLAERHOUT (Tielt 29.10.1939 – Oedelem). Sculptor. Works in Bruges: model of Halles and Belfry and bronze city map for the visually handicapped in front of Belfry and Halles on the Market Square; horses' heads on the watering place for carriage horses on the Wijngaardplein (1982); bronze sculpture on the Walplein 'Zeus, Leda, Prometheus and Pegasus visiting Bruges' (1982); 'Papageno' (1980) from Mozart's 'Die Zauberflöte' in

front of the City Theatre and in the pavement just opposite a part of the score from the same opera; statue of Willem van Saeftinge (1988) in Lissewege and Jacques Brel's 'Marieke' (1988) along the Coupurerei.

Gerard DAVID (Oudewater, The Netherlands about 1460 – Bruges 13.8.1423). painter, accepted into the Brugean painters' corporation in 1484. Lived in the Sint-Joris-straat. Called 'the last of the Flemish Primitives'. Masterpieces by him in Bruges: the diptych with the 'Judgement of Cambyses' (1498) and the triptych 'The Baptism of Christ' (1520) in the Groeninge Museum. The 'Transfiguration on Mount Tabor' in Our Lady's Church is attributed to him.

Anselmus Boëtius DE BOODT (Bruges about 1550 – 2.6.1632). Doctor and jurist, physicist and humanist. Court physician and councellor of emperor Rudolf II in Prague. Published scientific works, translations and collections of poems along the lines of the Counter Reformation, such as 'Symbola divina et humana' (1603) and other pietistic exhortations. Portrayed on a panel of the 'Transfiguration on Mount Tabor' attributed to Gerard David in Our Lady's Church. Memorial plaque on his house Ridderstraat 10.

Pieter DE CONINC (Bruges about 1255 – 1332). Brugean popular leader. Dean of the weavers. One-eyed, small, tough and eloquent. Lead a rising in Bruges end of June 1301, arrested, but freed and next exiled. Secretly returned to Bruges in January 1302, lead the destruction of the castles of Male and Sijsele and was the brain behind the Brugse Metten rising, 18th May. Took part in the Battle of the Golden Spurs, where he was knighted after one of the battles. Famous as a leader all over Europe. Received a house (in the Hoogstraat) and an annual allowance of 1,000 pounds in recognition from the city. Statue (1887) together with Jan Breydel on the Market square.

Joost DE DAMHOUDER (Bruges 15.11.1507 – Antwerp 22.1.1581). Jurist of interna-tional renown. Public prosecutor, pensionary and criminal recorder in Bruges. Wrote important juridical works such as 'Praxis Rerum Criminalium' (1565) and 'Praxis Rerum Civilium' (1965), the latter partly plagiarized from Filips Wielant. Also published the apology 'De Magnificentia Politiae Amplissimae Civitatis Brugarum' (1564). Portrait on Pieter Pourbus' painting in Our Lady's Church. Buried in the church of the Potterie.

Louis DELA CENSERIE (Bruges 27.9.1838 – 2.9.1909). Studied at the Academy of Bruges. Prize of Rome 1862. Architect. Teacher and director (1889) of the Academy. Director (1870) of the city public works. Backed by the Société Archéologique and by periodicals such as Rond den Heerd he realized the Hospital of the Sisters of Love in the present J. Sebrechtsstraat (1885-92), the State Teachers' Training College in the Sint-Jorisstraat (1880-83), the Provincial Court and Post Office in the Market square (1887-1921), all in neo-Gotic style. He restored the Old Recorders' House (1901-05), the Palace of Gruuthuse (1883-95), the Poorters' Lodge and the west façace of Our Lady's Church (1907-08) along the same lines. He was also the architect of the Central Railway Station (1895-98) of Antwerp and of the Peter and Paul's Church (1901-05) in Ostend.

Stefaan DEPUYDT (Gistel 1937 – Snellegem). Sculptor. Sculpture on the lawn in front of the State Institute for Higher Education in Sint-Michiels. Together with Livia Canes-traro he realized a number of sculptures for the City Hall façade (1986-88) and for the Joseph Ryelandt Hall (1987) of the conservatory in the Ezelstraat and also the fountain monument (1986) on the Zand.

Nikolaas DESPARS (Bruges 1522 – Koolkerke 20.11.1597). Alderman and Reformed

Mayor (1578-04). Wrote a chronicle 'Chronycke van den Lande ende Graefscepe van Vlaanderen 405-1492', first published in 1837-40. Lived in the castle Ten Berge in Koolkerke. Niche tomb in the church of the Potterie of which he was a guardian and governor. Portrait painting by Edward Wallays in the City Hall entrance passage.

Matthias DE VISCH (Reninge 1702 – Bruges 23.4.1785). Painter and draughtsman. Studied in Paris and Venice (with Piazetta). Director of the Academy in 1739. Very productive and influential 18th century painter. In the Gruuthuse Museum 'The Silver and Goldsmith's Trade' (1735), in de Groeninge Museum a beautiful 'Portrait of a Young Girl' (about 1750) and others, in the Brangwyn Museum several cityscapes, among which 'The Prison' (1746).

DUMERY. Family of Brugean bell-founders. Famous all over Europe. Joris (1715-87), Willem (1725-93), Jacobus (1773-1836), Willem (1772-1848). Joris, the most important one, provided a new 34 bells carillon and a clockwork cylinder in the Belfry in 1741. They also produced separate bells, monuments (Dolphin, Groeninge), balusters and lecterns. From 1740 to 1865 the bell-foundry was situated in the Klokstraat in West Bruges, which is commemorated in a bell cage put up in the Boeveriestraat in 1988.

EDWARD IV (Rouen 1441 – Westminster 1483). Son of Richard of York and brother of Margaret of York, who was married to Charles the Bold. King of England. From 13th January to 19th February 1471, in the period of the bloody Wars of the Roses, he stayed in Bruges with Louis of Gruuthuse, whose passion for beautiful manuscripts he shared. In gratitude for this hospitality Louis received the title of Earl of Winchester. The coat of arms of this 'haut et très puissant prince Edward, roy d'Angleterre' has been put up in Saint Saviour's Cathedral, among the coats of arms of the Knights of the Golden Fleece, who held their chapter here in 1478.

Queen EMMA (+ Winchester 1052), the wife of King Canute settled in Bruges in 1037 after her husband had died. She was welcomed by Baldwin V, the duke of Flanders, in the Steen. In the 'Encomium Emmae Reginae', a laudation for this queen, Bruges is said to be 'famous by the visit of numerous merchants and because the most appreciated goods abounded here'.

Joe ENGLISH (Bruges 5.8.1882 – Vinkem 31.8.1918). Son of an Irish maker of gold embroidery. After having studied at the Bruges and Antwerp academies (with Juliaan De Vriendt), a painter, draughtsman, illustrator of books and periodicals, designer of flags, picture postcards and picture stamps. Front soldier. Designed the Celtic heroes' tombstone. Memorial plaque at his house Canadastraat, Sint-Michiels.

Jan Antoon GAREMIJN (Bruges 15.4.1712 – 23.6.1799). Painter. Designer of triumphal archs. Lived in the Ridderstraat, later in the Grauwwerkersstraat. Director of the Academy (1765-75). Very productive drawing-room painter in castles and mansions. Paintings in the Gruuthuse Museum: 'Self-Portrait', 'Street Musicians', 'John with the Doughnuts', 'The Digging of the Ghent Canal', in Saint Sebastian's Corporation 'Saint Sebastian assisted by Angels', in churches (Our Lady's, Saint Anne's, Saint Giles') and cityscapes in the Brangwyn Museum, the Tillegem Castle in St-Michiels and others.

Marcus GERARDS or GHEERAERTS (Bruges about 1520 – England before 1604). Painter, etcher, draughtsman. Made altar scenes for Brugean churches but is famous mainly for his map of Bruges in ten copper plates 'Brugae Flandrorum Urbs et Emporium Mercatu Celebre' (1562), an invaluable historical and iconographic document. This map

and a number of the original copper plates are on view in the History Room of the City Hall. Also made etches for an edition of Esopet (1567) and for 'De Waerachtige Fabulen der Dieren' by Edwaerd de Dene. Emigrated to England for religious reasons, where his son Marcus II (Bruges 1561 – London 1636) became a court painter.

Guido GEZELLE (Bruges 1.5.1830 – 27.11.1899). Priest. One of the greatest poets in Dutch. Romantic themes, virtuoso form. Collected works (1980-88) in 8 volumes. Guido Gezelle Museum in his birthplace Rolweg. Five memorial plaques on the houses where he was born, lived and died. Statue (1930 by Jules Lagae) opposite Our Lady's Church. Monumental tomb on the municipal graveyard Steenbrugge-Assebroek.

Sir Alfred GILBERT (London 12.8.1854 – 4.11.1930). Both his parents were teachers of music and composers. Sculptor. Sculpted the little Eros statue on Picadilly Circus in London. Settled in Bruges with his wife and cousin Alice Jeanne Gilbert (†1916) in 1900. After her death he contracted a second marriage with his housekeeper Stephanie de Bourgh in 1919. Worked as a sculptor and jewel-designer on several addresses in Bruges. Returned to Engeland on the king's request in 1926, in order to finish the duke of Clarence's mausoleum in London. He was knighted in 1927.

Lodewijk van GRUUTHUSE (†1492). Son of Jan van Gruuthuse and best known scion of this family. Was knighted after the Battle of Gavere (1453) and received the knighthood in the Order of the Golden Fleece in their 10th chapter as a reward for a succesful mission in England where he had to prevent a princely marriage. His friendship with Edward IV, King of England, dates back to this period. When Edward was defeated by Warwick in 1470, Louis went to his rescue in Alkmaar. From 27th to 29th October the king stayed at Gruuthuse's castle in Oostkamp and in January and February in the Brugean palace. In 1470 Edward IV was able to recover his kingdom thanks to the financial support of Charles the Bold who, by his marriage to Margaret of York, had become his brother in law. Shortly afterwards Gruuthuse was promoted to the rank of Earl of Winchester. Councellor of Mary of Burgundy. Governor of Holland and Zeeland (1462-77). Bibliophile. The museum and the Gruuthuse manuscript are called after him. This manuscript contains seven rhymed prayers, two of which by Jan van Hulst, 147 songs with musical notation and sixteen allegorical poems, one of which by Jan van Hulst and a few by Jan Moritoen (Egidius song). Anonymous portrait in the Groeninge Museum.

GUNHILDE (†Bruges 24.8.1087). Earl Goldwin and his wife Gytha's daughter and the lady of two Somerset domains was exiled from her country and spent the last years of her life in Bruges. She was buried in Saint Donatian's Church. Her leaden memorial plaque with an inscription (24,7 × 20,2 cm), now preserved in the Saint Saviour's Cathedral museum, is the oldest archeological piece of evidence of the contacts between England en Bruges.

Pieter HUYSSENS (Bruges 22.2.1577 – 6.6.1637). One of the most important baroque architects in the Louw Countries. Born in a rich family, he was trained by his father, an important member of the mason's corporation, and became a master at the age of 22 already. Entered the jesuit order in 1596. Remained active as an architect in Maastricht, Antwerp (Carolus Borromeus Church), Ypres, Dunkirk, Belle, Bruges (the present Saint Walburga's Church) and others.

Adriaan ISENBRANT (about 1490 – Bruges July 1551). Painter. Became a freeman in 1510. Lived in the Vlamingstraat. Influenced by Gerard David. Bruges possesses paintings

by him in Our Lady's Church 'Our Lady of the Seven Sorrows' and in the Groeninge Museum 'Portrait of Paulus de Nigro' (1518) and a triptych with Madonna and Child.

Thomas Harper KING (1822 – Teigermonth, Devon 1892). Studied in Exeter and Ascott. A student of A. W. Pugin's. Converted to catholicism in 1844. Settled in Bruges in 1848 and married E. Morgan in 1851. Left for England in 1860. Published, among other books, a French translation of Pugin's 'True Principles of Pointed or Christian Architecture'. Involved as an architect in the designs of the neo-Gothic Magdalen's Church (1853) and responsible, with William Curtis Brangwyn, for the mural paintings in the Chapel of the Holy Blood (1865-69).

Jan Frans KINSOEN (Bruges 28.2.1771 – 18.10.1839). Painter. Was a tremendous success in Paris where he married and lived. First painter of Jérôme Bonaparte, King of Westphalia. Painted mainly portraits (of the Princes of Orange, Leopold I and others), several of which in the Groeninge Museum. Also on view there is one of his rare neoclassic historical pieces 'Belisarius at his Wife's Deathbed' (1836).

Jules LAGAE (Roeselare 15.3.1862 – Bruges 2.6.1931). Romantic-realistic sculptor. Prize of Rome (1888). Works by him in Bruges: bust of Guido Gezelle (1894) in the garden of the Gezelle Museum, statue of Guido Gezelle (1930) opposite Our Lady's Church. In 1987 his 'Flandria Nostra' was put up on the Muntplein.

Colard MANSION (? – Bruges 1486). Author, calligrapher and printer. Founded one of the first printing offices in Bruges (1474). Worked together with William Caxton, printer and governor of the English hanse in Bruges. Became the dean (1471-74) of the booksellers' corporation. Protégé of Louis of Gruuthuse. Well-known works: 'Jehan Bocace de Certals (1476), 'Jardin de Dévotion', 'La Somme Rurale' (1480) and Ovid's Metamorphoses.

MARGARET OF YORK (Fortheringay, Northamptonshire 1446 – Mechelen 1503). Richard of York's daughter and king Edward IV's wife, she became the third wife of Charles the Bold, the duke of Burgundy. The marriage was concluded in Damme at 5 a.m. on 3rd July 1468 in the presence of the bishops of Salisbury and Tournai, after which they entered the festively decorated city of Bruges. The celebration, including among others the Tournament of the Golden Tree, lasted for more than a week. This marriage has inspired and dominates the five-yearly Pageant of the Golden Tree in Bruges.

MARY OF BURGUNDY (Maria van Bourgondië) (Brussels 13.2.1457 – Bruges 2.3.1482). Granddaughter of Philip the Good, daughter of Charles the Bold and Isabelle of Bourbon, wife of Maximilian of Austria, mother of Philip the Fair and Margaret of Austria. Died in the Princes' Hall after a hunting-accident, probably in the woods of Wijnendale. Buried in Our Lady's Church, where a monumental tomb (1502) was put up and where her skeleton was found during the excavations in 1979.

Thomas MORE (London 1478–1535). English humanist, statesman and saint. A friend of Erasmus, who often visited him in Chelsea and started writing his 'Laus Stultitiae' there. Under Henry VIII he became a royal advisor, treasurer and ambassador in Bruges (1515-1516), where he took part in the negotiations of the privileges for the English and Scottish merchants. In 1521 he was in Bruges a second time, in cardinal Thomas Wolsey's suite of 500 people. Not wanting to follow the king in his divorce and schism, he had to resign, was confined in the Tower and beheaded on 6th July 1535. His most important work is 'Utopia' in which Bruges is mentioned. One of his descendants, Mother Mary

Augustina More, became the prioress (1766-1818) of the English Convent in the Carmers-straat (memorial tablet in the church).

Hans MEMLING (Seligenstadt, Hessen, Germany about 1435 – Bruges 11.8.1494). Painter. Via Brussels, where he probably worked with Rogier van der Weyden, he came to Bruges, where he became a burgher in 1465 and lived in the Sint-Jorisstraat and Jan Miraelstraat. Six paintings are preserved in the Memling Museum, Saint John's Hospital and two in the Groeninge Museum, all of them universal masterpieces of painting. Statue (1877) by Hendrik Pickery on the Woensdagmarkt. Memorial plaque on his house (?) in the Sint-Jorisstraat.

Jan MORITOEN (Bruges about 1355 – 1416 or 1417). Perhaps the son of the cloth-trader Bartholomeus Moritoen. From 1408 to 1410 he was one of the three almsmasters in the parish of Saint Giles'. Became an alderman in 1413 and a city councillor in 1415-16. One (?) of the poets of the 'Rhetorycke ende Ghebedenbouck van Mher Loys vanden Gruuthuyse', the so-called Gruuthuse manuscript. His name is commemorated in the adult education association 'Moritoen', Eekhoutstraat 66.

Jozef ODEVAERE (Bruges 2.12.1775 – Brussels 26.2.1830). Painter. Studied in Paris with J. B. Suvée and J. L. David. Great prize for painting (1804). Became the court painter of king William I of the Netherlands in 1814. Portraits and historical paintings in the Groeninge Museum.

Luc PEIRE (Bruges 7.7.1916 – Paris). Painter. Godecharle Prize 1942. Exhibited in the 1968 Biennial of Venice. From 1955 onwards strict linear verticalism. Many of his works integrated in architecture. Environments. In the Groeninge Museum, where a retrospective exhibition with catalogue was held in 1966, 'Manolete' (1957) and 'Agadir' (1964).

Pieter PEPERS (Bruges 10.10.1730 – 28.6.1785). Sculptor, trained in Paris in the late baroque and rococo style. A number of works: pump decorated with lion, bear and coat of arms of Bruges on the Eiermarkt (1761), statue of Ferdinand Verbiest in the park of the Rooigem Castle Sint-Kruis (1772), four decorative elements of which have been put on the inner court of the Gruuthuse Palace, Peter and Paul (1765) in the public garden around Saint Saviour's Cathedral on the side of the Steenstraat; Jan Nepomucenus (1767) on the bridge over the Dijver; Our Lady with Child, marble (1776) in Saint Saviour's Cathedral.

Gustaaf PICKERY (Bruges 9.8.1862 – 28.2.1921). Sculptor. Son of Hendrik. Made among others the equestrian statue (1903) of Louis of Gruuthuse over the entrance of the Gruuthuse Museum, the Saint Michael (1905), a gilt copper statue on top of the Provincial Court on the Market square and ten statues (about 1910) on the stone stairs of honour of this Government Palace.

Hendrik PICKERY (Bruges 17.9.1828 – 27.7.1894). Sculptor: the statue of Jacob van Maerlant (1860) in Damme, the white marble statue of Hans Memling (1871) on the Woensdagmarkt. Also designed the gilt copper statues (1884) on top of the Recorder's House on the Burg, two lions (1893) at the bottom of the stairs of the Government Palace on the Market square and ten statues of rulers in this Palace's council chamber. Also realized a lot of sculpture for private houses, such as the four allegories (1875) in the Academiestraat 14. His own bust (1901) by his son Gustaaf stands on the Begijnenvest.

Pieter POURBUS (Gouda, The Netherlands 1523-24 – Bruges 20.1.1584). Painter, architect and cartographer. Son-in-law of Lanceloot Blondeel. Freeman in the Brugean corporation in 1543. Renaissance painter. Religious scenes in Brugean churches and a

number of splendid portraits. In the Groeninge Museum: 'The Last Judgement' (1551), the double portrait 'Jan van Eyewerve and Jacquemine Buuck' (1551).

Jan PROVOOST (Mons about 1465 – Bruges 1529). Painter, architect, cartographer. Became a burgher of Bruges in 1494 and a member and later the dean of the corporation. Met Albrecht Dürer in Antwerp in 1521 and accompanied him to Bruges, where he took him round. In the Groeninge Museum: 'The Last Judgement' (1525), two panels of a triptych with the donors and their patron saints Nicolas and Godelieve, 'The Miser and Death' and an impressive 'Crucifixion'.

Hendrik PULINX (Bruges 1.4.1698 – 17.2.1781). Sculptor, wood carver, cartographer, architect, ceramist. In 1720 'stadsoversiender', surveyor of the city public works. Designer of the baroque church of the English Convent (1739) in the Carmersstraat, of the rococo English Orphanage, now grammar school, along the Spiegelrei. Realized the pulpit of the Chapel of the Holy Blood, the marble tombs of the bishops Van Susteren (1747) and de Castillion (1753) in Saint Saviour's Cathedral. In 1750, together with his son, Hendrik Pulinx jr (1724-87), he founded a manufactory of earthenware, which went bankrupt in 1763.

Georges RODENBACH (Tournai 16.7.1855 – Paris 25.12.1898). Jurist, poet and novelist. Published collections of poems in the symbolist and Parnasse style, stories and a number of novels, the best known of which are situated in Bruges: 'Bruges-la-Morte' (1892) has been translated into eight languages, filmed twice and adapted into the opera 'Die tote Stadt' by Erich Wolfgang Korngold, and 'Le Carillonneur' (1897) his last and literarily best work. Commemorative plaque at the house De Roode Steen, corner Genthof and Spiegelrei.

Octave ROTSAERT (Bruges 21.7.1885 – 1964). Sculptor. Studied at the Academy of Bruges and at the Higher Institute for Fine Arts in Antwerp. A student of Thomas Vinçotte. Workshop Tempelhof, Sint-Pieters. Works by him in Bruges: The Pax sculpture on the inner court of the former Saint John's hospital (1947), portrait medallions of Dr. Sebrechts and his wife on the wall next to the entrance to the Sebrechts Park, Oude Zak, bronze buffaloes (1947) on the Canada Bridge, Leopold I laan, reminding of the liberation of Bruges via this bridge on 12th September 1944, bust of Maurits Sabbe (1950) near the Lockhouse of the Lake of Love, equestrian statue of King Albert I (1954) in the King Albert Park between 't Zand and the railway station.

Joseph RYELANDT (Bruges 7.4.1870 – 29.6.1965). Baron. Composer. Private student of Edgard Tinel. Director (1924-45) of the muncipal Music Conservatory. Composer of oratoriums, musical dramas and songs. At his request the poet Guido Gezelle wrote a text called 'The 24 Hours of Our Lord's Bloody Day's Journey' which Ryelandt set to music for four voices and small orchestra. His neo-Gothic house called King David, designed by the architect Huib Hoste, was pulled down in 1970. In 1987 his name was given to the new organ hall of the Conservatory in the former Theresians' church on the Van Acker square in the Ezelstraat.

Julius SABBE (Ghent 4.2.1846 – Bruges 3.7.1910). Teacher of Dutch at the Royal Atheneum. Founder of the monthly 'De Halletoren' (1874-81) and the weekly 'De Brugsche Beiaard' (1881-1914). Promotor of Bruges-Seaport (1907) and of the Breydel and De Coninc monument (1887) on the Market square. Poet (sonnets 'Mijn Brugge', 1912). Bronze commemorative plaque with medallion by Ernest Callebout at his house

Potterierei 34. Portrait by Jef Vande Fackere (1906) in the Groeninge Museum.

Maurits SABBE (Bruges 9.2.1873 – Antwerp 12.2.1938). Son of Julius. Philologist, teacher, prose-writer. Published scientific work and a series of Brugean stories, among which 'De Filosoof van 't Sashuis' (The Philosopher of the Lockhouse – 1907) has remained best known and has been filmed and translated. Bronze bust (1950) by Octave Rotsaert near the 16th century Lockhouse at the Lake of Love.

Rik SLABBINCK (Bruges 3.8.1914). Painter, draughtsman. Co-founder of 'La Jeune Peinture Belge'. Was a teacher at the Higher Institute for Fine Arts in Antwerp. Exhibited at the Venice Biennial in 1948 and 1954. Important exhibition in New York in 1987. Portraits, nudes, still-lives and landscapes are his most common themes, always developed in bright and pure colour surfaces. 'Self-Portrait' (1939) and 'Landscape' (1964) in the Groeninge Museum, where a retrospective exhibition with catalogue was organized in 1964.

Pol SPILLIAERT (De Panne 1935 – Bruges). Sculptor. Godecharle Prize 1959. Laureate sculpture West Flanders 1970. Abstract work in geometrical shapes, powerfully and sensitively worked out in several materials, such as polyester for 'Siloewit' (1961-68) in the little garden next to the entrance of the Groeninge Museum and marble for 'Formed by the Wind' (1984) in the Biekorf library, Kuipersstraat.

Arthur STAINFORTH Esq. (Brussels 31.3.1898 – Bruges 29.5.1954). Settled in Bruges in 1928. Inspirator of the Cercle Brugeois du Livre et de l'Estampe. Ex libris expert. Published a number of carefully edited and well illustrated literary mostly French works, such as Henri Godar's 'Histoire de la Gilde des Archers de Saint Sébastien de la ville de Bruges'.

John STEINMETZ (London 12.12.1795 – Bruges 1883). Author, bibliophile and art collector. Settled in Bruges in 1819. Bequeathed his collection of about 17,000 prints and drawings to the City of Bruges in 1863. His name still lives in the Steinmetz Collection of the Muncipal Museums, Mariastraat 32 Bis.

Simon STEVIN (Bruges 1748 – The Hague 1620). Clerk in Bruges and Antwerp. Became a member of the Chamber of Rhetoric of the Holy Ghost on 16th March 1571. Studied mathematics, physics and linguistics at the university of Leyden. Became adviser of prince Maurice of Nassau and a famous physicist, engineer and fortress-builder. Author of a series of scientific works, most of them written in Dutch. Statue (1846) by Eugène Simonis on the Simon Stevin square.

Stijn STREUVELS (Heule 3.10.1871 – Ingooigem 15.8.1969). Pseudonym of Frank Lateur. Important Flemish prose writer. Nephew of Guido Gezelle's. First a baker and from the beginning of 1889 till Easter 1891 an apprentice with the pastrycook Van Mullem, Schouwburgplein. Held a lecture about 'How I saw and experienced Bruges' in the Government Palace in Bruges on 16th March 1954.

John SUTTON OF NORWOOD-PARK (Sudbrooke-Holme, Lancashire 18.10.1820 – Bruges 6.6.1873). English baronet. Founder of the Seminarium Anglo-Belgicum, where Guido Gezelle was a teacher and later the vice-rector (commemorative plaque at Saint Leo's College, Potterierei). Benefactor of Saint Giles' parish. Musician, organist, promotor of church music and of neo-Gothic architecture. Got acquainted with Jean-Baptiste de Bethune via the British neo-Gothic promotor Welby Pugin.

Gilbert SWIMBERGHE (Bruges 14.5.1927). Painter. Developed from an expressionist

start into a geometrical-constructivist design about 1950, either in colours or in black and white and delicate shades of grey. Also graphic work, reliefs and mosaics. In the Groeninge Museum, where a retrospective exhibition with catalogue was held in 1977: 'Composition with Red', painting (1967), 'Relief 1971', wood, cardboard and enamel, and 'Grisaille', painting (1987).

Achiel VAN ACKER (Bruges 8.4.1898 – 10.7.1975). Socialist politician. Member of Parliament, minister and twice prime-minister. Chairman (1961) of the Chamber of Representatives. Book-seller, book-dealer, publisher ('De Garve'). Founder of the weekly 'Vlaams Weekblad' (1932) still being published. Wrote numerous articles and aphorisms, but also poems and memoirs (2 vol., 1964, 1967). Bust (1983) by Idel Ianchelivici on the Van Acker square, Ezelstraat. Commemorative plaque on his house Sint-Annarei 23.

Hugo VAN DER GOES (Ghent? – Brussels 1482). Painter and designer of festive decoration. Rather isolated character among the Flemish Primitives. The Groeninge Museum possesses one of his most brillant works 'The Death of Our Lady' (about 1470).

Jan VAN EYCK (Maaseik? about 1390 – Bruges 1441). Father of Flemish painting. In 1425 court painter, diplomat and chancellor of Philip the Good. In the Groeninge Museum two masterpieces and milestones in the history of paining: 'Madonna with Canon van der Paele' (1436), 'Portrait of Margaret van Eyck' (1439). Statue by Jan-Robert Calloigne on the Burg (1820) and by Hendrik Pickery on the Jan van Eyck square (1878).

Lodewijk VAN HAECKE (Bruges 18.1.1829 – 24.10.1912). Priest. Pro-Flemish popular figure. A teacher of French in Poperinge and at Saint Louis' College in Bruges. Curate in Roeselare, next teacher of French and English in Ostend and Roeselare. Talented preacher and lecturer. Published the periodical 'Zeesterre' (1862-65). A curate of the Chapel of the Holy Blood for more than forty years and published 'Le Précieux Sang à Bruges' (1869) which was often reprinted and also translated into English and Dutch. About his alleged satanic practices mentioned by Joris-Karl Huysmans, the Brugean journalist Herman Bossier published 'Geschiedenis van een romanfiguur' (1942 – History of a Novel Character). Van Haecke public garden in the Ezelstraat between the numbers 119 and 123 with passage to the Raamstraat.

Zeger VAN MALE (Bruges 1504 – 7.7.1601). Merchant living in the Garenmarkt. Was a city councillor and alderman, guardian of charitable institutions, governor of the Bogarden school. In recognition, he received an annual allowance from the city at the age of 92. Wrote among others 'Deerlicke Lamentatie van de Destructie ende grote Declinatie vande Stede van Brugghe' (Pitiful Lamentation about the Destruction and the Great Decline of the City of Bruges – 1591), diplomatic edition in 1977. Portrait on epitaph painting by Pieter Pourbus in Saint James's Church.

Jan Baptist VAN MEUNINKHOVE (? – Bruges 12.1.1704). Became a freeman in Bruges in 1644. Pupil of Jacob van Oost, sr. Famous mainly for his well painted and especially historically and iconographically accurate marines and cityscapes (in the Brangwyn Museum), such as the Market, the Burg, interior of Saint Donatian's Church. Also paintings about the stay of king Charles II of England in Bruges.

Jacob VAN OOST (Bruges 1601-1671). Painter. Freeman in 1621. Travelled in Italy. Back in Bruges in 1628. In 1633 dean of the corporation. Most important representative of baroque painting in Bruges. In the Groeninge Museum a remarkable 'Portrait of a Brugean Family' (1645) and several other works in Brugean churches. Commemorative

plaque at his house Wapenmakersstraat 3.

Juan Luis VIVES (Valencia 1492 – Bruges 1540). Spanish humanist, educationalist and author. Lived in the Vlamingstraat from 1512 onwards. Friend of Erasmus, Thomas More and Ignatius of Loyala whom he received in Bruges. Boarding-school holder. Published among others an important work about the poor relief. Bronze bust by the Spanish sculptor Ramon Mateu on a base designed by the architect Marcel Koekelbergh was put up near the Boniface bridge 'with the cooperation of the Brugean city council by the Spanish primary education in memory of the excellent educationalist of Valencia'.

James WEALE (London 8.3.1838 – 26.4.1917). British art historian. Lived in the house 'Ter Balie', corner of Sint-Jorisstraat and Sinte-Clarastraat (commemorative plaque, 1924)), from 1856 to 1878. Together with Guido Gezelle, he founded the weekly 'Rond den Heerd' (1865). Published important studies about Van Eyck, Memling, David and others.

Henri Victor WOLVENS, true name Wolvenspergens (Brussels 6.6.1896 – Bruges 31.1.1977). Painter, draughtsman and etcher with mainly expressionist work. Lived in the Moerstraat from 1930 onwards. Portraits, interiors, landscapes, mainly sea and beach scenes, all of them painted in a powerful and dynamic style. In the Groeninge Museum, where a retrospective exhibition with catalogue was held in 1959: 'The Deserted Party Table' (1935), 'The Commercial Inner Harbour of Bruges' (1939), 'Beach in Koksijde' (1952) and 'The Pier in Zeebrugge' (1954).

LIST OF THE PROTECTED MONUMENTS IN BRUGES

in accordance with the law of 7.8.1931 on the conservation of monuments and landscapes and with the decrees of 13.7.1972 and 3.3.1976 laid down in 'Koninklijke Besluiten' (KB – Royal Decrees). Since 1982 these matters are decided on by the 'Vlaamse Executieve' (VE – Flemish Government) and by 'Ministerieel Besluit' (MB – Ministerial Order). The well-known international blue and white sign has been affixed to these protected monuments.

BRUGES INTRA MUROS

Major Architecture

1. Burg. Chapel of the Holy Blood and Basilica of Saint Basil – KB 25.3.1938.
2. Carmersstraat 83, Church of the English Convent – KB 9.7.1974 and convent – VE 22.9.1982.
3. Ezelstraat, Anglican Church – KB 5.12.1962.
4. Ezelstraat, Monastery of the Discalced Carmelites – KB 9.7.1974. with interior, hermitage and plague house – VE 21.6.1984.
5. Katelijnestraat, Chapel of the Bogarden school, now Municipal Academy of Fine Arts – KB 20.7.1946.
6. Keersstraat 1, Saint Peter's Chapel or 't Keerske – KB 16.9.1966.
7. Kreupelenstraat, Chapel of Our Lady of Blindekens – VE 22.12.1982.
8. Our Lady's Church – KB 25.3.1938.
9. Peperstraat, Jerusalem Church – KB 25.3.1938.
10. Potterierei, Former Abbey of the Dunes, now Major Seminary – KB 28.5.1962.
11. Predikherenrei, Remnants of the former Monastery of the Dominicans, especially the remnants of the west porch and the south wall of the church – KB 17.12.1980.
12. Saint Anne's Church – KB 28.3.1958.
13. Saint Giles' Church – KB 8.2.1946.
14. Saint James' Church – KB 25.3.1938.
15. Saint Saviour's Cathedral – KB 25.3.1938.
16. Saint Walburga's Church – KB 20.2.1939
17. Snaggaardstraat, Chapel of Spermalie – KB 10.12.1980.

Military Architecture

18. Ezelpoort – KB 5.12.1962 (Donkey's Gate).
19. Gentpoort – KB 13.8.1953 (Ghent Gate).
20. Kruispoort – KB 5.12.1962 (Cross Gate).
21. Smedenpoort – KB 5.12.1962 (Blacksmith's Gate).

Civil Architecture

22. Beguinage, chapel and complex of buildings – KB 20.2.1939.
23. Burg, The Franc – KB 25.3.1938.
24. Burg, The Civil Recorders' House – KB 3.7.1942.
25. Burg, City Hall – KB 25.3.1938.
26. Burg, The Provost's House – KB 5.12.1962.
27. Dijver, Gruuthuse Palace – KB 25.3.1938.
28. Kruisvest, Saint John's Mill or Schelle Mill – KB 7.2.1943.
29. Kruisvest, The New Parrot, former Hoge Seine Mill of Beveren/IJzer – KB 14.4.1944 and KB 6.2.1970.
30. Mariastraat, Saint John's Hospital – KB 3.7.1942.
31. Markt, Belfry and Halles – KB 25.3.1938.
32. Vismarkt – KB 5.12.1962 (Fish Market).
33. Vlamingstraat 33, The Genoese Lodge or White Wool Hall – KB 15.3.1951.

Minor Architecture

34. Academiestraat 14-16, State Archives – KB 9.7.1974.
35. Balstraat 2-12, Almshouses Adornes – KB 10.7.1973.
36. Balstraat 27-41, Almshouses of the Shoemakers (now Municipal Museum of Folklore) – KB 9.7.1974.
37. Beenhouwersstraat 2 – VE 7.12.1983.
38. Biddersstraat 29-31-33 – KB 14.10.1975.
39. Biskajersplein 6, House Den Struys – KB 9.7.1974.
40. Boeveriestraat 5-7 and Gloribusstraat 1-5, Almshouses Van Campen – KB 9.7.1974.
41. Boeveriestraat 9-19 en Gloribusstraat 2-13, Almshouses Van Peenen – KB 9.7.1974.
42. Boeveriestraat 52-76, Almshouses De Moor – KB 9.7.1974.
43. Boeveriestraat 59-69 – KB 9.7.1974.
44. Braambergstraat 25 – KB 9-7-1974.
45. Carmersstraat 79, Part of the English Convent – VE 22.9.1982.
46. Carmersstraat 178, Saint Sebastian's Guild – KB 20.9.1958 and KB 27.5.1975.
47. Cordoeaniersstraat 5, House Den Steur – KB 9.7.1974.
48. Coupure 1 and 1 bis, Hotel d'Hanin de Moerkercke, together with Witte Leertouwersstraat 1 and 1 bis – VE 15.9.1982.
49. Dijver 12, Porch of the Provost's House of Our Lady's Church, now Groeninge Museum – KB 9.7.1974.
50. Dijver 16, House Arents, now Brangwyn museum – KB 5.12.1962.
51. Drie Kroezenstraat 2-14, Almshouses Our Lady of the Seven Sorrows – KB 9.12.1980.
52. Ezelstraat 83-95, Almshouses Saint Joos – KB 9.7.1974.
53. Freren Fonteinstraat 14 – KB 10.12.1980.
54. Garenmarkt 5 – KB 9.7.1974.
55. Genthof 1-3 – KB 9.7.1974.
56. Genthof 7 – KB 9.7.1974.

57. Genthof 11 and Woensdagmarkt 10 – KB 24.5.1976.
58. Grauwwerkersstraat 3, Former Consulate of Genoa – KB 15.3.1951.
59. Groene Rei, Almshouses The Pelican – KB 6.11.1961.
60. Groeninge 20-30 – KB 9.7.1974.
61. Heilige-Geeststraat 4, Hall of Pittem, now Bishop's Residence – KB 9.7.1974.
62. Hoedenmakersstraat 11 – KB 9.7.1974.
63. Hoefijzerlaan 14 – KB 20.3.1980.
64. Hoefijzerlaan 17 – KB 28.3.1979.
65. Hoogstraat 6-8, House The SevenTurrets – KB 9.7.1974.
66. Hoogstraat 18 – KB 9.2.1978.
67. Huidenvettersplein 14, The Former Municipal Assize – KB 9.7.1974.
68. Jan van Eyckplein 1, The Custom's House and The 'Pijnders' (unloaders) House – KB 5.12.1962.
69. Jeruzalemstraat 56-60 – KB 9.7.1974.
70. Jozef Suvéestraat 2 – KB 9.7.1974.
71. Kammakersstraat 7-25, Almshouses Van Paemel, M. Voet and Blindekens – KB 9.8.1974.
72. Kammakersstraat 27-31, Almshouses – VE 22.12.1982.
73. Kastanjeboomstraat 1-5 – KB 9.7.1974.
74. Kastanjeboomstraat 13, Garden House – KB 9.7.1974.
75. Katelijnestraat 79-85, Almshouses De Generaliteit – KB 9.7.1974.
76. Katelijnestraat 87-101, Almshouses Hertsberge – KB 9.7.1974.
77. Katelijnestraat, Old Chimney, 16th century building and chapel of the former Bogarden School, now Municipal Academy of Fine Arts – KB 20.7.1946.
78. Katelijnestraat, Buildings of the Barge – KB 10.9.1980.
79. Kleine Nieuwstraat, between 24 and 26, Shrub – KB 9.7.1974.
80. Komvest 43, Storehouses of the former Inner Harbour – KB 22.11.1974.
81. Korte Rijkepijndersstraat 24, House The Three Swans – KB 9.7.1974.
82. Kreupelenstraat 10-18, Almshouses of Our Lady of Blindekens – VE 22.12.1982.
83. Kuipersstraat 23, The Black House – KB 9.7.1974.
84. Vlamingstraat 90, Wooden Façade in Korte Winkel – KB 9.7.1974.
85. Krom Genthof 1, House of the Orientals – KB 9.7.1974.
86. Langerei 7, Porch of De Woecker – KB 9.7.1974.
87. Langerei 13 – KB 9.7.1974.
88. Langerei 23, Former Convent of Sarepta – KB 9.7.1974.
89. Langestraat 44-50 – KB 9.7.1974.
90. Mallebergplein – KB 9.7.1974.
91. Mariastraat 10 – House The Pelican – KB 9.7.1974.
92. Markt 15 – House Boeckhoute – KB 9.7.1974.
93. Naaldenstraat 7, Hall of Gistel – KB 9.7.1974.
94. Naaldenstraat 19-21, Hall of Bladelin – KB 9.7.1974.
95. Nieuwe Gentweg 8-54, Almshouses De Meulenaere – KB 9.7.1974.
96. Nieuwe Gentweg 57-70, Almshouses Saint Joseph – KB 9.7.1974.
97. Oliebaan, Farm Cortvriendt – KB 14.10.1975.
98. Oost-Gistelhof 2 – MB 3.7.1985.

99. Oude Burg 21, Orangery of the House de Halleux – KB 15.3.1951.
100. Oude Burg 24 – KB 9.7.1974.
101. Oude Burg 27 – KB 9.7.1974.
102. Oude Gentweg 126-130 – Almshouses of the Tailors – KB 9.7.1974.
103. Oude Zomerstraat 2 – KB 9.7.1974.
104. Peperstraat 1-3, House Adornes – KB 13.8.1953.
105. Philipstockstraat 33 – KB 9.7.1974.
106. Pieter Pourbusstraat 5 – KB 9.7.1974.
107. Predikherenstraat 25 – House van Beversluys – KB 9.7.1974.
108. Prinsenhof 8 – VE 29.6.1983.
109. Sint-Amandstraat 10, House The Parrot – KB 9.7.1974.
110. Sint-Annarei 22 – KB 9.7.1974.
111. Sinte-Clarastraat between 48 and 50, Farm – KB 7.5.1975.
112. Sint-Jakobsstraat 23, Music Conservatory – KB 9.7.1974.
113. Sint-Jakobsstraat 68 – KB 23.3.1979.
114. Sint-Jansstraat 16 – KB 9.7.1974.
115. Sint-Jorisstraat 9-15 – KB 9.7.1974.
116. Sint-Jorisstraat 35 – Jonckhof of the Saint George's Guild – KB 9.7.1974.
117. Sint-Maartensplein 5-6 – KB 9.7.1974.
118. Sint-Niklaasstraat 5-7 – KB 11.12.1974.
119. Snaggaardstraat 21, belonging to the English Convent – VE 22.9.1982.
120. Snaggaardstraat 58, belonging to the English Convent – VE 22.9.1982.
121. Spanjaardstraat 7, House Au Jambon – KB 9.7.1974.
122. Spanjaardstraat 16, House de la Torre – KB 5.9.1977.
123. Spanjaardstraat 19, House Pietà or Haunted House – KB 9.7.1974.
124. Spiegelrei 7 – KB 26.3.1976.
125. Spiegelrei 15, Former Monastery of the English Jesuits, now Grammar School – KB 9.7.1974.
126. Spiegelrei 23 – KB 9.7.1974.
127. Spinolarei 3 – KB 9.7.1974.
128. Steenstraat 25, Corporation House of the Masons – KB 9.7.1974.
129. Steenstraat 38, Corporation House of the Carpenters – KB 9.7.1974.
130. Steenstraat 40, Corporation House of the Shoemakers – KB 9.7.1974.
131. Twijnstraat 5 – KB 9.2.1978.
132. Twijnstraat 7 – KB 9.7.1974.
133. Verwersdijk 20, Statue of Our Lady – KB 19.12.1980.
134. Visspaanstraat 46-60, Almshouses – KN 19.8.1980.
135. Vlamingstraat 11, House The Mint – KB 9.7.1974.
136. Vlamingstraat 51 – KB 9.7.1974.
137. Vlamingstraat 100, Bay – KB 15.3.1951.
138. Wijnzakstraat 2, House The Crown – KB 5.12.1962.
139. Witte Leertouwersstraat 1 and 1bis, together with Coupure 1 and 1bis, hotel d'Hanin de Moerkercke – VE 15.9.1982.
140. Woensdagmarkt 6, Convent of the Black Sisters – KB 9.7.1974.
141. Wollestraat 25 – KB 9.7.1974.

142. Wollestraat 53 – KB 9.7.1974.
143. Zilverstraat, House Vasquez – KB 9.7.1974.
144. Zwarte Leertouwersstraat 9 – KB 10.12.1980.
145. Zwarte Leertouwersstraat 68-82, Almshouses de la Fontaine – KB 9.7.1974.

Landscapes and Cityscapes

146. Beguinage – KB 20.2.1939.
147. Kruisvest with the Mills, the Saint Sebastian's Guild and the Guido Gezelle Museum – KB 20.9.1958 and 28.5.1962.
148. Katelijnestraat 160, Buildings of The Barge and surrounding area – KB 10.9.1980.
149. Carmersstraat 83 – The surroundings of the English Convent – VE 22.9.1982.

BRUGES EXTRA MUROS

Assebroek

150. Church of Our Lady of the Immaculate Conception, Pastoor Verhaegheplein 11, Church and Organ – KB 28.11.1978.
151. Pastoor Verhaegheplein and surrounding area, townscape – KB 28.11.1978.
152. Farm complex De Zeven Torens – KB 8.7.1970.
153. Landscape of the Beukendreef – KB 5.5.1959.
154. Landscape south of Our Lady's Church, the grasslands of Assebroek – KB 13.9.1976.

Dudzele

155. Ruins of the Romanesque Tower of the former Saint Leonard's Church – KB 20.2.1939.
156. Statiesteenweg 28, Farm De Goudblomme – KB 11.9.1981.
157. Statiesteenweg 45, Farm De Rozeblomme – KB 13.1.1978.
158. Westkapellesteenweg 28, House with Smithy and surrounding area (Church, Churchyard,...) protected as townscape – KB 21.8.1979.

Koolkerke

159. Landscape of the Beieren Castle – KB 23.6.1976.
160. Dudzeelse steenweg 460, Castle De Groene Poorte and surrounding area – KB 2.2.1981.

Lissewege

161. Church and Tower of Our Lady's Church – KB 19.4.1937.
162. Barn of the former Abbey of Ter Doest – KB 25.3.1938.

163. Landscape of the grasslands nearby the farm Groot Ter Doest and de west side of the canal Brugge-Zeebrugge (Boudewijn canal) – KB 23.9.1981.
164. Lisseweegs Vaartje, Stone Wind Mill De Witte Molen – KB 28.5.1962.

Sint-Kruis

165. Castle of Male, Great Tower – KB 5.5.1959.

Sint-Michiels

166. Castle of Tillegem – KB 20.7.1946.
167. Landscape with the Castle of Tillegem, the Moat, the Ponds and the Park – KB 20.7.1946.
168. Heidelbergstraat 78, Castle of the White Sisters of Africa (monument) and surrounding area (townscape) – VE 27.10.1982.

Sint-Pieters

169. Oude Oostendse Steenweg, the Zandwege Mill – VE 27.10.1982.

INDEX

172